PUVIS DE CHAVANNES

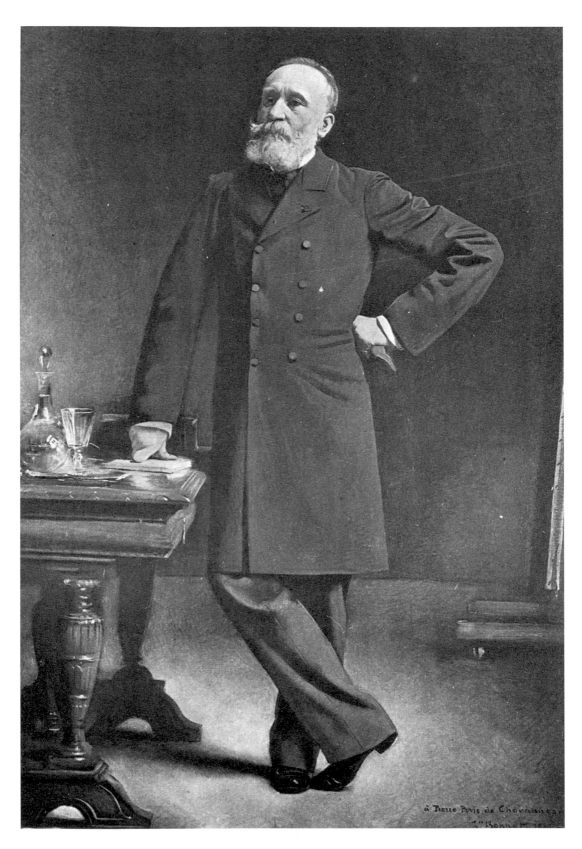

Frontispiece BONNAT: *Portrait of Pierre Puvis de Chavannes* 1882. Private Collection, France.

PUVIS DE CHAVANNES

BY

BRIAN PETRIE

edited and with a preface by
Simon Lee

ASHGATE

Published by

Ashgate Publishing Limited Ashgate Publishing Company
Gower House Old Post Road
Croft Road Brookfield
Aldershot Vermont 05036-9704
Hants GU11 3HR USA
England

First published 1997

British Library Cataloguing in Publication Data
Petrie, Brian
 Puvis de Chavannes
 1. Puvis de Chavannes, Pierre Cécile 2. Painters – France –
 Biography 3. Painting, Modern – 19th century – France
 4. Painting, French 5. Mural painting and decoration, French
 I. Title II. Puvis de Chavannes, Pierre Cécile III. Lee, Simon
 759.4

Library of Congress Catalog Card Number: 97-074710

ISBN 1 85928 451 5

Produced for the publishers by
John Taylor Book Ventures
Hatfield, Herts

Printed in Great Britain by BAS Printers Ltd, Over Wallop, Hampshire

CONTENTS

PREFACE

In his own lifetime Pierre-Cécile Puvis de Chavannes acquired great fame and the reputation as the foremost mural painter of his generation. Almost uniquely he also gained the approval and acclaim of both the artistic establishment and the younger generation of artists such as Van Gogh, Gauguin, Seurat, Matisse and Picasso. In 1895 he was the guest of honour and feted at a grand banquet attended by 550 guests and presided over by Rodin. In 1899, the year after his death, a large retrospective of his work was held at the Salon of the Société des Beaux-Arts. But since the early years of the century interest in his work has sharply waned. It is only since the 1970s that he has drawn limited scholarly attention which gave rise to a number of theses and to the important exhibition in Paris and Ottawa in 1977. Most recently, in 1994, Aimée Brown Price has organised an impressive and stimulating exhibition of his work at the Van Gogh Museum in Amsterdam.

It was Brian Petrie's intention to write a short but authoritative monograph on Puvis to introduce him to a wider public. His interest in Puvis was primarily concerned with an investigation of the artistic and cultural context of the artist in the latter half of the nineteenth century. In his article on 'Puvis de Chavannes and French Symbolist Painting', in *Studio International* (May 1972) he established his credentials in this field and shortly afterwards embarked on a longer and more detailed study. Tragically the commission to produce a serious study of Puvis coincided with the onset of multiple sclerosis and the rapid deterioration of his physical condition curtailed the production and completion of the manuscript. Even so, the draft manuscript of the body of the text had been prepared and it is this manuscript which forms the text of this book. Brian Petrie died in November 1984, at the age of 43, and was not able to edit or proof read this study. It has been prepared for publication by

MaryAnne Stevens, Peter Fitzgerald, and myself, and we have found no need to make any editorial modifications to the text, which presented an original, consistent and, in our view, subtle study of the artist. We have added a brief bibliography and chronological table but in all other respects it is the book which Brian Petrie wrote and hoped to see published.

Brian's scholarship and thought was deep and wide-ranging, his prose free of jargon and his insight into the works revealed a complex and humane sensibility both on the part of the artist and his biographer. Thus, this volume can serve as a fitting memorial to Brian Petrie as well as an accessible introduction to the work and milieu of Puvis de Chavannes.

SIMON LEE
Reading, 1997

INTRODUCTION

Young Girls by the Sea (Plate VIII) is a painting which, though relatively little-known, is among the most beautiful French paintings of the late nineteenth century belonging to the Musée d'Orsay. It was first exhibited at the official Salon in 1879 and is from the artist's maturity. In its simplicity it is a distillation of Puvis de Chavannes's style, and its characteristics will be found throughout the artist's work. Each of the three figures is tender, graceful, and sensuous. Physically each is at peace with herself. They are arranged in a setting whose linear rhythms have a rigorous stability which complements, by contrast, the intimate empathy provoked by these beautiful figures. The sensuality here, and the feeling it induces is not only the result of careful study from life, but of a naturalism modified by an aesthetic judgement which is not content with mere analysis, however observant, but which tends toward a rhythmic synthesis of forms. However, the flowering plants on the dune are clearly the outcome of careful study of the type. Sensitivity and delicacy in the parts coexist with a broad structural sense.

If the painting is not a simple record, and if there is no feeling that it could be related in any plausible sense to a scene in contemporary life, to what end was it painted? What were the painter's ambitions? The work was first exhibited with the note 'Decorative Panel' added after its title in the catalogue of the Salon. It originally possessed a border of decorative motifs painted by the artist himself, and as such it followed the pattern established by him when painting the very large decorative murals for public places which formed his main artistic activity. Some of the formal attributes of the work, notably its lack of the illusionism commonly sought by the painters of the time, are attributable to this fact. But the emotional value of the painting is such as to demand a less functional explanation. This decoration has its own poetic charge, which is the

product of a special combination of aesthetic and human values. By, and through painterly means, Puvis has expressed a sensibility, a cast of mind, an emotion, which accepts the world and rejoices in it, but which is also innately contemplative. This sensibility avoids rhetoric but is determined by all means available to art, formal and empathetic, to impose itself. There is an emotion which the spectator may be slow to recognise since he must first find it within himself; an emotion to recapture for which this work will always act as a mnemonic and which will thereafter be recognised elsewhere in art as in life.

Great artists are necessarily 'men of their time'. This truism holds as much for Puvis de Chavannes as it does for his better-known contemporaries and admirers Seurat, Gauguin, Rodin and Van Gogh. Although Puvis was one of the most important French painters at the end of the nineteenth century, he was not himself greatly in love with his times. His artistic credo can be found in a letter of 1888, where he spoke of his ambition to paint 'some beautiful, natural and eternal scene expressive of human feeling'. It is consistent with such an ambition that on the few occasions when he made any attempt to adapt his essentially timeless style to modern themes, the results were not happy, and that the question of his relationship with the modern movement in the arts at the end of the century – that Symbolism with which, then and since, he has often been associated – should remain equivocal. He participated in the administration of the arts, being for many years a member of the Salon Jury and becoming in 1890, president of the rival Salon, the *Société Nationale des Beaux-Arts*, which had been established by liberals discontented with the long-lived *Société des Artistes Français*. But he filled such posts with detachment. His was an art, and a life, which is not easily labelled.

In Puvis's work there are affinities with Romanticism which had been predominant in his youth, with Symbolism, and even with that Naturalism abhorred by the Symbolists. Late in the century there was also a new spirit of classicism to be found in the work of Seurat, Maillol and later, Picasso; and these were all artists who felt Puvis's influence and copied his work. (This notoriously slippery term, 'classicism' may be the most acceptable definition, though not to be understood as implying any conscious revivalism, in that it embodies the related moral and aesthetic

sense of order in Puvis's works.) Such concern to depict a harmonious, ideal society through harmonious composition appears in its purest form in the *Pleasant Land* of 1882 (Plate XI). This masterpiece does not offer its ideal vision in nineteenth-century terms, or in those of antiquity. This is no hedonistic idyll, such as that offered by Ingres in his *Golden Age* (also a work whose purpose was decorative) or by Matisse in his *Joy of Life* of 1905, another painting that has some affinity. In the *Pleasant Land* we witness no more than a pause in the necessary labour of fruit-gathering, an activity sufficiently demanding to confer on one of these figures a sense of respite from strenuous activity which is instantly reminiscent of one of Degas's ironing women. (Degas was one among the many who admired Puvis's art.) The fishermen's work continues on the shore and even the wrestling children can be understood as preparing themselves for the active, and if necessary, military manhood, which is treated more explicitly in the painter's *Pro Patria Ludus* (Plate X), exhibited at the Salon in the same year.

This composition, with its beautiful sense of interval, includes to the left an architectonic group whose classicising manner was immediately taken up by Seurat in his first major painting, *Une Baignade, Asnières*. The contrast between Seurat's conventional perspective and Puvis's attention to the picture-plane, his tendency towards the frieze-like, is the natural result of Puvis's concern, as a decorative artist, with the two-dimensional canvas, and the simple harmony of blue and pale gold reveals the same concern.

Puvis was in a certain sense a conservative artist, but this was not conservatism in the sense of entrenched academic opposition to the new; he is recorded as an admirer of Monet, of Degas, of Bazille and even of Beardsley. Nor was his classicism mere nostalgia for the irrecoverable past, like that expressed by Leconte de Lisle in his poem *Venus de Milo*:

> Oh! que ne suis-je né dans le saint Archipel,
> Aux siècles glorieux où la terre inspirée
> Voyait le ciel descendre à son premier appel!

Instead he shared with that poet another view which could compensate for his disillusion with the present by his hope for the future, the ordered and harmonious fabric of whose society might be adumbrated in a correspond-

ing present aesthetic. (Perhaps the most notable more recent example of this kind of equivalence between ethic and aesthetic is to be found in the work of Mondrian.) Puvis's conservatism was that of the long view, seeking to reassert a sense of human identity threatened by the growth during his lifetime of a new febrile urban race.

In his mature work as a decorative artist, Puvis is the descendant of Raphael, rather than of the Italian Primitives or the Baroque. Like that of Raphael, Puvis's art is 'classic', based on the observation of life and the living model, rather than systematic study of the antique or on the invention of a highly individualistic manner. Preferring understatement to the risk of over-expression, his art is closer to the spirit of Raphael in the *Stanza della Segnatura* than to the Raphael of the later *Stanze* or the Tapestry Cartoons.

The unveiling in 1877 of the first of Puvis's two major mural sequences in the Panthéon depicting episodes from the life of Saint Genevieve confirmed his reputation. Until that time critical hostility had outweighed critical acclaim, and an earlier popular success, that of *The Balloon* and *The Carrier Pigeon* (Plates 43, 44) had certainly owed as much to their appeal to patriotic sentiment at the time of the war as it had to their artistic appeal. After 1877 adverse criticism was far from silenced, but a consensus of approval gathered strength. Puvis worked as a muralist, using *toiles marouflées*, canvases glued to the wall. These were always exhibited at the Salon before departing to the provincial destinations for which they were painted, but one reason for the success of the Panthéon works was no doubt their accessibility, in the centre of Paris. The first Panthéon works also mark the attainment of his mature style as a muralist. All but one element of his plastic language had long been present in his works; the last to reach maturity was his distinctive and poetic sense of colour. Only the insensitive could now agree with such disparaging epithets as 'anaemic'. Before 1877 it had been all too common to judge Puvis's art by criteria little different from those applying to the easel-pictures in whose company they were seen at the Salon, but now there was little excuse for persistence in this error. The so-called 'lack of finish', the apparently crude modelling and the absence of delicacy in his draughtsmanship could be seen in the Panthéon to have their own purposes.

By the end of Puvis's life nearly all contemporary artists and critics professed a deep admiration for his work. Despite his apparent lack of interest in all things 'contemporary', there was one sense in which his art was very much of its time. In retrospect it can be seen as a summation of most French art preceding the 'modernism' of the twentieth century, even while it necessarily assimilated some aspects of contemporary styles. This can be seen as we follow the development of his work.

ONE

EARLY CAREER

Théophile Gautier, Puvis's friend and, during the earlier part of his career, his most devoted critical supporter, welcomed with enthusiasm *The Return from the Hunt* (Plate 6) in his review of the 1859 Salon. (This was only Puvis's second appearance at the Salon; his first, in 1850–51 had gone un-noticed.) *The Return from the Hunt* was the second version of a composition which had formed part of Puvis's first decorative cycle, completed four years previously at his brother's country house near Cuiseaux. Gautier remarked on the stylistic eclecticism: 'a great taste for antiquity mixed with a certain medieval naivety', and 'a little reminiscent of *The Triumphs* of Andrea Mantegna'. But the Greek, and thus necessarily sculptural quality, together with the absence of finish are implicit in the decorative ambitions of the work: 'too much relief is detrimental to mural decoration'.

One of Gautier's earlier enthusiasms had been for the work of Théodore Chassériau (who had been, toward the end of his short life, Puvis's friend and unofficial master, and in whose studio Puvis probably met the Princess Cantacuzène (Plate 1)). Chassériau's work had the expressive qualities, and even some of those motifs that were to be echoed on more than one occasion in the art of Puvis. It was Chassériau's *Trojan Women* of which Gautier wrote in 1852 a decade after the painting's exhibition: 'their sorrow did not destroy their beauty, their feminine despair wept with grace and was spread in charming groups over the beaches and the rocks . . .'. Here are two salient aspects of Gautier's aesthetic of *L'Art pour L'Art* – Art for Art's sake – Beauty and Impassibility. The latter implies a restraint in visually expressed emotion; the former, a beauty both hellenising and, specifically, sculptural – sculptural whether or not it is embodied in marble; paint too can be handled sculpturally. Puvis's art showed affinities with the hellenising aspect of

Parnassianism and *L'Art pour L'Art*, but it did so on the understanding that this was only a metaphor – a universal metaphor – for certain values of a moral and social nature which remained in every sense alive. Puvis was perhaps closer in this respect to the spirit in which Leconte de Lisle and Louis Ménard wrote than to Gautier. Nonetheless, Gautier continued in later reviews to emphasise Puvis's *detachment*, if not precisely *impassibility*. It is doubtful that Puvis's impassibility quite equalled that of the painter satirised by Jean Dolent when he commented that the soutane worn by a priest in one of his paintings and the red ribbon of the Legion of Honour awarded to himself were each merely *notes de couleur*.

In 1870, Gautier wrote of 'A truly marvellous isolation where certain artists live during their own times . . . Puvis de Chavannes is one such soul'. This issue of historicism and contemporaneity was addressed by Gautier. The poet wrote in 1865, 'I have always preferred the statue to the woman', – a remark which Gautier's biographers would have no trouble in disproving – 'and marble to the flesh'. But in 1870 he could write a sonnet which reads in part:

> J'aimais autrefois la forme païenne,
> Je m'étais créé, fou d'antiquité
> Un blanc idéal de marbre sculpté
> D'hétaïre grecque ou milésienne.

But now he no longer loved the Greek and the sculptural, but:

> Maintenant j'adore une Italienne
> Un type accompli de modernité
> Qui met des gilets, fume et prend du thé
> Et qu'on croit Anglaise ou Parisienne'.

Considering their close friendship, it is likely that *Summer* of 1873 (Plate VI) contains indirect homage to Gautier's ideas. The issue hinges on the sculptural values often found in Puvis's work, values noted particularly with regard to this painting by some critics. Gautier himself had remarked perhaps more often on this quality in Puvis's work than on any other. For Gautier, sculpture was aesthetically the nearest plastic analogue to verse itself. (It is not surprising then, to find poetic sentiment and musicality were thought to be characteristic of Puvis's later work.) In a

16

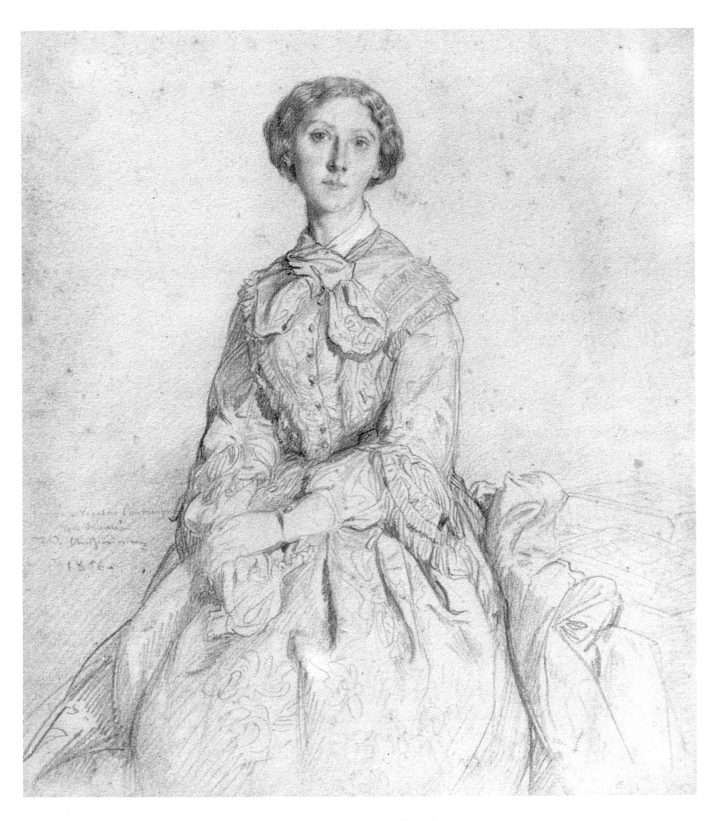

1. CHASSÉRIAU: *Princess Cantacuzène*. 1856. Private Collection, London.

discussion of the *Venus de Milo*, published in 1870, Gautier considered whether the figure was 'goddess' – an aesthetic representative of the *beau idéal,* or 'woman' modelled on a unique and real creature. Puvis would seem to have made a particular effort to create a figure both real and divine in *Summer,* where a figure whose sculptural quality has often been noticed, an 'agrarian Venus' (to borrow a term used by Gautier on another occasion), occupies a prominent place. It must have been whilst Gautier was dying, in the autumn of 1872, that Puvis was considering this painting, and he created something specifically antique, generically reminiscent of the *Venus de Milo* herself, in this figure. But there are earlier instances of this concern to humanise what otherwise might have appeared too 'divine', sculptural, or cold and in aesthetic terms impassible. One such instance is the *Magdalene in the Desert* (Plate IV) of 1870. The subject could be said to require precisely this humanised divinity, but the gentleness, restraint, and monumentality of this figure, qualities reinforced by the design of the landscape setting, all conform with the ambitions of Gautier's aesthetic when considered in abstract terms.

It is no doubt purely coincidental that the painting by Puvis owned by Gautier should have been another, earlier *Christ and the Magdalene* (its composition was totally different). But there is one case of an earlier, closer, and more entertaining collaboration between the two of them. In 1863, Puvis asked if he might paint the set-decoration for a private birthday performance of two of the poet's one-act plays at Neuilly. For this occasion there was to be a remarkable audience, including the painters Cabanel, Baudry, Hébert and Doré – all luminaries of the Second Empire – also Charles Garnier, soon to distinguish himself as architect of the Paris Opera House. Among the writers: Baudelaire (who arrived covered in mud, according to Gautier's daughter Judith, from whose memoirs this information derives, having deliberately and perversely trodden on a fierce dog's tail on his way, and been pushed into the gutter for his pains), Alexandre Dumas (*pére et fils*), Flaubert, and Paul de Saint-Victor, who was another poet and critical supporter of Puvis. So nervous was the painter when his work was revealed that he fled to the bottom of the garden! The decorations are inevitably lost. From the little we know of them, from Judith's account, they seem to have included some attractive –

and for Puvis unusual – passages of still-life painting (unlike Gautier himself, Puvis despised neither Courbet nor Manet).

'It's a pity, that I didn't know you sooner', Gautier is said to have enjoyed teasing Puvis, 'I would have taught you how to paint'. Indeed the poet himself did have some ambitions in this field, having in his youth started an artist's training, and in 1857 resigned from the Salon Jury in order to submit pseudonymously a *Melancholy* (which remained unfinished). So in his critical writing he could claim to be more than a mere 'aesthete' in the pejorative sense, and the issues raised in discussing Puvis are worth noticing. The subject most frequently raised in these Salon reviews between 1859 and 1870 concerned what Gautier felt to be the sculptural aspect of Puvis's art, and he was apt to notice what he felt to be the Greek or Antique aspects of this style. Another matter often frequently mentioned concerned the specifically decorative aspects of Puvis's style, some of which were to become the stock-in-trade of critics hostile to Puvis's art, who, on seeing these works out of context in the Salon often failed to realise that decorative art had different requirements from those of easel-painting. A firm contour lacking the miniaturist's delicacy was one such quality, as was the rejection of all illusionistic procedures and the avoidance of tonal contrasts strong enough to suggest 'holes in the wall'. Gautier also noted a generally tapestry-like quality and a special 'harmony' and 'poetry' in the colour of these works. These were works due to become fashionable in the 1890s, but meanwhile anathematic to the prevailing Realist-Naturalist styles whose supporters thought that these were the vehicles of 'progress' in painting.

Gautier also frequently mentions the 'idea' as an essential component in his friend's art. This term was also to become fashionable – perhaps too fashionable – in the nineties, but now it was used simply to stress the allegorical nature of these works. The corollary to this allegorism was the detachment from the present of most of these paintings (*Marseilles, Gateway to the Orient* is a salient exception).

As can be seen from the preceding remarks, the question of the 'natural' if not of 'Naturalism' as a self-conscious modern movement, was of necessity in the forefront of artistic consciousness during the 1860s. The tenets of this movement and its supporters were completely opposed

19

to those of 'Art for Art's sake' but Puvis's was always a 'natural' art without subscribing to this or to any other 'ism'. And this was recognised by Gautier when in praise of *Marseilles, Gateway to the Orient* (Plate II) in particular, he summarised what was always to remain the essence of Puvis's work, in marvelling that any painting could be simultaneously so 'natural' and so 'poetic'. Here was another way in which Gautier could combine the aesthetic essence of his love of the statue with that of the woman, the marble and the flesh.

These were the most important, and in many cases frequently repeated, matters raised by Gautier. Puvis's apparent homage to the aesthetic of his friend in the *Summer* of 1873 has already been mentioned and it remains only to note the presence of the two men, Gautier posthumously, in the *Saint Radegonde at the Convent of Sainte-Croix* of 1874 (Plate 51). Here Gautier sits with Puvis behind him in a painting which is in more than one sense a homage to poetry, both verbal and visual.

Another critic, though less devoted personally, was no less interesting and important as a symptom of public and theoretical reaction of Puvis's work. Emile Zola had been the leading exponent of Naturalist values in the visual, as well, of course, as in the literary arts since the 1860s when he had been the great supporter of Manet in particular. 'Greek sculpture', said Zola in 1868, 'must be a monstrosity to those who live in the fever of [a world ruled by] scientific investigation', but in 1872 he was able to refer to *Hope* in passing praise of its originality (Plate 46) and in 1875 he was to praise Puvis as the only master of decorative painting on the evidence of the *Radegonde* itself. In an article of 1880 Zola was able, interestingly, to preserve his devotion to a naturalistic art together with some verbal comment on the particular features which distinguished that of Puvis: 'the only painter who understands large-scale decoration'; he found in the cartoon for *Pro Patria Ludus* (Plate 62) exhibited in that year, 'a beautiful composition, wise in its simplicity . . . simplified drawing, unified tone, (Zola chose to ignore that the work was only a nearly monochromatic cartoon in the interests of this stick with which to beat the academic establishment) . . . which do not disturb the architecture. But what should be praised above all is that even while simplifying he remains devoted to nature, his sobriety does not do any damage to the truth; there

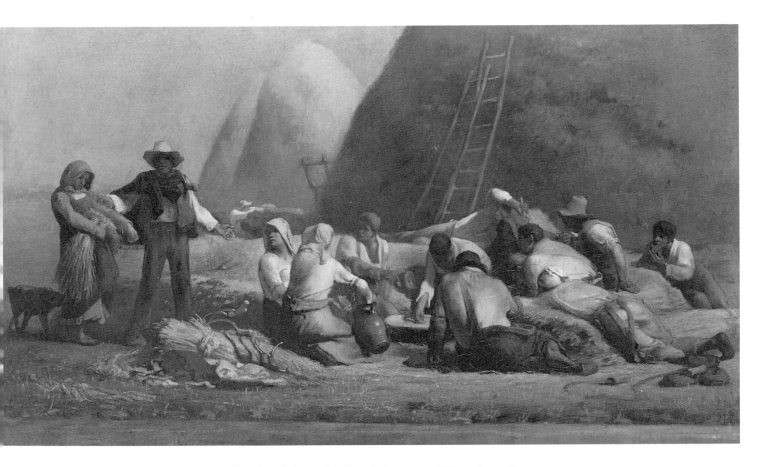

2. MILLET: *Harvesters Resting.* Salon of 1853. Museum of Fine Arts, Boston.

is here an almost hieratic convention in line and in colour, but we can feel the humanity under the symbol.' This was extremely well put, and it anticipates the reserve shown by Zola in 1896 when he expressed his doubts, not about Puvis himself, but about his disastrous influence. The Symbolist movement and the aestheticism of the 'Decadents' were wholly unacceptable to a man like Zola, and it is appropriate that his last comment on Puvis should touch on what has remained a vexed question in any discussion of his art.

In an interview given to a journalist in 1895, Puvis dismissed most of the work he had done in the 1850s as a *romantisme à tous crins*, a frenzied Romanticism. The early decorations for his brother's house *Le Brouchy*, near Cuiseaux, which Puvis later felt to have determined the course his later career was to take, are actually far more eclectic than they are Romantic, and there are evident recollections of Millet's Realism, and in particular of his *Harvesters resting* (Plate 2), exhibited at the Salon in

21

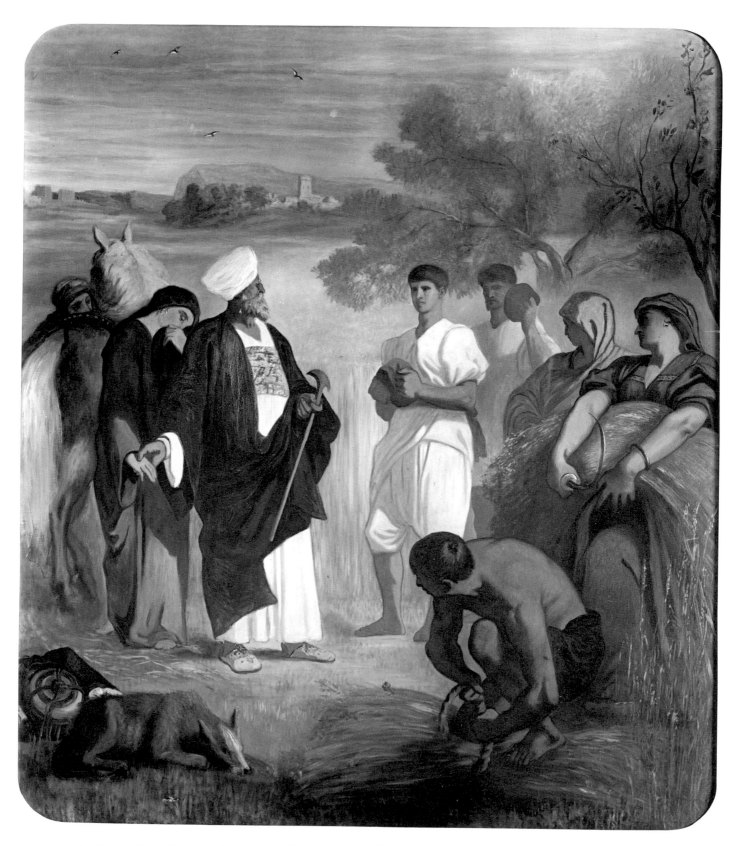

3. *Ruth and Boaz* (Decoration for the dining room at Le Brouchy) 1854–55. Private Collection, France.

1853, in Puvis's *Ruth and Boaz (Summer)* (Plate 3) of the following year. Millet's painting had itself been recognised by many critics, and was at first intended as a depiction of the biblical theme. Puvis's paintings at Cuiseaux are all intended to have an allegorical function, as was felt to befit decorative projects. In this case each work fills three roles: as biblical narrative, as allegory of a season and as token of one of the four essential foodstuffs, fish, flesh, corn and wine, the whole culminating in the preparations for the feast at the return of the prodigal. (This painting could be felt apt both to its site in the dining room as well as to Puvis's own quite recent return from his travels in Italy.) Puvis at the end of his life was strongly to deny any conscious stylistic association with Millet (who was for a time much appreciated by Gautier), but these affinities are present and underline the concern of the painter with whatever was natural.

The large paintings are accompanied and complemented by four small overdoor lunettes which allegorise, in the form of still-lifes, Peace, War, and Arts and the Sciences. That devoted to the Sciences includes an open book on which Puvis wrote some words invisible from below: *Merde pour les Savants du Monde* (Shit on the wise of the world), which surely indicate the triumph Puvis felt on here confirming a career very different from that intended for him by his father, who had died in 1843, and who had meant his son to follow him into his own profession of civil and mining engineer. Soon after entering the *École Polytechnique* Puvis had fallen ill, withdrawn, and visited Italy.

This Italian trip was surely responsible for much of the eclecticism present in these paintings. Emphasis on contour, a characteristic of much early Italian fresco painting is one feature which was to remain present throughout Puvis's career (the painter's only known experiment with fresco, a medium often falsely attributed to him, took place at this time on the exterior of the stable block at his brother's house, but these works have been much damaged by the weather), whilst Tintoretto would seem to be present behind *The Return of the Prodigal Son* (Plate 4) and Raphael behind *The Miraculous Draught of Fishes* (Plate 5). The colouring in all these works is more intense than it was habitually to become, but the broad manner of maturity is already present. Whatever their specific stylistic sources, the broader technical qualities of Puvis's art here gained

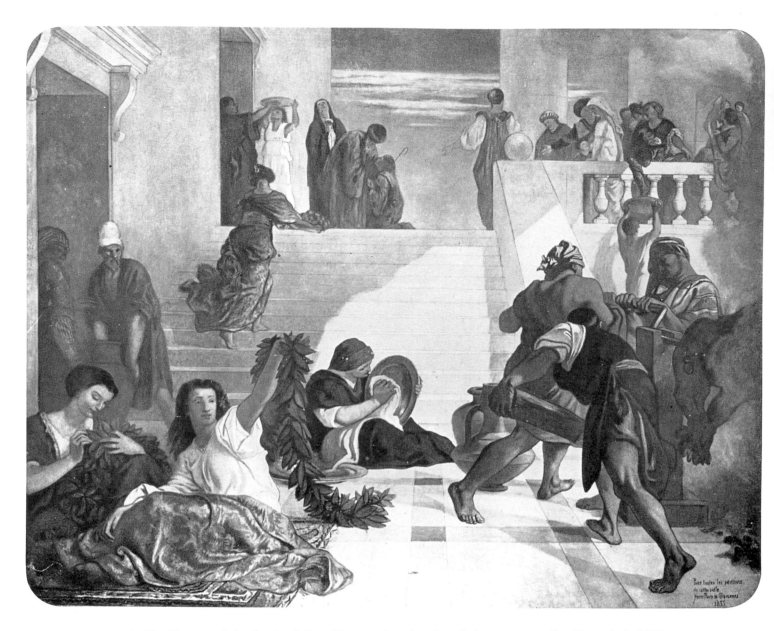

4. *The Return of the Prodigal Son* (Decoration for the dining room at Le Brouchy) 1855.
Private Collection, France.

5. *The Miraculous Draught of Fishes* (Decoration for the dining room at Le Brouchy)
1854–55. Private Collection, France.

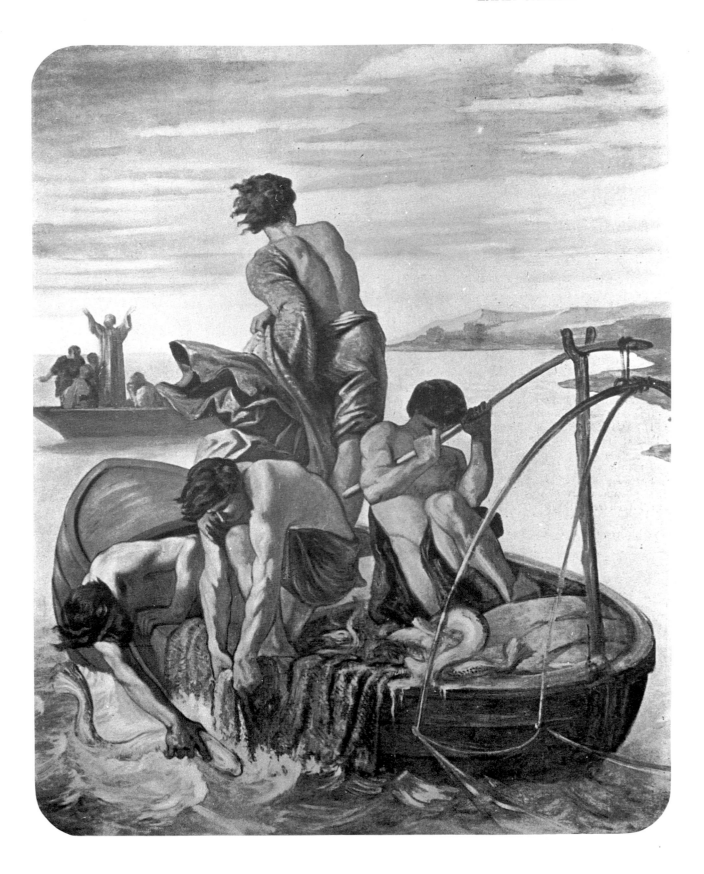

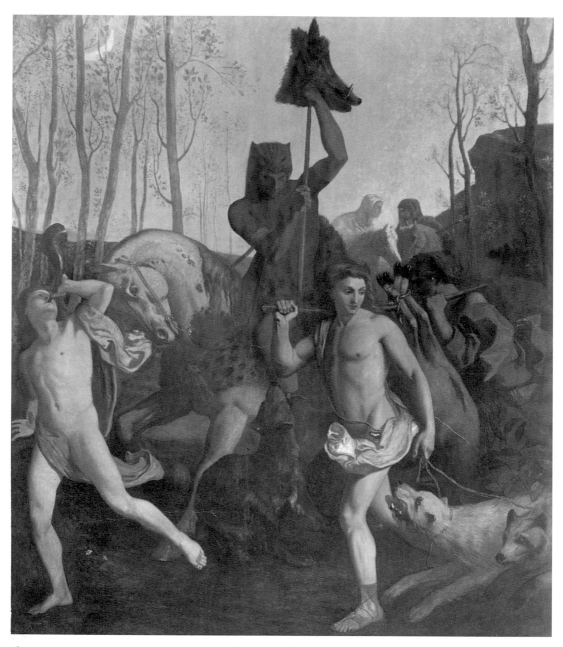

the approval of Gautier on the exhibition of a second version of *The Return from the Hunt* (Plate 6) at the Salon of 1859. This was the first occasion on which one of his works had been accepted since a small *Pietà* had passed completely un-noticed in the only previous Salon where Puvis had exhibited, that of 1850–51.

The 'frenzied Romanticism' which Puvis was later to so much regret, is more evident in the melodramatic *Execution of Saint John the Baptist* of 1856 (Plate 7) or the *Meditation* (Plate 8) of the following year, with its

6. *The Return from the Hunt* 1859. Musée des Beaux-Arts, Marseilles.

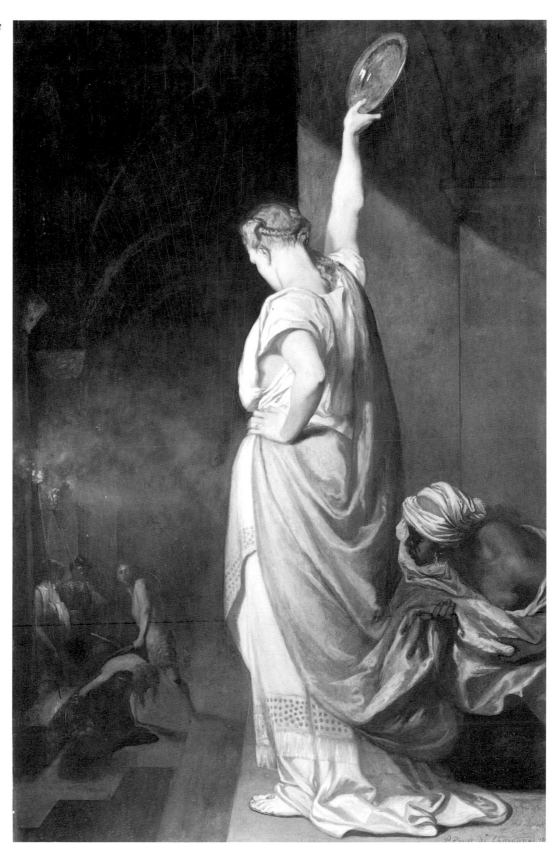

7. *The Execution of Saint John the Baptist* 1856. Museum Boymans – van Beuningen, Rotterdam.

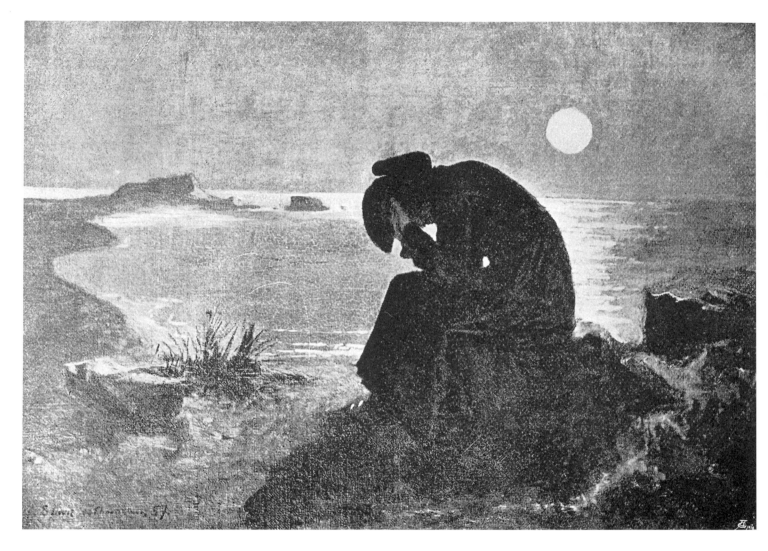

8. *Meditation* 1857. Present whereabouts unknown (Stolen from the artist during the siege of the Commune in 1871).

lonely priest on the seashore, who is reminiscent of the melancholy Jocelyn in Lamartine's eponymous narrative poem. 'Meditation' was a word often used by Lamartine, and was to be used again by Puvis as the title for one of his works. Puvis met Lamartine briefly, and was also to meet Villiers de l'Isle Adam of whom he painted a portrait in 1857 (it is now in the Städel Institute, Frankfurt). In a letter of 1861 he wrote too of

the earlier 'contagion Musset et Senancour' to which he, like most others of his generation, had been subject. There is little trace of Musset's more passionate romanticism in Puvis's later work, but Senancour's introspective *Obermann* was to remain a pattern of his mature sensibility. In 1849 Matthew Arnold wrote some lines on Senancour which could be thought no less applicable to Puvis himself:

> Ah! two desires toss about
> The poet's feverish blood.
> One drives him to the world without
> And one to solitude.

Another early work, *Mademoiselle de Sombreuil Drinking a Glass of Blood to Save her Father's Life* (1851) dwelt on the horrors of the revolution, Puvis's distaste for which was later to lead to his refusal of a commission from the state to paint an '*Apotheosis of the Revolution*'. He felt the revolution to epitomise the 'politics of hate and envy'. A more romantic-historical approach was adopted in *Julia Surprised* (mid 1850s) where the Emperor Augustus's wife, another Messalina, hides from a group of soldiers whilst on a nocturnal escapade. There could be no better evidence for the diversity of Puvis's subject matter at this time than that afforded by a painting in the gallery at Lyons: *Jean Cavalier playing the Luther chorale for his dying mother* (Plate 9) was a subject drawn from the Wars of Religion which followed the revocation of the Edict of Nantes in the seventeenth century. This is one of the first works showing the influence of Thomas Couture, in whose studio he had worked in 1849, not long before Manet's arrival to study under the creator of the famous *Romans of the Decadence* which had been the sensation of the Salon in 1847. Another romantic trait, fondness for exotic settings, with perhaps an interest in Shakespeare, can be found in *Little Black Tortoise Monger in Venice* of 1854. The tortoises, one of them overturned, may be thought to constitute an oblique, and witty, reference to *Othello* – the tortoise is an emblem of womanhood. In 1844 Chassériau had produced a magnificent series of etchings – widely admired, not least by Gautier – illustrating this theme. The overturned tortoise may represent Desdemona's fate as opposed to Bianca's. This romantic pre-occupation with overwhelming emotions, whether heroic, dramatic or melancholy, seems to extend even to the

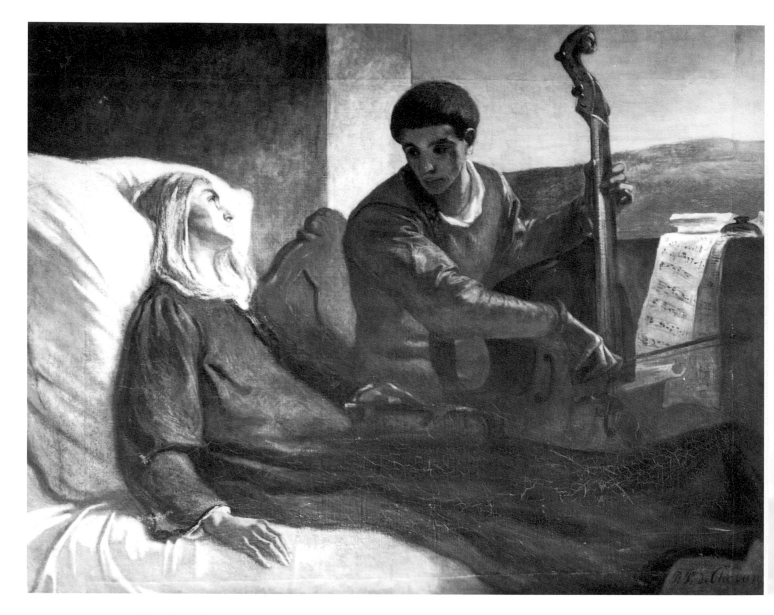

9. *Jean Cavalier playing the Luther Chorale for his dying mother* 1851. Musée des Beaux-Arts, Lyons.

ostensibly realistic painting *The Village Firemen* (Plate 10) of 1857. Such a subject is bound to remind us that Courbet had attempted a similar albeit urban theme not long before; but Puvis, as the surviving drawings show, made no attempt to adopt the realist method of working directly from nature. His method was, as he put it much later, that of working not 'from' but 'after' nature, and the work from memory which that implies

10. *The Village Firemen* 1857. Hermitage Museum, Leningrad.

was clearly less important here than was invention. Memory and invention, these two anti-realistic principles, were to become crucial at the end of the century as the paintings and the letters of Van Gogh, another admirer of Puvis's work, make plain.

Both Coutures's paintings, and his book *Méthode et Entretiens d'Atelier* (1867), make it clear that he was a very scrupulous craftsman,

31

and the example of his cautious but sensitive handling seems to be recalled in Puvis's beautiful and delicately treated *Portrait of a Woman* of 1852 (Plate 11). Puvis had little more enthusiasm for his three-month stay in Couture's studio ('I dozed through my time there', he later recalled), than he did for his fortnight with Delacroix. Though he was often accused by adverse critics of lacking the basic skills of his art, Puvis did acquire a real, though generally unspectacular, technical mastery, and in 1869 he could write to his old friend Bauderon de Vermeron (with whom he had earlier travelled in Italy) that he had grown quite '*fanatique d'exécution*', and the *Magdalene* (Plate IV) painted in that year confirms this remark. The scumbled, textured effects achieved in the rocks to the left, and the almost virtuoso treatment of the Magdalene's hair suggest that though Puvis's study under Couture was, unlike Manet's six years, short-lived, it nevertheless offered him clues which he later followed up on his own. In fact Puvis was not, in the end, ungrateful to Couture, for though in the catalogue to the Salon of 1859 he had described himself as the pupil of Henri Scheffer alone, in 1861 he added Couture's name, and many years later, in 1880, he helped organise a memorial exhibition of his work at the *École des Beaux-Arts*.

Puvis decided to continue his education on his own after leaving Couture, to which end he attended anatomy classes at the same *École*, and with some friends who included the painters Bida and Ricard, he hired a gymnasium where he was able to work from the model. In 1852 he moved into a studio at 11, Place Pigalle which was to remain his base for many years, indeed until his marriage in 1897. The stylistic Romanticism of these years is very evident, once more, in the *Self-Portrait* of 1857 (Plate 12) with its emphatic, saturated local colour and very marked contrasts of light and shade, which are also to be found in the coeval *Martyrdom of Saint Sebastian* (Plate 13) with its moon seen through the trees. It was characteristic of Puvis's economy of means that the figure here seen drinking in the foreground should have reappeared many years later, in the central section of the *Sorbonne* (Plate 74). But perhaps no early work of Puvis better reveals the element of stylistic continuity between his earlier and his mature work than the *Execution of St John the Baptist* painted in 1856 (Plate 7). The simplified modelling and stressed contour of the principal figure already shows the artist to be much concerned with the

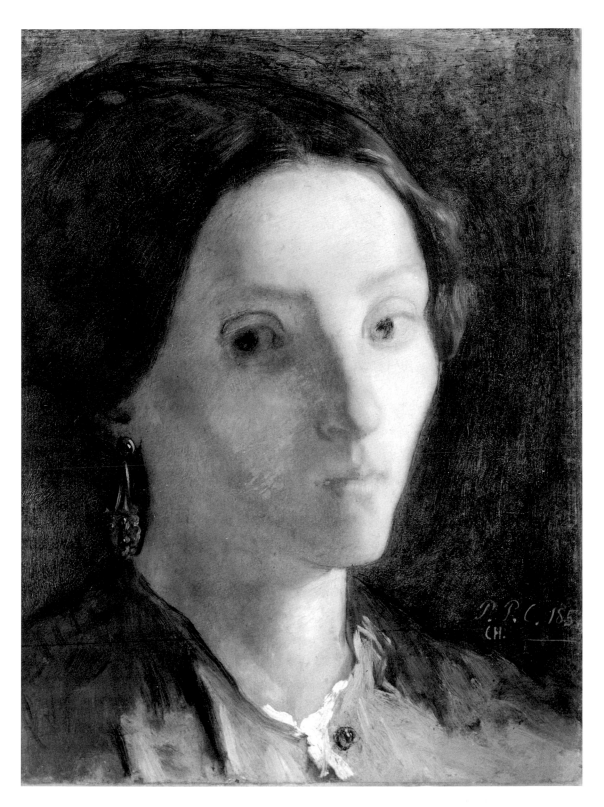

11. *Portrait of a Woman* 1852. Musée des Beaux-Arts, Algiers.

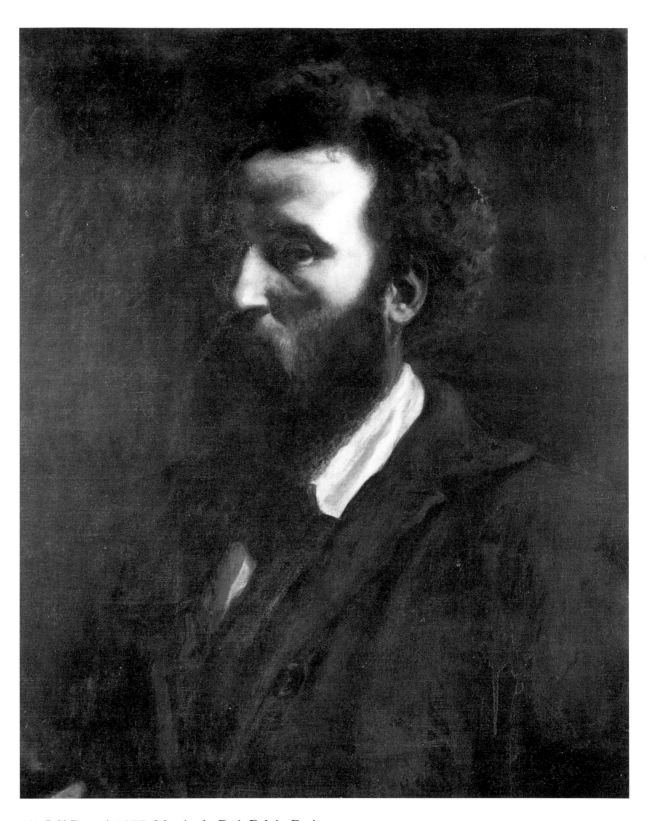

12. *Self-Portrait* 1857. Musée du Petit Palais, Paris.

13. *The Martyrdom of Saint Sebastian* 1862. (Etching after the painting of 1857). Bibliothèque Nationale, Paris.

design of his works in the graphic sense, as well as the dramatic sense, at this time. But the colour is lurid, and the Salome betrays very clearly the source of the studio pose on which she is modelled, a pose satirised by Gavarni in one of his lithographs from the series called *D'Après Nature* published in 1859. In this lithograph entitled *Une Faction* the model stands with her back to the artist, her arm holding its pose over her head by grasping a cord suspended from the ceiling. This was, and is, a common and necessary studio practice, whose use made the melodramatic nature of this idea possible, and as such the idea was skillfully handled, but Puvis had not yet totally mastered the art that conceals artifice, and his preference in his maturity for poses of stasis like that of the woman standing to the left in the *Pleasant Land* (Plate XI) is more easily understandable as a somewhat puritanical distaste for these artifices, itself contributing to the formation of his style.

However great his debts to Couture or to Delacroix it was certainly Chassériau who exerted the more lasting influence. Puvis was never officially his pupil, but he seems to have been a frequent visitor to his studio in the years immediately preceding Chassériau's death in 1856. Chassériau's career was almost the reverse of Puvis's. He had been the pupil of Ingres, but by the time Puvis came to know him personally, both his favoured themes and his painterly manner had become almost canonically Romantic. Whereas Puvis's development was toward increasing emotional restraint and classically lucid articulation, Chassériau, like Delacroix, loved Arab military and harem scenes and Shakespearean subjects. However, the works by which Puvis was most impressed preceded Chassériau's most Romantic period; these were the decorations for the grand staircase of the Cour des Comptes painted between 1844 and 1848, and *The Trojan Women*. This can be seen clearly enough if we compare *The Trojan Women* (Plate 14) with almost any of Puvis's paintings, and it is supported by a number of notes made by Chassériau at about the time when he painted that picture, for they contain some striking anticipations of Puvis's own aesthetic. Sensibility apart, these notes (which Puvis may have known), include such technical injunctions to himself as never to forget that 'firmness and simplicity of tone' and a 'beautiful, flowing line' should be sought; his requirement for 'flesh painted clearly and purely, with few half-tones and no fussy modelling';

14. CHASSÉRIAU: *The Trojan Women* 1841. (Destroyed in Budapest in 1945).

and the assertion that 'to make a painting agreeable to the eye, especially when there are numerous figures, they should be firm, simple and well settled' (*bien assises*). These ambitions were fulfilled, so far as can be judged from photographs, in the foreground group of *The Trojan Women*, as indeed they are in the two-family group to the right in *Pro Patria Ludus* (Plate X). Such ideas were, however, subordinate to Chassériau's culminating invocation of 'that liaison of naivety and grandeur which is the true sublimity of art', an expression which could serve as a generic description of Puvis's style.

TWO

THE FIRST PUBLIC DECORATIONS

Chassériau also had an important rôle in inspiring the works which mark Puvis's first success as a public decorator. With *Concordia* (Peace) and *Bellum* (War) of 1861, Puvis's long association with the new Musée Napoléon in Amiens was initiated. They were not painted with that destination in mind, but after the State's purchase of *Concordia* (Plate 15) from the Salon for 7,000 francs and the Museum's architect had expressed interest in the work, Puvis donated *Bellum* (Plate 16) as the necessary

15. *Concordia* 1861. Musée de Picardie, Amiens.

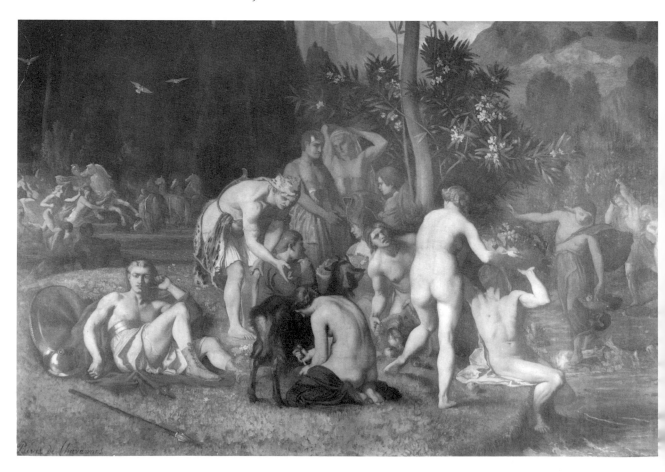

pendant. The two works decorate the long first floor gallery, now called the Galerie Puvis de Chavannes, behind the building's main façade.

The subjects of these allegories were therefore not chosen for their relevance to a particular location, as was to be the case with most of Puvis's later decorations for public places. The themes are in themselves commonplace enough, and had been recently employed in decorative works by both Delacroix and Chassériau. In the library at the Palais Bourbon, Delacroix had presented them within a specific historical guise suitable to their setting, with his *Orpheus Civilising the Greeks* and *Attila Trampling Italy and the Arts*. At the Cour de Comptes, Chassériau (Plates 17–19) had adopted a more generalised procedure combining abstract personifications and typical but non-specific episodes, and this was the model followed by Puvis. It is evident, however, that for all his thematic and stylistic dependence on Chassériau, Puvis went further in

16. *Bellum* 1861. Musée de Picardie, Amiens.

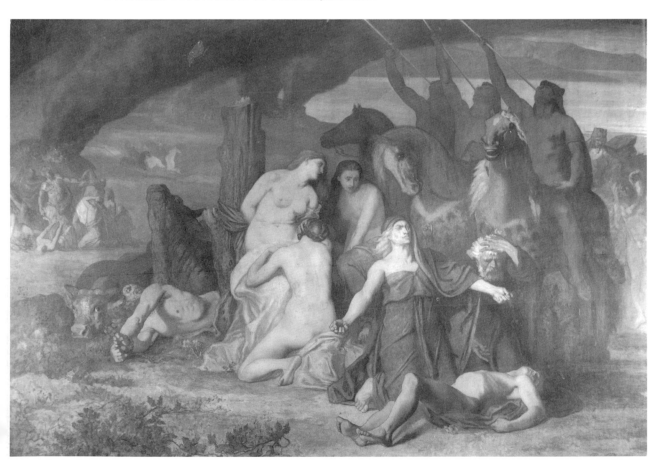

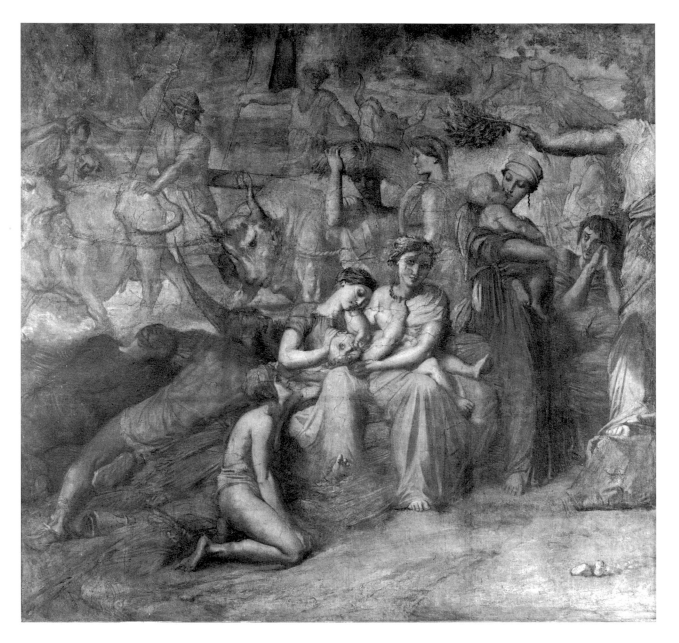

17. CHASSÉRIAU: *Peace* (Fragment of the Cour des Comptes decorations) 1844–48. Louvre, Paris.

establishing a dialectical relationship between his two paintings. Thus the warriors of *Concordia* exercise their horsemanship in the background while others rest prominently at ease in the foreground. In this way the painting anticipates the meaning of *Pro Patria Ludus* (Plate X) with which the series of works at Amiens was completed twenty years later. A similar dialectic exists in the contrast between the flowering tree in *Concordia* and the shattered stump in *Bellum*, while in this painting the

40

18. CHASSÉRIAU: *War* (study) 1844–45, Louvre, Paris.

19. CHASSÉRIAU: *War (The Blacksmiths)* (Fragment of the Cour des Comptes decorations) 1844–48, Louvre, Paris.

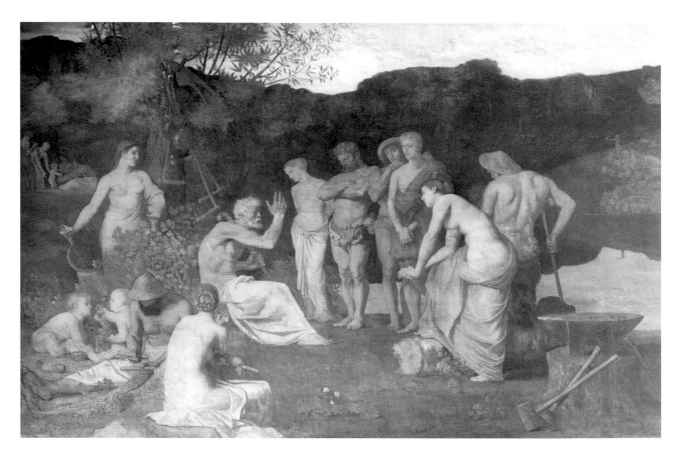

20. *Rest* 1863. Musée de Picardie, Amiens.

yoked oxen show contrasting attitudes, one lowing in protest, the other resigned, which parallel those of the male and female captives. These contrasts were originally reinforced by the emblems incorporated in the decorative borders of the two paintings, fruit and flowers for *Concordia* and arms, armour and victorious laurels for *Bellum*. These borders were suppressed in favour of a decor consistent with the then fashionable (and Imperially approved) 'Pompeiian' taste which was used throughout the long gallery, but were repeated in the small reductions, now in the Philadelphia Museum of Art, which were painted in 1867. Puvis was rewarded with a second-class medal for the large paintings after their appearance in the Salon of 1861. He even won the approval of a critic devoted to Realism, Théophile Thoré, though like Gautier, Thoré recognised the eclecticism of the style, finding prominent echoes of Poussin, the Florentines, Ary Scheffer, Couture and even Phidias. The tendency of Puvis's art to polarise opinion was demonstrated by Gautier's

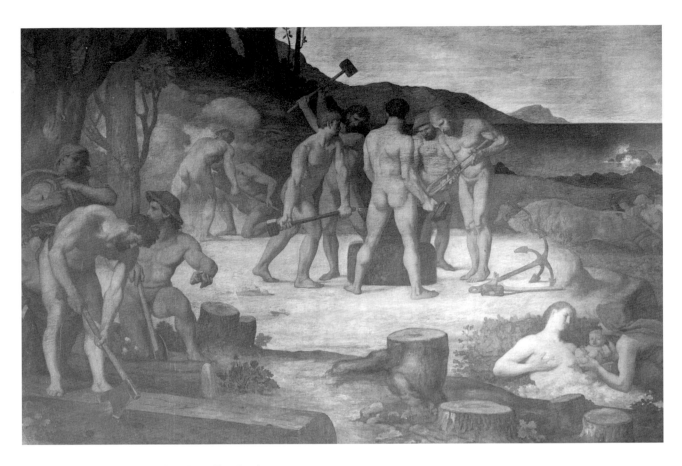

21. *Work* 1863. Musée de Picardie, Amiens.

own appreciation: 'in a time of prose and realism, this young artist is naturally heroic, epic, and monumental'. The heroic aspect seems certainly to have appealed to the 'Sâr' Josephin Péladan's liturgical instincts, for when thirty years later Erik Satie composed three pieces for performance at Péladan's Rosicrucian ceremonies, the three victorious trumpeters from *Bellum* appeared on the cover of the published score. Gautier's 'monumentality' is particularly evident in the classicising pyramidical structure of the main group of figures in *Concordia*.

According to Puvis's first biographer Marius Vachon the landscapes in these works were based on recollections of the Pyrenees (*Concordia*) and the Gulf of Gascony (*Bellum*). Puvis claimed several times to work from memory in his landscapes, thus anticipating what was to become an article of faith with some Symbolists. From the same source we hear that the landscapes in Puvis's next two major works, *Rest* and *Work* (Plates 20, 21) were based respectively on the recollection of a site on the banks of the

Seine near Bas-Meudon and a scene on the Mediterranean coast. Puvis considered these two paintings to be complementary to *Concordia* and *Bellum*, and he used the argument that the four compositions formed a unified whole in an effort to persuade Count Nieuwerkerke, the Minister of Fine Arts, to advocate their purchase by the State. He also proposed to send all four canvases to the Gobelins factory so that they might serve as cartoons for tapestries. Nothing came of this, but the ambition interestingly reflects the comments of some critics and anticipates a much later request from a then Minister in the 1890s. Meanwhile Puvis was

22. The Amiens Cycle *in situ* (Left: *Pro Patria Ludus*, Centre: *Work*, Medallion: *Study*, Right: *Ave Picardia Nutrix*).

obliged to make a gift of this second pair of works to the Museum at Amiens, and it is easy to believe that the authorities, aware of the artist's ambition and also of his financial self-sufficiency played an opportunist part in the negotiations. It is not easy to believe, on the other hand, that it was wholly accidental, as Puvis later claimed, that these two paintings proved to be of a size exactly suited, with their decorative borders, to fit the lateral walls on the upper level of the Grand Staircase in the Museum (Plate 22). All four works were eventually installed in 1864, and the painter's wish to have them seen together was overridden by his reluctance to sacrifice the decorative borders he had designed for *Concordia* and *Bellum*, for without their borders these two works could have been fitted onto the walls on each side of the door into the upstairs gallery adjoining *Work* and *Rest*. This area was used soon after for *Ave Picardia Nutrix* (Plates 28, 29). Ironically the borders for *Concordia* and *Bellum* were sacrificed soon afterwards.

As with the earlier pair of works, the allegories here are of the most universal kind and are treated in Chassériau's episodic manner, more especially in *Work* where the motif of smiths at the forge was adapted from the allegory of War at the Cour des Comptes. The woman in labour (*en travail*) was thought a bad pun by the hostile Castagnary, but Puvis wherever possible went out of his way to include every aspect of life, and this was indeed the *travail* of women. The allegory is completed by woodcutters and carpenters and a more distant glimpse of ploughmen at work, all executed in a heroic manner reminiscent of Raphael's later Vatican *Stanze* or of his Tapestry Cartoons. That a still more complex and less unified scheme was at one stage envisaged can be seen from the study (Plate 23), with its crowded group of harvesters receding into the distance, one of whom, the crouching figure binding a sheaf, is a repetition from *Ruth and Boaz* at Cuiseaux (Plate 3). *Rest*, which was Puvis's own favourite among the four paintings, is a more focussed design, deriving its greater unity from the narrative feature of an elderly sage addressing his heterogeneous audience. This figure's similarity to a classical relief design, and still greater affinity with the protagonist in Corot's *Homer and the Shepherds* (1845), suggest that Puvis may deliberately have centred this characteristic expression of ideal community life, of which this rest from labour is an episode, on the idea of a recitation by the

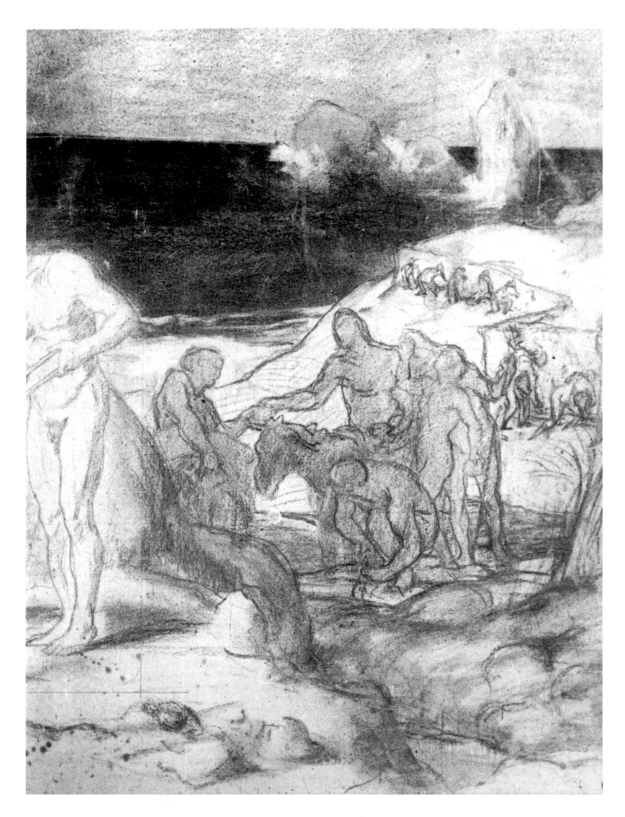

23. *Work* (study) 1863. Musée de Picardie, Amiens.

24. *Rest* (study) 1863. Louvre, Paris.

blind Homer. The concave grouping of the figures also has its unity reinforced by the containing range of hills, a device Puvis was to use again and one which underlines how fundamental and how significant for Puvis was the idea of 'figures in a landscape'. In one respect *Rest* does seem less coherent than *Work*. The figure style is remarkably varied, its echoes of Ingres and of the Antique are accompanied but not totally disguised by the trappings of a Millet-like peasant genre. This latter was surely based less on another man's art than it was on nature, as can be seen in the beautiful study of a figure eventually omitted from the work (Plate 24). Puvis's naturalistic *gaucherie* can be felt in this work, and seen the more clearly for its contrast with some figures of 'grace' as approved by the schools. In Puvis's later, more synthetic manner, such forms as that of the man standing with arms crossed in the centre of *Rest* were more skilfully adapted to the whole than is here the case, a development accompanied by

47

his abandonment of large and relatively elaborately finished drawings like this one.

All of the first four works for Amiens were executed in a wax-based medium which was quite commonly employed for decorative paintings in the nineteenth century. Puvis was able with this medium to achieve the broad decorative effects which some found disagreeable – 'muddy gri-sailles' to Castagnary – but the colours seem to have survived less well here than elsewhere, and whether or not he suspected this to be likely, or for convenience, Puvis subsequently always used the oil-medium, and found the means to achieve with it the effect he sought (to the extent that many believed his works to be frescoes). According to Baudoüin, Puvis's reluctance to work in true fresco was due to his susceptibility to vertigo, making it impossible for him to work *in situ*. Baudoüin's account of his master's methods indicates that Puvis would carefully size the canvas to attain a matt, slightly rough, surface, and then extract excess oil from the paints with blotting paper. Puvis still executed some passages in a fully 'painterly' fashion – and like those added *a secco* to fresco, these were the final touches to the work and were most prominent in foreground details.

The next work which was destined for Amiens was almost certainly *Autumn* (Plate 25). Puvis had already devised an allegorical treatment of the seasons in his first decorative scheme at Cuiseaux (Plate 3). Such relatively simple themes allowed him the greatest scope for the decorative arrangement of this composition. Here, he used the minimal narrative element of fruit-picking as an excuse to justify the still rather mannered poses of his nudes. The allegory is clearly human, not merely seasonal, in its reference, and the implication of the seated woman's advancing years is clear enough. Louise d'Argencourt has shown that Puvis planned this painting as the first of another series of four paintings to decorate an octagonal room in the wing of the Musée Napoléon (re-named the Musée de Picardie in 1870), opposite that in which *Concordia* and *Bellum* were placed, but this project was not favourably received and the remaining three seasons were not executed.

This work was awarded a third-class medal at the 1864 Salon. It was attacked by Castagnary for its classicising conventions, but praised by Gautier who showed his understanding of Puvis's true objectives in commending this 'fresco-like colour range . . . it is limpid and blonde

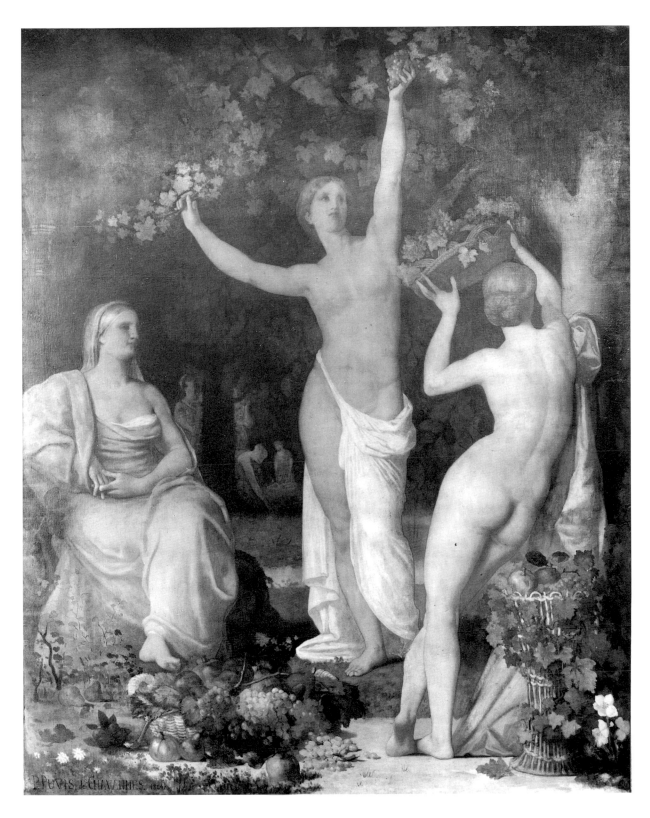

25. *Autumn* 1864. Musée des Beaux-Arts, Lyons.

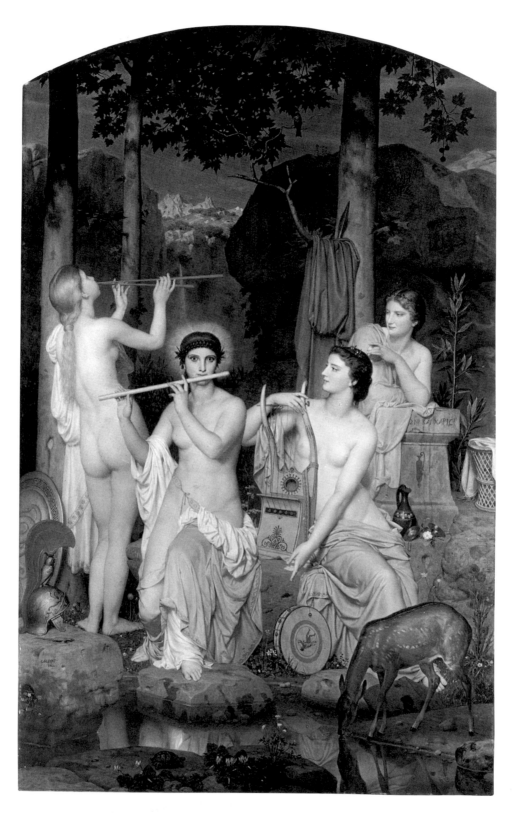

26. GLEYRE: *Minerva and the Graces* 1866. Musée cantonale de Lausanne.

without the heavy shadows that makes holes in the wall'. Nevertheless, we may feel that Puvis has not yet fully mastered his *métier*. Not only do the mannered poses seem unduly artificial, but there also seems to be some conflict between the models best suited to tapestry design, which Puvis was considering at this time, and to mural painting. In particular the rich still life of fruit in the foreground, though painterly in its handling, seems a motif more suited to tapestry than mural painting. Puvis was indeed thinking of tapestry at this time, but as his later work at the Panthéon also shows, he enjoyed the use of paint in a way which makes nonsense of any attempt to separate his art on every level from that of artists like Courbet and Millet. Puvis thus painted in a manner consistent neither with the 'progressive' art of the time nor with the academic, suave naturalism of such Second Empire favourites as Cabanel, and Bouguereau. *Minerva and the Graces* (Plate 26) by Charles Gleyre, a work of 1866, affords a useful comparison with Puvis's *Autumn*, since it clearly springs from and addresses itself to the same taste, though Gleyre was commercially-speaking a good deal more successful: Puvis was paid 4,000 francs for *Autumn* in 1864, while two years later Gleyre sold his *Minerva* for 25,000 francs. The careful archaeological detail in *Minerva*, its classical theme and classicising manner allow the spectator an almost voyeuristic response legitimised by Art, for, costume and trappings apart, these are clearly young ladies of the mid-nineteenth century. It exemplifies the popular academicism quite different from Puvis's more detached manner. The survivors of the School of Ingres, especially the Neo-Grecs, afford an ostensibly closer parallel with Puvis's style. Amaury-Duval's now destroyed decorations for the Chateau de Linières in the Vendée drew Puvis's customarily liberal praise. However, photographs of these works seem to show an uncomfortable mixture of a derivative classicising style with bourgeois genre subject-manner – young ladies playing badminton for example.

What distinguished Puvis from all these artists was certainly intrinsic to his temperament, which was akin to the impassibility upheld by the advocates of *L'Art pour L'Art*. Gautier did nothing to form Puvis's style, but was able to situate it between warring academic and avant-garde polarities. Although Puvis's paintings are often full of humane and especially domestic incident, this has never the effect of debased classi-

THE FIRST PUBLIC DECORATIONS

cism, of a canon fatally compromised, which marks most Neo-Grec painting. Puvis did not work away from a canon but towards a naturally conceived classicism, one more of feeling than of style. His concern for natural dignity implied a selective naturalism, a belief in beauty as an ideal to which painting might aspire and whether plain or 'critical' – as Proudhon considered Courbet's realism to be – embodying a truth higher than that of reportage.

Puvis has sometimes been linked with Millet, for whom, as with Corot, he held a great admiration, while at the same time denying that either had influenced him in any way. Millet's *Hager and Ishmael*, of 1849 (Plate 27) seems strikingly to anticipate the little *Orpheus* (Plate 64) painted by Puvis in 1883, though it would be rash to deduce too much from this perhaps accidental resemblance, for this painting is almost unique in Millet's oeuvre, owing its simplified and apparently Puvis-like technique to its unusually large size and apparently unfinished condition. *Orpheus* is by comparison a tiny painting, whose style and reductive treatment of subject-matter are wholly consistent with the internal logic of Puvis's development. Whatever the truth of this matter some reference to Millet seems valid in a wider sense, for his relaxed realism and his devotion to the figure in unacademic, natural poses have much in common with Puvis's mature manner, as does the very technique of his drawings, softly but confidently modelled in crayons or chalks and affirming contour without pedantry. This comparison is also justified by the landscape element in the work of both painters, which is a unique feature of Puvis's among the decorative artists of the time. This contributes much to the poetic feeling of these works and sometimes even to their allegorical significance, by the choice of open or more enclosed vistas. Had Millet lived to execute his share of the decorations of the Panthéon (he was commissioned at the same time as Puvis in 1874), the whole question of their relationship might now be less equivocal.

Some critics were also keen to see in Puvis the natural scion of the nineteenth-century school of Lyons. In the same letter of 1888 in which Puvis denied the influence of Corot and Millet he far more forcefully rejected any affinity with the Christian mysticism of this school. He had indeed alluded to this tradition, as a matter of duty, in *Christian Inspiration* (Plate 65) which formed part of the decorative cycle for the

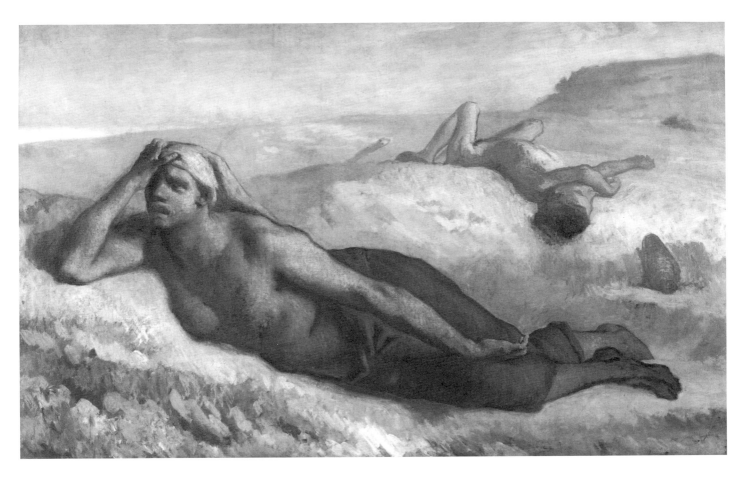

27. MILLET: *Hagar and Ishmael* 1849. Mesdag Museum, The Hague.

museum at Lyons, but the attempt made by some writers to link Puvis
with Janmot, Orsel and Mottez, the 'French Nazarenes', had arisen from
the naïve application of Hippolyte Taine's influential doctrines asserting
the determining influence of racial and geographical factors on the arts,
rather than from real observation. Another Lyonnais, Paul Chenavard,
had conceived some allegories for the decoration of the Panthéon under
the Second Republic. These works, for which sketches survive, were neo-
Michelangelesque in style and mystico-socialist, palingenetic, even
Fourierist in meaning. Chenavard has thus been most unreasonably con-
nected with Puvis, whose pride was wounded by this abuse of his own
ideals and sense of stylistic individuality, to the extent that he lost his
customary good manners to dismiss 'this prating, intolerably sceptical
ancient whose style is devoid of the slightest personal character'.

Puvis referred in this same letter to yet another Lyonnais painter,

Hippolyte Flandrin. He was found to be 'a grey and melancholy figure' who 'has painted various church walls in a sober and traditional manner, of which his gentle master Ingres remarked "it's good but it's stupid"'. But the hieratic, primitivising style with which Flandrin executed the decorations at Saint-Germain-des-Prés in Paris in the 1840s, with their occasional use of gold grounds, does seem to have been recalled by Puvis when he was faced with the special problems of the Panthéon Frieze, in which his usual naturalism had to be adapted for a programme requiring a processional, iconic approach. To at least one contemporary critic, Puvis's Panthéon works seem worthy successors to Flandrin's at Saint-Germain. René Ménard wrote: 'nothing' [in the intervening years] 'has risen to such a nobility of conception', and it is true that Flandrin's style, with its deliberate archaisms, has a *gravitas*, a weight and measured rhythm in composition and in the treatment of the figure, which is akin to the art of Puvis.

Puvis's objection to the 'absurd mania, common to many critics, to trace fatherhoods in matters of art', and his anxiety to contradict them, accord with his dismissal of Chenavard as lacking an individual manner. This unwarranted defensiveness is partly attributable to his awareness that, however independent his work was in contemporary terms, it was strongly marked by the great tradition of decorative painting established during the Renaissance, a circumstance rendering him vulnerable in an age given to a growing and alarming cult of novelty and originality, a word which he detested. He thus found himself having to defend his own originality whilst simultaneously denying that this was a value of any intrinsic importance.

Given the eclecticism apparent in Puvis's earlier manner, his attitude toward the old masters and his relationship with his contemporaries calls for a brief comment. It is impossible to ignore the borrowed sixteenth century Venetian manner in *Return of the Prodigal Son*, 1879 (Plate 58), and on the other hand, a comparison with Giotto and his school seems irresistible even in so late, albeit untypical a work as the Victor Hugo ceiling (Plate 76). The device of having flying draperies apparently unmoved by any wind, borrowed by the Renaissance from antiquity, was ridiculed by Puvis: 'if the wind was really strong enough to blow draperies about like that, the bodies themselves would be blown off

balance. They would be carried by the air as water supports fishes.' Yet this, and the mannered poses, all recreated from the model, still occur in *Ave Picardia Nutrix* (Plates 28, 29), the figures of Erato and Euterpe in *The Sacred Grove* (Plate XVI) and the Boston *Muses* (Plate 85). This aggressively commonsense approach and his concern above all for plausibility, are responsible for his characteristic dismissal of the Italian, particularly Mannerist, sixteenth century. Even so, his defensive claim to have looked little at the art of the past is quite implausible.

Once again we come to the ruling principle, slow to emerge, of Puvis's aesthetic – 'truth to nature'. For Puvis this meant freeing himself from the old masters' hegemony, to avoid being, in Gauguin's words, 'crushed by their talent', while yet remaining faithful to their spirit. Something of its meaning can be deduced from Puvis's rather surprising admiration for Rubens, whom he called the most 'human of men in his apparently most pompous work' – one who looked beyond the idea of style in its superficial, formal sense to the spirit in which a great work is executed. Similarly, if Puvis's work often reminds us of Raphael without suggesting a dependence as particular as that which shaped the Venetian-inspired *Return of the Prodigal*, this is because by the mid-1870s he attained a maturity of which Raphael's work can be taken as exemplary. This was not as a *particular* style, but something akin to what Maurice Denis was later to call 'style' itself, the neo-traditional styleless style, the hallmark of the Classical – as opposed to Neo-Classical – manner. A system of signs adapted from nature, not a banal copy of nature, still less the adoption of another's particular vision. Towards the end of his life Puvis expressed the matter with complete clarity: 'The only thing that one can take from the masters is their naïvety, their humility before nature. Only the Antique can be studied without danger, for the Antique is Nature herself; you will not acquire any mannerism by copying the Illissus.' There was nothing new in these ideas, which bear the stamp of most academic teaching of the period, but Puvis's earlier experience meant that he knew what he was *not* doing, and his later practise made him well qualified to pronounce them. Puvis was the last great artist to make so fundamental an attempt to come to terms with the past. Manet's and later Picasso's, moves in this direction were much more self-conscious and intellectualised, less organically related to their art.

28. *Ave Picardia Nutrix* (left side: *Cider*) 1865. Musée de Picardie, Amiens.

The next group of works for Amiens, which appeared at the Salon of 1865 under the generic title *Ave Picardia Nutrix* (Hail, Picardy the nourisher) are themselves a characteristic combination of naturalism and eclecticism. This composition was designed to decorate the wall on the first floor which separates the well of the grand staircase from the adjoining Galerie Puvis de Chavannes. Access to this gallery is gained through the large central door which divides the painting into two parts; two smaller doorways occupy the extremities to left and right. Here too Puvis forewent what he considered his just reward, permitting the Museum, financed by the state, to acquire the work for 6,000 francs, half what he considered its true worth.

Puvis conceived this work as an allegorical reconstruction of the birth

29. *Ave Picardia Nutrix* (right side: *The River*) 1865. Musée de Picardie, Amiens.

of civilisation in one of France's richest provinces. He seems to have suffered occasional pangs of guilt at his inability to present his idea in modern terms. His rare attempts to do so, like the allegory of *Physics* at Boston (Plate 78) are not successful, and he was surely right on this occasion to allow the analogy with the industrial ambition and optimism of the Second Empire to be inferred from this primitive vision, rather than to attempt explicitly to portray them. The subsidiary motifs of house building in *Cider* (Plate 28) and bridge-building in *The River* (Plate 29) do, however, complement the themes otherwise devoted exclusively to agricultural and, what was in France a long-standing political preoccupation, human fruitfulness. The only exception to this selection of themes expressive of provincial and national pride is formed by the group of

30. *Ave Picardia Nutrix* (study for *The River*) 1865. Musée de Picardie, Amiens.

bathers in *The River* (which is, of course, the Somme) who anticipate Puvis's more generalised allegories of summer, particularly that at the Hôtel de Ville in Paris. One of these bathers, seen as though emerging from the hollow trunk of an ancient willow, he half seriously described as 'the nymph of these waters'.

Artistic 'paternities' aside, there is in this work evidence enough of the artist's indebtedness to the Italian tradition. The old man with a staff and the old woman winding flax in *Cider* are characterised as a secular St. Joseph and St. Elizabeth and are comparable with those in Raphael's *Canigiani Holy Family*. The child supporting a basket of fruit recalls Mantegna's *putti* supporting an inscribed tablet at the *Camera degli Sposi* in Mantua. The mothers with children on each side of the central doorway recall traditional allegories of Charity, like that by Andrea del Sarto in the Louvre. Traits of a more Mannerist style seem to be present in the silhouetted forms of the bridge-builders and in the extreme *contrapposto* of the bather in *The River, a première pensée* for whom is here reproduced (Plate 30). This invention would not seem out of place as a 'Diana Surprised' by Primaticcio, but none of these figures is borrowed directly from any such source. They reveal, though, how disingenuous was Puvis's claim that he looked little at the works of the masters and also how relatively unassimilated were such influences at this stage in his career.

The cast shadows in this painting are in some instances far stronger than is usually the case with Puvis's decorative works. He created a particularly beautiful shadowed *profil perdu* for the woman grasping a basket to the left of *Cider*, a device which exceeds the normally purely conventional and descriptive modelling he gave his figures. This may well be due to the fact that when this work was executed the stairwell was not lit as it is today, but from windows piercing the opposite wall, where *Pro Patria Ludus* was later placed. The painter seems initially to have been uncertain as to the precise nature of the site he was to decorate, for some early studies imply that all three doors in the wall on which the work is situated were to be of the same, smaller size, so that the continuity of the landscape falling gently from the uplands on the left to the river valley on the right could be more clearly indicated. In the event the sense of continuity owes more to Puvis's classicising sense of design than to the

landscape motif, in particular to the pedimental grouping of the figures on each side of the central doorway. The whole central section of *Cider* is itself conceived in pyramidal form, but monotony is avoided by the opening to the middle distance in the corresponding part of *The River*. Because of the relatively restricted space available, it is difficult to take in the whole of this enormous work at a glance, but that Puvis intended that it should be seen is proved by his unsuccessful attempt to persuade the Museum authorities to remove a line of five busts placed on the balustrade to the upper landing, which interfered with the spectator's view from the only practical vantage point on the half-landings to right or left.

Vigilance, Fantasy, History, Concentration (1866), were commissioned by the sculptress Noémie Cadiot, who practised under the name of Claude Vignon, for the vestibule of her new house at Passy. The four themes are to be understood as abstractions of the creative process. History, inscribing on a tablet the knowledge derived from archaeological investigation, suggests the educational function of this discipline and the artist's need to document his theme (Plate 31). At the same time the new growth of an old trunk stands as a symbol of continual rebirth, while a fragment of antique sculpture embodies both a general reference to exemplary antiquity and a specific allusion to the art practised by Puvis's patroness. This painting is complemented by historical allusion in *Fantasy* (Plate 32), where artistic imagination, or inspiration, is presented in the form of Pegasus raising the sacred Hippocrene fountain with a stamp of his hoof on Mount Helicon, sacred to the Muses. These are the two larger of the four works, and clearly expressive of a conservative, academic view of high culture of a kind pervasive in Puvis's art but which was given new life amongst creative artists by the Parnassians in France, and by the classical manner found in England a little later in the painting of Leighton, Albert Moore and Whistler.

Concentration, or *Meditation* (Plate 33) and *Vigilance* (Plate 34) are more generalised personifications. Meditation, in her forest privacy, seems to stand for that isolated process of clarification of artistic ideas to which Puvis often referred in his comments on his own artistic practice, while Vigilance standing triumphant like a Pharos with her lamp upheld against a new dawn, can be understood as the emergence of the artist's conception out of confusion to lucidity and as emblem of the illumination cast far and wide by the conquering creative spirit.

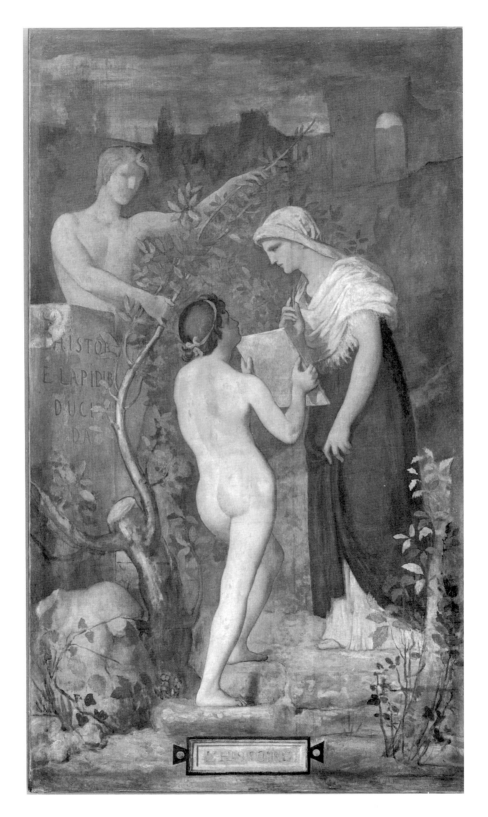

31. *History* 1866 (for L'Hôtel Vignon). Musée d'Orsay, Paris.

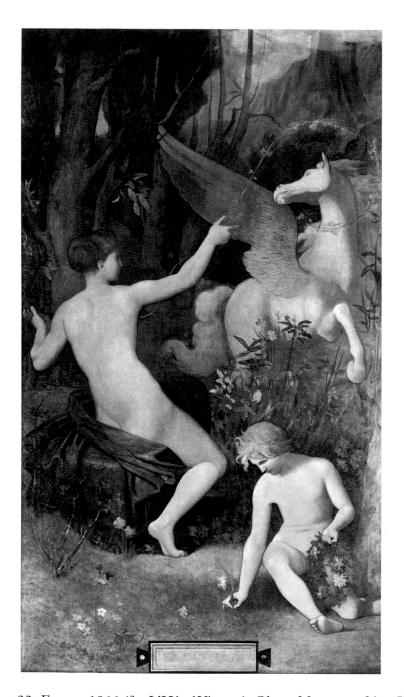

32. *Fantasy* 1866 (for L'Hôtel Vignon). Ohara Museum of Art, Kurashiki, Japan

The four works are executed *en camaïeu*, in a near-monochrome dominated by a unifying deep turquoise tonality which suggests that they were intended to be seen in an artificial light. They remain more interesting as documents of Puvis's formal conception of artistic activity, than as works of art in their own right.

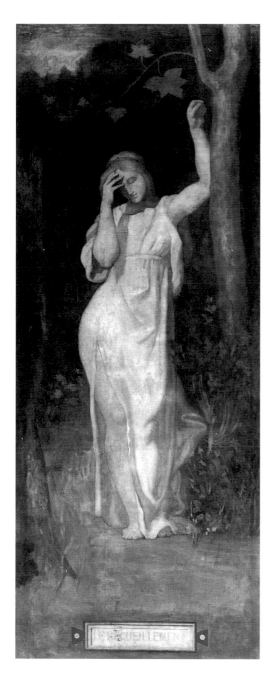

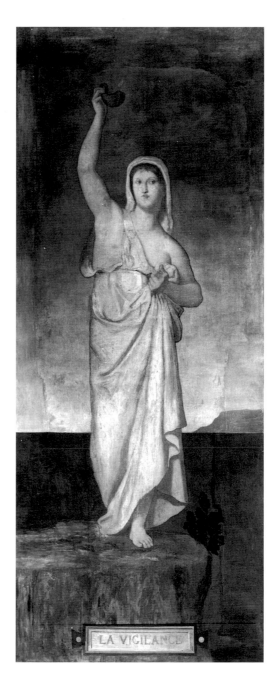

33. *Concentration* 1866 (for L'Hôtel Vignon). Musée d'Orsay, Paris.

34. *Vigilance* 1866 (for L'Hôtel Vignon). Musée d'Orsay, Paris.

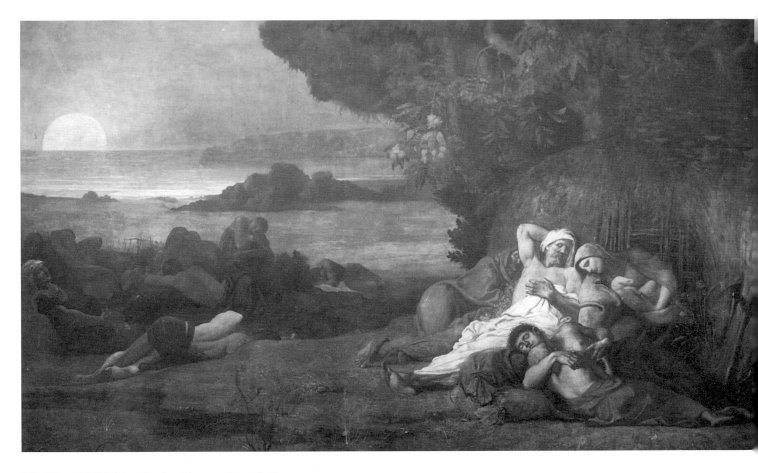

35. *Sleep* 1867. Musée des Beaux-Arts, Lille.

36. *Sleep* (study) 1867. Pushkin Museum, Moscow.

37. *Sleep* (compositional study) 1867.
Musée des Beaux-Arts, Lille.

THREE

ARTISTIC MATURITY

It is not altogether easy to specify a particular work marking Puvis's accession to artistic maturity, but one of those which would take a prime place in any list of candidates is *Sleep* shown at the Salon of 1867 (Plate 35). These sleeping harvesters (Plate 36) are not characterised as belonging to any particular race or nation, but in the catalogue to the Salon, Puvis included these words: *Tempus erat quo prima quies mortalibus aegris incipit* (Virgil, Aeneid II), (It was the time of first rest for distressed mortals). Virgil was here describing the sleep of the Trojans, while the Greeks were introducing the horse into their midst, but it is characteristic of Puvis that the painting should bear no visible relationship to this theme. This is an ideal, poetic antiquity, like that promoted in mid-century in the poems of Leconte de Lisle, and it could yet pass as an exercise in contemporary naturalism in the manner of Millet, with an ethic of mutual trust and shared experience which is central to Puvis's work as a whole. A small sketch, unusually executed in pen and wash, represents an earlier stage in the development of Puvis's idea. The beautiful cool moonlight is here (Plate 37) illustrated as well as expressed in tone, and a tented encampment in the background implies a more precise narrative intent than that finally adopted.

This very large painting was not executed on commission, as were most of his decorative works. It was awarded a third-class medal at the *Exposition Universelle* of 1867, and Puvis was then honoured as Chevalier of the Legion of Honour. He was still subject to attacks from both conservative and progressive critics, one of the latter being Castagnary, who by an ironic turn of fortune was to become *Directeur des Beaux Arts* in 1887, when the State offered to buy a work by Puvis for their collection of work by living artists in the Galerie du Luxembourg. Puvis himself thought highly of the still unsold *Sleep* and would gladly have seen this work in that gallery, but it was *The Poor Fisherman* that was chosen. The

38. *Pleasant Land* (figure study) 1882. Private Collection, England.

State did however offer to pay half the purchase price of 12,000 francs when *Sleep* was bought by the gallery at Lille in the same year.

The 'naturalist' aspect of Puvis's style, whereby there is hardly a figure in his mature works with whom we cannot empathise on a plain, human physical level, was dependent above all on his treatment of his models. To compare a figure like that of the woman who stands to the right of centre in the study for the *Pleasant Land* (Plate 38) with a Degas laundress or a Manet bar-girl is to understand the sense in which Puvis's was, like theirs, a naturalistic art. Puvis's models were encouraged whenever possible to adopt poses of natural ease owing nothing to pre-conceived notions of the graceful, nor to what in an attack on the French tradition of decorative painting (though with particular reference to Coypel's ceiling for the chapel at Versailles) he saw as 'an abuse of pretentious gesture'. He did in fact employ academic devices himself, like the plumb-line to establish the figures' centre-of-gravity, which can be seen in the same study for the *Pleasant Land* to ensure the effect he must have had in mind when he said of his works that they 'could easily be performed'. He used professional models fairly extensively in the earlier part of his career; their presence can be sensed above all in the works of the Amiens cycle. But he turned increasingly to members of his own circle like his pupil Paul Baudoüin, who has been recognised as the model for *The Poor Fisherman* (Plate IX) and to female models like the painter Suzanne Valadon, who claimed to have sat for every figure in *The Sacred Grove* at Lyons, and of course to Marie Cantacuzène. Both were models whose grace was natural rather than acquired through a professional studio training.

The development of such figures was preceded by small freely handled exploratory sketches. Studies would then be made from the model, and these, squared up for transfer by himself or by his assistants, would take their places in a full scale cartoon. The earlier decorations, however, and notably those at Amiens, seem to have been done without any intervening cartoons, which may account for the fact that some of the surviving drawings for these paintings are larger than those he made later. Indeed, according to Paul Baudoüin, who was his assistant for many years, Puvis insisted that life-drawings should be done to a scale no larger than could be accommodated on a half-sheet of Ingres paper, so that a

sense of ensemble could be preserved, and this is confirmed by the vast majority of surviving drawings. The irregular shape of the larger early drawings in their surviving form suggests that they were cut from the sheet to experiment with various groupings, so that the compositional process could continue even after the poses of some of the main figures had been finally established. Later this sort of process was often maintained when he would redraft his figures onto tracing paper which could be affixed to a white ground so that compositional variants could be recorded. At this stage a small oil-sketch was often prepared.

This piecemeal method of composition was more suited to decorative works where figures embodied generalised values, than to narrative history with a dynamic group engaged in a specific activity. It also made possible the repetition, in works like the 1869 *At the Fountain* (Plate 39), of figures created for other works – in this case *Rest* of 1863 – re-used in another guise. In a smaller version of this, an oil sketch, at Rheims, the figure on the left is transformed into a male, her water-carrier's yoke needing minimal adjustment to become an archer's bow. Puvis's groupings were usually quite literally 'constructed' rather than imagined as a whole, *ab initio*. A comparison with Gleyre's *Minerva and the Graces* (Plate 26) again confirms how broad, bold and close to the avant-garde art of Courbet or Manet Puvis could be, despite his lack of interest in contemporary themes. Puvis's compositional methods meant the subordination of naturalism to essentially idealising and architectonic, but nonetheless plausible arrangements. Some particularly interesting changes which illustrate this process can be seen in comparing the study for *Pro Patria Ludus* with the finished work (Plates 61, 62). In the final composition greater weight was given to the group at the extreme left by incorporating in it some figures who had previously formed part of the group left-centre. At the same time he re-distributed a number of figures to create the masterly grouping at the extreme right. In this painting one of the four main figure groups retains the pyramidal structure derived from the Renaissance which he had often employed in his earlier works, but though such imposed structural devices persist throughout Puvis's career, they became less frequent in his later work, as he grew more convincingly to reconcile structural harmony with a natural vision.

Puvis had worked particularly hard to reconcile these two qualities in

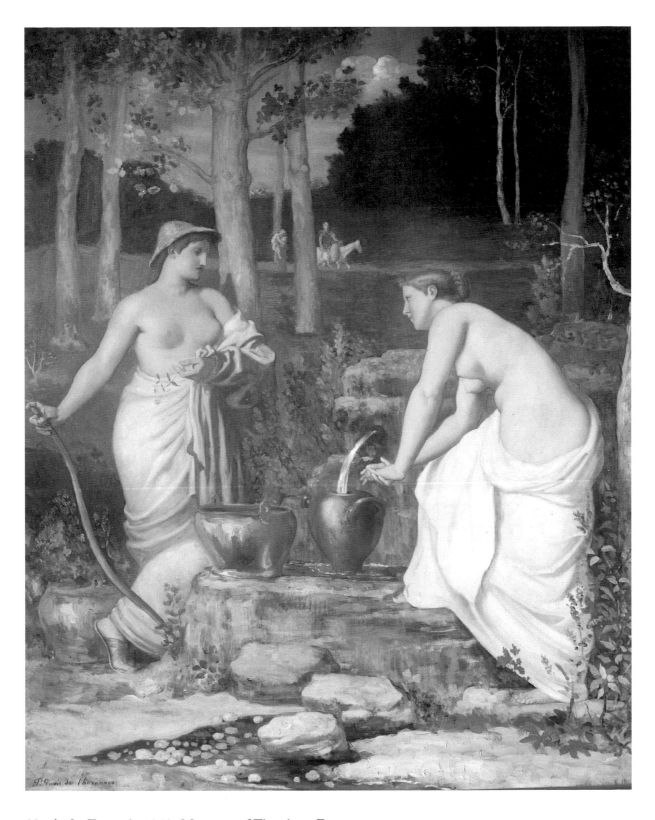

39. *At the Fountain* 1869. Museum of Fine Arts, Boston.

his two large decorations for the new museum, the Palais Longchamp, at Marseilles (Plates I and II). The two themes themselves, Marseilles as a Greek colony and Marseilles as a modern port, might have been designed to test structural harmony and naturalistic skills. Puvis was commissioned in 1867 on the recommendation of the museum's architect, who had been impressed by the achievement at Amiens. *Ave Picardia Nutrix* had been the allegory of a province; and for the Hôtel Vignon, Puvis had allegorised art itself. He wavered between these two approaches before settling on the theme of his next major project. In his first application for the commission he described himself not as a decorative artist, but as a 'History Painter', and he proposed that his two paintings should treat the art of Antiquity and the modern art of Provence, the first by depiction of the building of the Temple of Diana (a temple-building scene had already been considered by Puvis at the time of his works for *Le Brouchy*, as a surviving oil-sketch shows) and the modern art by an episode from the life of Puget, the Baroque sculptor and native of Marseilles. He then thought of 'pagan Marseilles and Christian Marseilles', an idea later to be adapted for *Vision of Antiquity* and *Christian Inspiration* (Plates XV and 65) at Lyons. In the event the more academic elements were confined to a temple-building scene in the left background of *Massilia, Greek Colony* (Plate I), while for the foreground Puvis adopted a more popular approach, with a little genre group grilling fish, in an attempt to suggest the under-lying continuity of past and present. On the shore there can be seen shipbuilding and trading activities and trade in fine goods is also suggested by the group in the right foreground who provide an historical link with the more materialistic theme – provoked by the recent opening of the Suez Canal – of *Marseilles, Gateway to the Orient*.

In this contemporary scene the port is seen from the deck of a Turkish trading vessel whose passengers include (as Puvis told Guigou), an American, a Jew, a Greek and an Arab. Castagnary was typically dismissive of this effort to combine a picturesque orientalism echoing the exoticism of Chassériau and Delacroix with an allegory of modern commercial enterprise: 'instead of beating his brains to imagine the impossible, all he had to do was go to Marseilles and paint what was under his eyes . . . the port in all its activity, stevedores, grain shipments . . . this is what the citizens visiting their museum could every day have contem-

plated with renewed pride'. Castagnary implied that Puvis had not visited the city, but according to Vachon's account he had indeed done so; not to make sketches of dockers, but to acquaint himself with the landscape. Puvis told him that it was on returning from a visit to Château d'If, one of the off-shore islands visible in *Massilia, Greek Colony*, that he decided to paint the port as seen from the sea. Thus he overcame a problem posed by his working method and of which he had spoken to Guigou in these terms: 'I had thought of representing the sea full of ships seen from the quayside . . . but I was embarrassed by a thousand foreground details so difficult to simplify . . .'. Castagnary would have preferred a scene like Manet's view of the port at Bordeaux, but he had failed to consider the problem of scale. Vachon's story of the visit to Marseilles has been challenged by Jacques Foucart (Paris/Ottawa Catalogue 1976–77) who cites a letter in which Puvis asked the architect Espérandieu for photographs of sketches of the Château d'If. Yet Camille Mauclair claims that the landscape in *Greek Colony* is very accurate and that the viewpoint can be precisely identified as a spot near l'Estaque. Although Puvis may well have used photographs as an additional aid there is little reason to doubt that he followed his normal practise of visiting the site of his projected work. Moreover it is difficult to believe that Puvis, depicting a scene set in a climatically stronger light than any other in which he ever worked, in the best-lit setting (which this staircase is), should have created by accident his most intensely coloured murals. But Castagnary was unappeasable and decried the colouring as 'fantastic, like that of coloured maps'. Any stick would do to beat this threat to the ideology of Naturalism. The drawing (Plate 40) for an Oriental to the right in *Marseilles, Gateway to the Orient*, with its colour-notes like those often made by Delacroix, for every feature of his costume, is proof of Puvis's care over every aspect of these works; and the studies of deckhands (Plate 41) are beautiful evidence of his care to give a convincing presence to every figure in his design. A study for a builder outlining his plans on the ground towards the rear of *Greek Colony* is another instance of Puvis working not as imitator but in the spirit of the High Renaissance, for here there would seem to be indirect recollections of the 'Heraclitus' in Raphael's *School of Athens*. But of all the individual figures in these works perhaps the most remarkable is that of a mother on the vessel's deck, her limp child stretched over her knees and her 'Grecian'

41. *Marseilles, Gateway to the Orient*
(drawing of a deck-hand) 1868–69.
Musée des Beaux-Arts, Marseilles.

40. *Marseilles, Gateway to the Orient* (drawing of an oriental)
1868–69. Musée des Beaux-Arts, Marseilles.

profile providing an extraordinary anticipation of some inventions by Picasso.

In 1855 the great 'Atticising' Parnassian poet Leconte de Lisle had written in the preface to his *Poèmes et Poèsies* of 'order, clarity and harmony, these three incomparable qualities of the Greek genius'. These were also the qualities on which Puvis insisted in his own work. 'I am convinced', he told Paul Guigou, 'that the best organised idea, that is to say the simplest and the clearest, is also necessarily the most decorative and the most beautiful. I love order because I passionately love clarity, clarity above all. There is nothing I hate more than what is vague and nebulous: obscurity is good only to conceal deformities.' It was this insistence on logic, so consistent with France's traditional conception of her own distinctive culture, that enabled Ernest Renan's son Ary, one of Puvis's pupils and assistants, to describe in 1896 his former master as 'the pivot on which turns our national aesthetic'. For here is Puvis's pragmatism: order, clarity and harmony were not merely values in accordance with his personal taste. They were also a rational response, in the light of tradition, to what he understood to be the special requirements of decorative mural painting.

42. *The Execution of Saint John the Baptist* 1869. National Gallery, London.

FOUR

PUVIS AND THE FRANCO-PRUSSIAN WAR

Order, clarity and harmony were not only the requirements of wall paintings, however. Easel paintings too shared in these aspects of his style, as is well demonstrated by *The Execution of Saint John the Baptist* of 1869, whose two versions show a progressive simplification and reduction to a greater conciseness, the smaller Birmingham version being the later (Plates 42 and III). The larger version is unfinished and remained unsigned, the smaller bears the date 14 December 1869 (which was Puvis's forty-fifth birthday). In the larger painting there are still some traces of the more elaborate narrative approach which had marked the earlier, melodramatic, treatment of this theme painted in 1856 (Plate 7), which Puvis was later to condemn as excessivly 'romantic'. The smaller painting is hieratic, almost icon-like, and the executioner's gesture, despite its notional vitality, seems frozen into a formal structure that could never be broken. A High Renaissance prototype seems to have been subject to a classicising aesthetic, reminiscent of the style of Puvis's friend Gustave Moreau and his cult of 'Beautiful Inertia'. The head of Salome is an idealised portrait of Marie Cantacuzène.

The smaller work was widely condemned on its appearance in the Salon of 1870. Castagnary excelled himself with his comparison of the painting to an *Image d'Epinal* (a popular coloured woodcut) but with less modelling and an 'almost childlike naivety', concluding that this was no more than a 'grotesque vignette'. But by 1892 a revolution in taste had occurred: in that year one of these works (it is not clear which) was even considered for purchase as a companion to *The Poor Fisherman* in the Luxembourg Gallery.

A particular painting by the same Gustave Moreau, his *Young Thracian Girl recovering the head of Orpheus* (Salon of 1866) is also apparently recalled by Puvis in another painting which he exhibited at

the Salon of 1870, *Saint Mary Magdalen in the Desert* (Plate IV). (This painting is also known as *The Magdalen at Sainte-Baume*, Sainte-Baume being the place not far from Marseilles where the Magdalen was reported to have passed her last years.) It seems very likely that Puvis was encouraged to paint this work, which very successfully captures the effect of the parched and rocky hinterland behind Marseilles, by a visit to that city in preparation for his nearly contemporary work in the museum there. The simple, almost geometric design of this painting anticipates by ten years that of *Young Girls by the Sea* (Plate VIII). There Puvis's palette is more personal and a complete expression of his sensibility, but the colouring of this painting is memorable for its contrast of warm and cool tonalities and, like the scumbled treatment of the rocky outcrop on the left, the Magdalen's hair is brilliantly expressive as a combination of the sensuality associated with the Saint herself.

At the 1870 Salon, Puvis and Manet were to share the disapproval of some critics as being marked by the same misplaced concern with originality. A different view was expressed by Berthe Morisot, to whom Puvis had shortly before offered some advice on the handling of perspective, and who now expressed in her letters an admiration both for this work of Puvis, and for Manet's portrait of Eva Gonzalés, at the same Salon.

The Franco-Prussian war marked an inevitable interval in Puvis's work as a decorative artist, but also led to his creation of two of his most successful easel paintings – successful in their appeal to the contemporary spirit of the French public for patriotic, if not for artistic reasons. These were *The Balloon* and *The Carrier Pigeon* (Plates 43, 44), each of which carries an inscription on its frame, reading, for *The Balloon*: 'Besieged Paris entrusts to the air her call to France,' and for *The Carrier Pigeon*: 'Having escaped the enemy talon, the awaited message exalts the heart of the proud city'.

During the siege of Paris, Puvis was a member of the National Guard in a company which included Manet, Bracquemond, Tissot and other artists. A little later his own brother was a member of the *Assemblée Nationale* which supported the crushing of the Commune, to which Puvis was himself violently hostile. His experience inspired these two

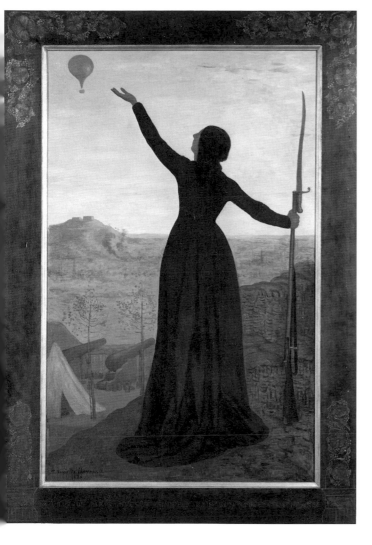

43. *The Balloon* 1870. Musée d'Orsay, Paris.

44. *The Carrier Pigeon* 1871.
Musée d'Orsay, Paris.

patriotic allegories which were lithographed and which soon gained wide popularity through that very accessible medium.

Before the siege ended with the French capitulation on 28 January 1871 some seventy balloons had left the city with mail, and on one famous occasion, with the politician Gambetta on board. They also carried the pigeons which, though many were lost, brought back to Paris some 60,000 letters on rolls of film. The photographer Nadar, an enthusiastic

balloonist who was responsible for improvements to both these emergency services during the siege, painted Gambetta's departure aboard the *Armand Barbès* on 7 October 1870 (Plate 45). Puvis's allegorical mode led him to substitute, as indeed did Daumier in his lithographs of related themes, a female personification of the city for Nadar's crowd. His landscape is however recognisable as a view of Mont Valérien, at Suresnes, on the perimeter of the siege, taken from Montmartre. In *The Carrier Pigeon* the figure protecting the bird from the Prussian Eagle is again recognisably modelled on Marie Cantacuzène; she stands on a prominence overlooking the snow-covered Pont de Sully and the Île de Saint-Louis, with Notre-Dame in the distance.

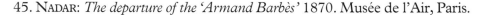

45. NADAR: *The departure of the 'Armand Barbès'* 1870. Musée de l'Air, Paris.

It is not clear whether Puvis had planned both these paintings from the start, or whether *The Carrier Pigeon*, the later of the two, was added as an afterthought. At all events Paul de Saint-Victor, a writer, critic, and friend of Gautier's, who had been one of the painter's more consistent supporters over the previous decade, wrote on 26 December 1876 a retrospective article, *L'Art pendant le siège*, in which he praised *The Balloon* but at the same time regretted the absence from it of a carrier-pigeon returning at full speed. 'History will never produce a more touching and beautiful legend', he wrote, 'than that of these lifesaving birds.' Immediately afterwards Puvis wrote to an unnamed 'cher Monsieur et ami', almost certainly Saint-Victor, that he was to finish a second figure complementary to the first, which he hoped would be 'not too different from the one you have glanced at [a sketch?] and so marvellously described'.

Both paintings were executed in a near monochrome, deep brown or black, which was suitable for adaptation to lithographs. The two paintings were donated in 1874 by the French Government to a sale in New York on behalf of the victims of the Chicago fire of 1871.

Puvis continued to show his concern with the war and its aftermath with his next well-known easel-painting, *Hope,* of which he produced two versions, one clothed (Plate V) and the other nude (Plate 16). The larger, draped, version was exhibited at the first Republican Salon after the fall of the Empire in 1872. The painting was bought by Durand-Ruel, the dealer best-known for his support of the Impressionists, but who remained for many years a supporter of Puvis and commissioned many smaller replicas of the large works. It was in his gallery, at Puvis's first one-man exhibition in 1887, that Van Gogh saw both versions of *Hope* which during the following year he recalled in a letter to his brother: 'That *Hope* by Puvis . . . it is so true. There is an art of the future, and it is going to be so lovely and so young . . .'. He had characteristically altered the meaning of this allegory of the rebirth of France, but it is often in the nature of Puvis's art that this should be possible, however precise the emblems used. Such work transcends the limiting circumstances to which it refers. Gauguin also much admired this work, taking a photograph of the smaller version with him to Tahiti, where it appeared on the wall behind some flowers in a still life which he painted in 1901.

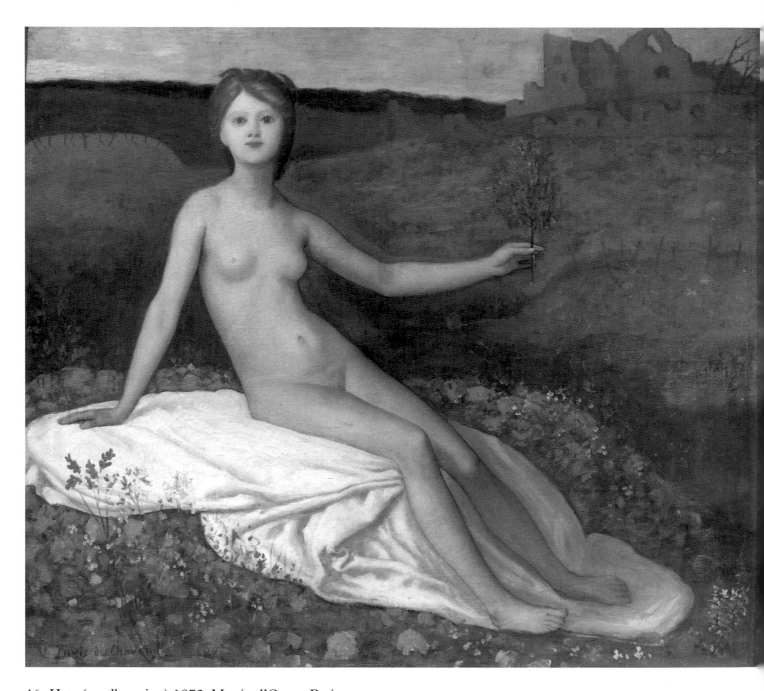

46. *Hope* (small version) 1872. Musée d'Orsay, Paris.

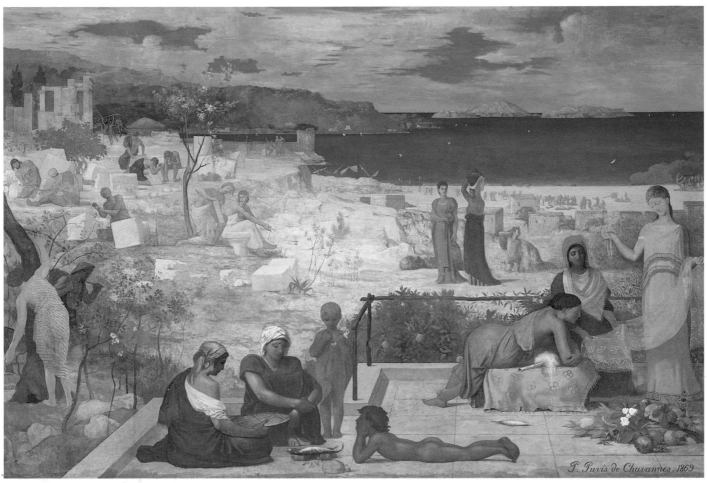

I. *Massilia, Greek Colony* 1869, Musée des Beaux-Arts (Palais Longchamp), Marseilles.

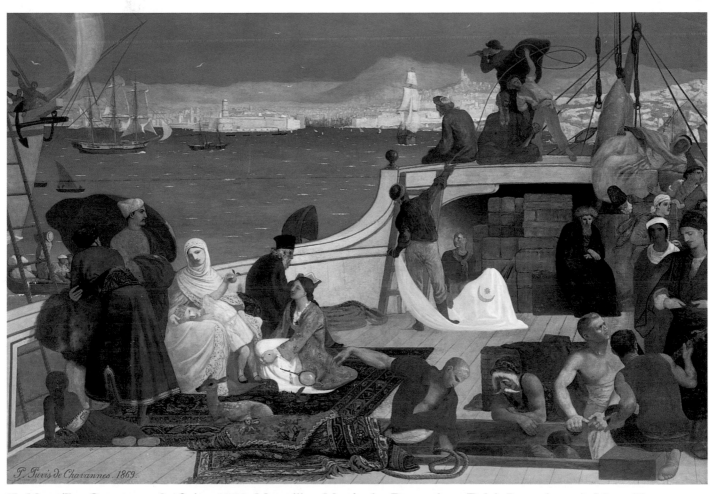

II. *Marseilles, Gateway to the Orient* 1869, Marseilles, Musée des Beaux-Arts (Palais Longchamp), Marseilles.

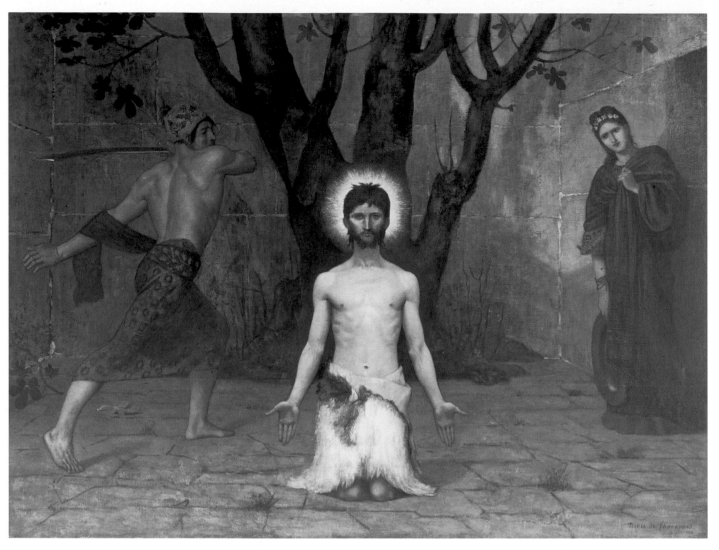

III. *The Execution of Saint John the Baptist* 1869, The Barber Institute of Fine Arts, University of Birmingham.

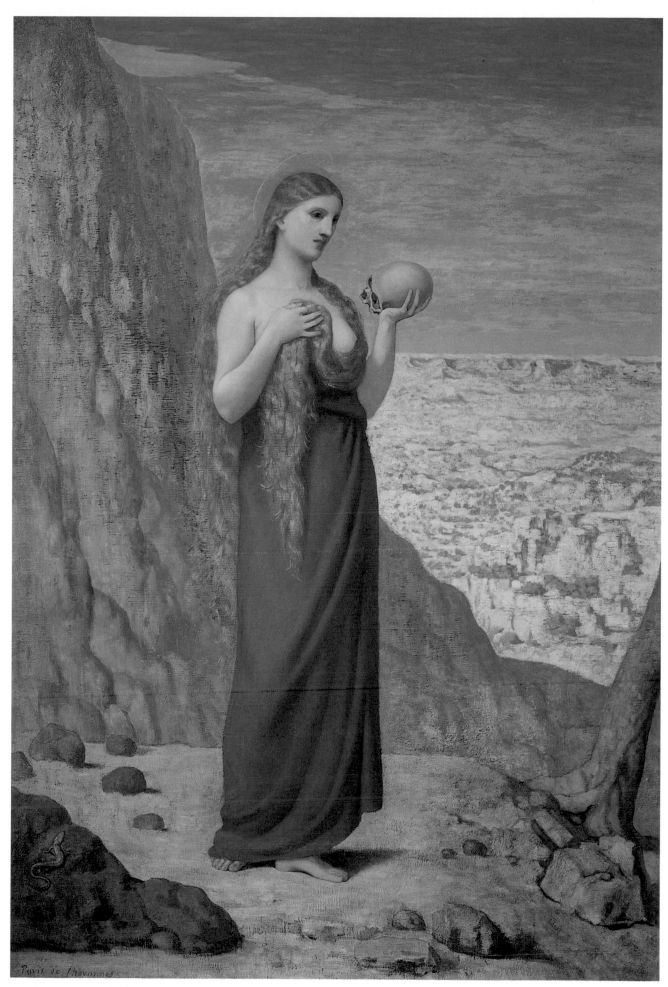

IV. *Saint Mary Magdalen in the Desert* 1869, Städelsches Kunstinstitut, Frankfurt.

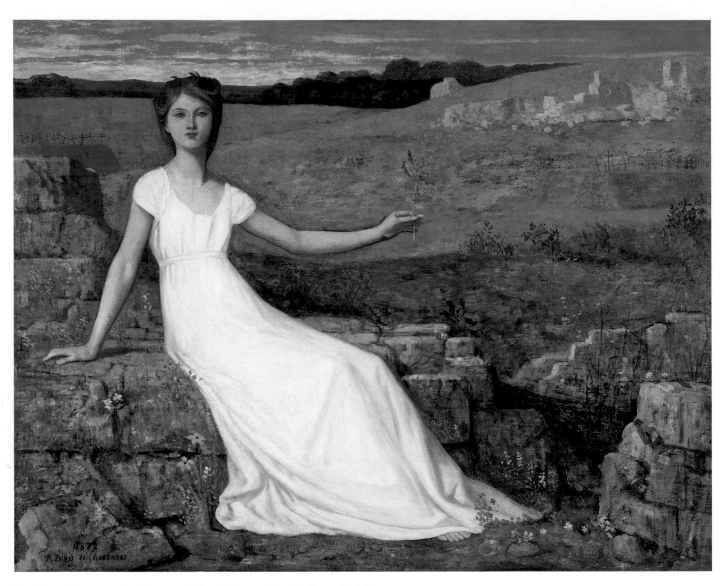

V. *Hope* (large version) 1872, The Walters Art Gallery, Baltimore.

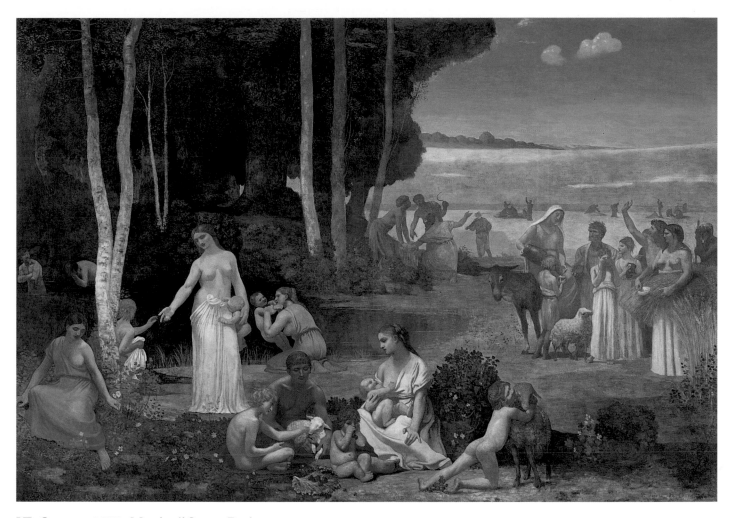

VI. *Summer* 1873, Musée d'Orsay, Paris.

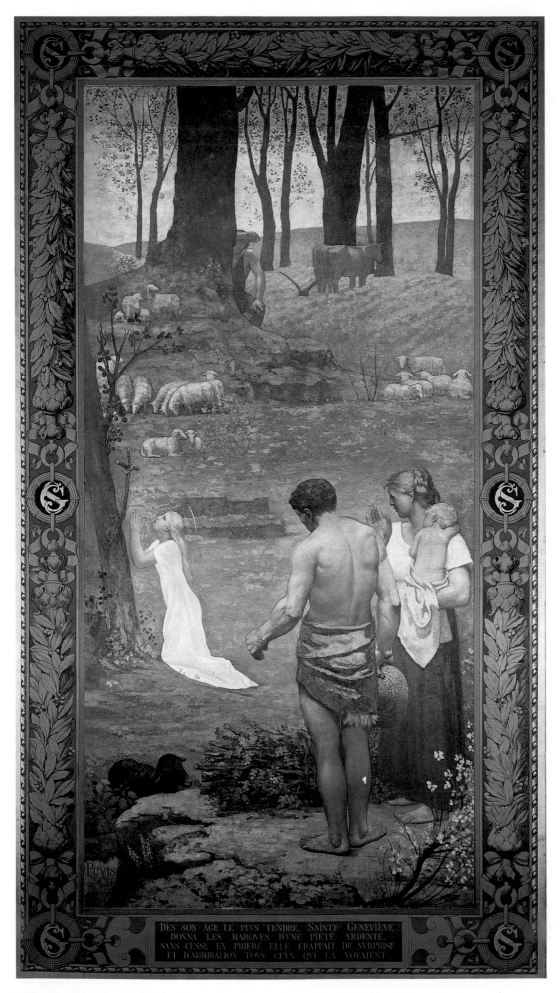

VII. *The Childhood of Saint Genevieve* (central panel) 1877, Panthéon, Paris.

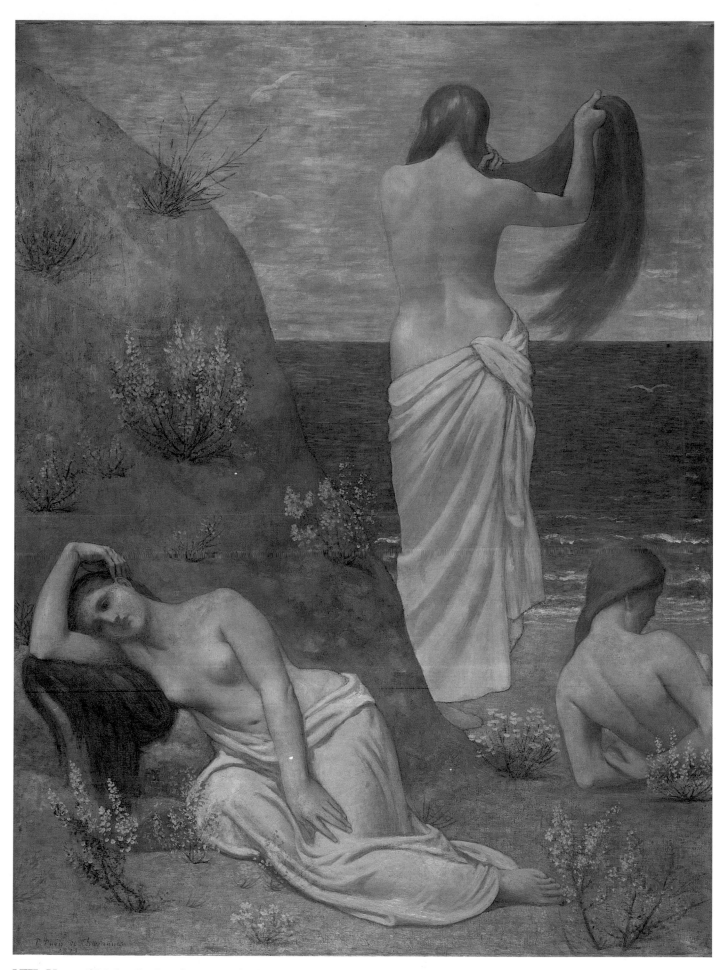

VIII. *Young Girls by the Sea* (large version) 1879, Musée d'Orsay, Paris.

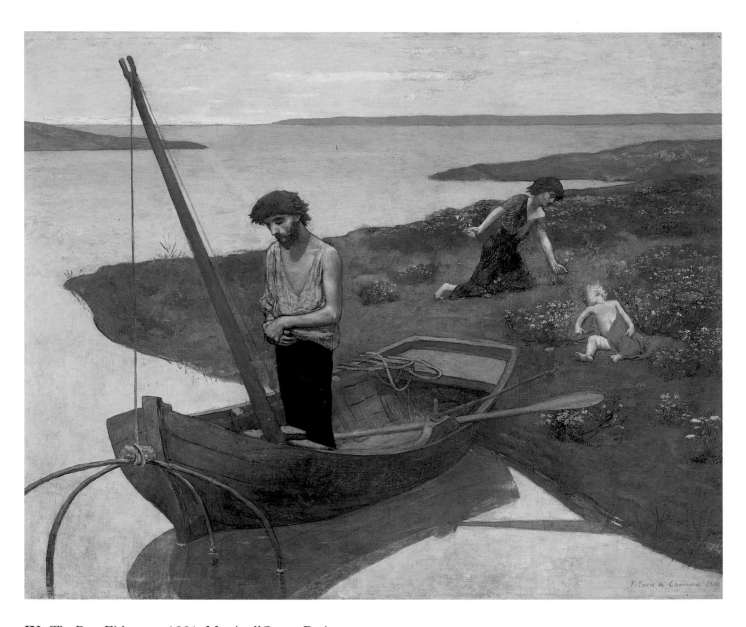

IX. *The Poor Fisherman* 1881, Musée d'Orsay, Paris.

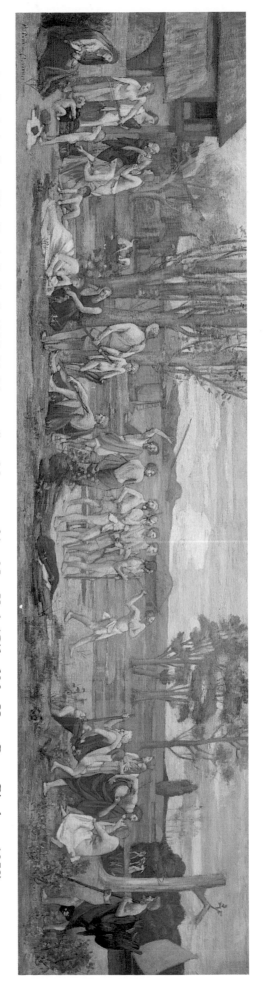

X. *Ludus Pro Patria* (replica of 'Pro Patria Ludus') 1888–89, Metropolitan Museum of Art, New York (Gift of Mrs Harry Payne Bingham, 1958).

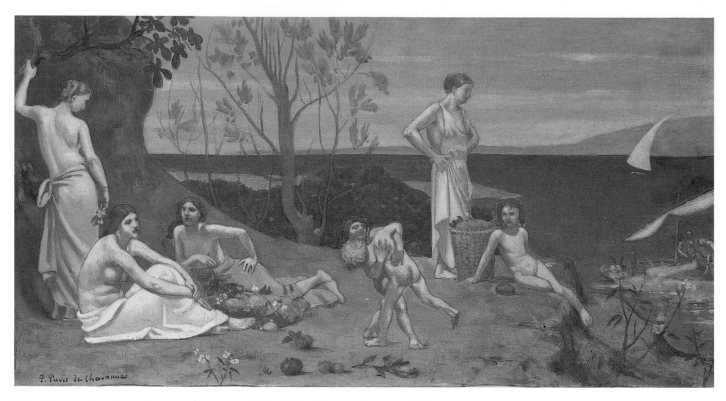

XI. *Pleasant Land* (reduced version) c.1882, Yale University Art Gallery, New Haven
(The Mary Gertrude Abbey Fund).

XII. *The Dream* 1883, Musée d'Orsay, Paris.

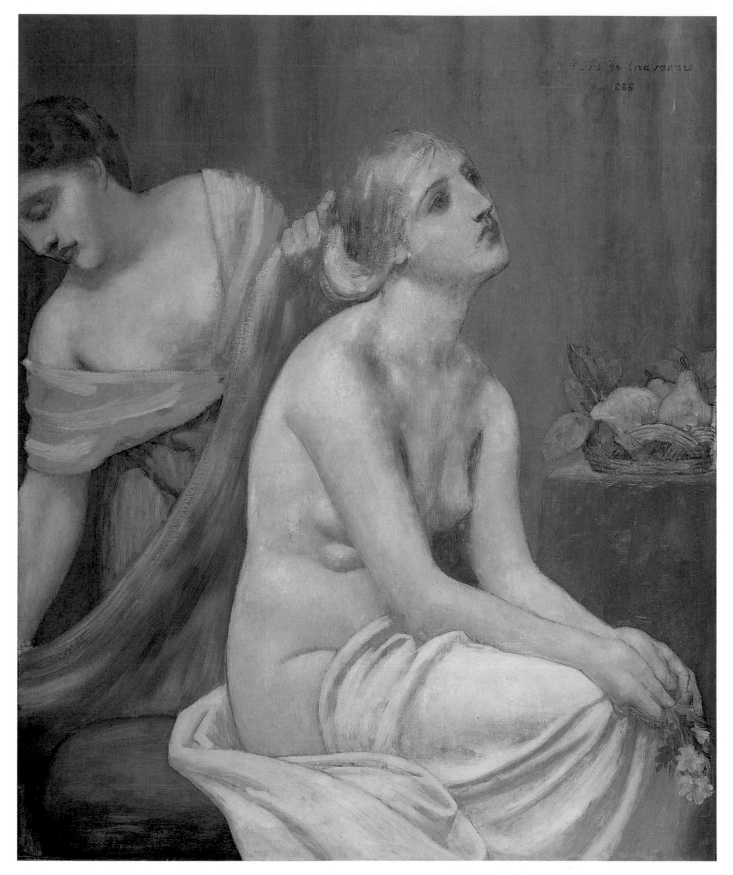

XIII. *Woman at her Toilette* 1883, Musée d'Orsay, Paris.

XIV. *Madame Marie Cantacuzène* 1883, Musée des Beaux-Arts, Lyons.

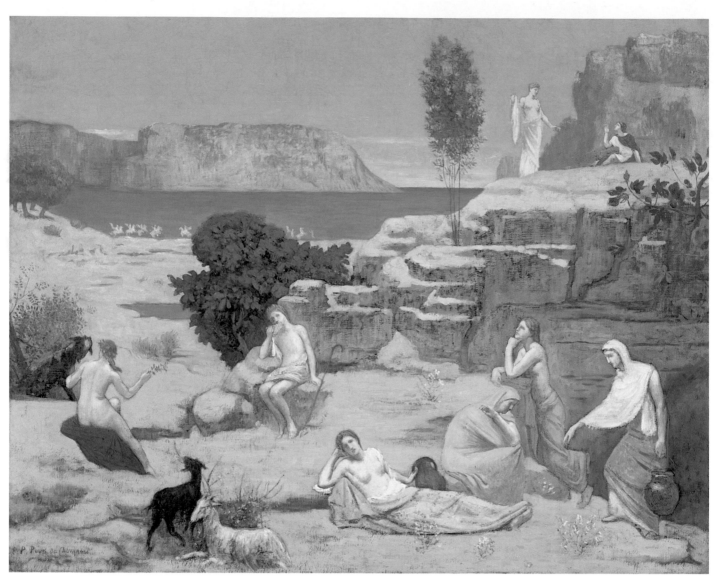

XV. *A Vision of Antiquity-Symbol of Form* c.1887–89, Carnegie Museum of Art, Pittsburgh.

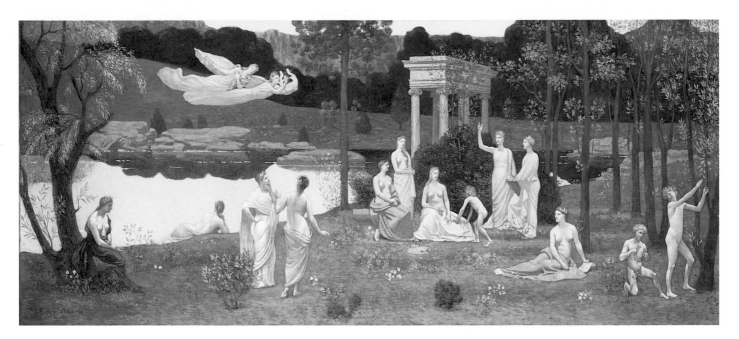

XVI. *The Sacred Grove beloved of the Arts and of the Muses* (reduced version) 1884–89?, The Art Institute of Chicago.

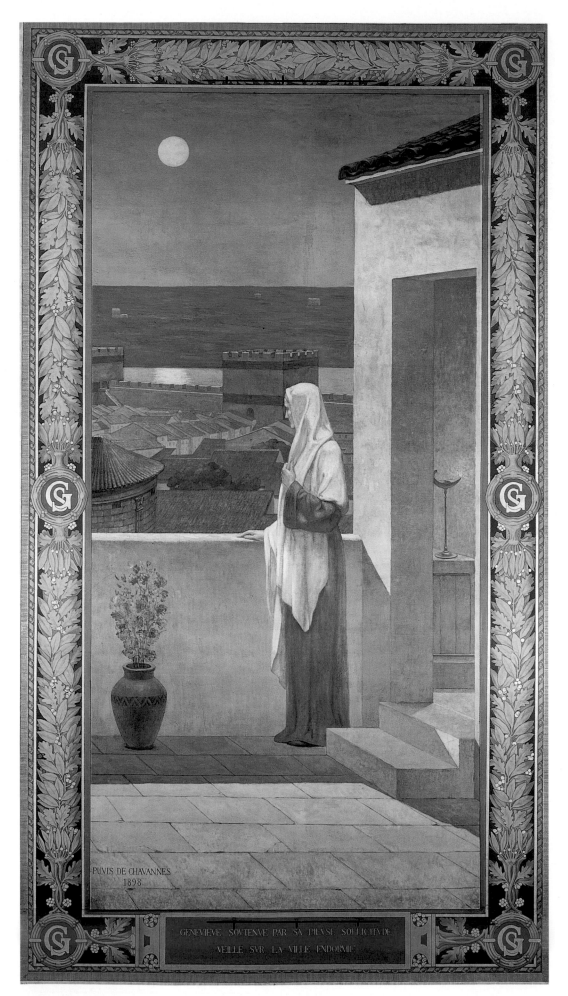

XVII. *Saint Genevieve's Vigil* 1898, Panthéon, Paris.

The precise circumstances to which the paintings refer were of course those of France's defeat, her own civil strife in 1870–71, and her anticipated regeneration from the graves and ruins which form the setting for the figure. It is the frailty of rebirth and, as the sky reveals, of the dawn; but it is also a confident vision, with its spring flowers and the oak of fortitude. In the larger version, there are daffodils and she holds a twig which appears as a young sapling silhouetted against her discarded drapery in the smaller version. There was perhaps even a variation of intent between the larger painting exhibited at the Salon, where the figure seems to imply a greater sense of will and purpose through the draped form than does the girl in the smaller painting, who has the appearance of a purely natural phenomenon.

With these paintings Puvis did not repeat the success he had enjoyed with *The Balloon* and *The Carrier Pigeon*. Both versions remained unsold for many years, and Castagnary shared the widespread distaste felt for the Salon version, concluding his remarks with the patronising words of the pained radical: 'I know that I have before me, if not a superior talent, then at least an unusual conviction, and one should try not to wound such disinterested good faith'.

In 1872 Puvis was elected to the Salon Jury for the first time, though only as a supplementary juror, one of the last five of the twenty elected at that time, so he felt it safe to withdraw on the grounds of commitments elsewhere. Charles Blanc, Director of Fine Arts under the new Republican administration, was arguing for a selection procedure no less strict than that which had prevailed under the Empire, and in Puvis's absence the Jury rejected *Death and the Maidens* (Plate 47) while admitting the larger version of *Hope*. This was the last time a work by Puvis was rejected by the Salon, but he was not again elected to the Jury until 1879, thereafter being a consistent member of a liberal disposition.

Death and the Maidens was exhibited later in 1872 under the title *The Reaper* – at Durand-Ruel's where it was seen by the poet Théodore de Banville who praised its Mantegna-like landscape, as he chose to regard it, though we may feel that both in handling and style Courbet's *Roche de Dix Heures* or *Vallon du Communal* offer much closer prototypes for this enclosed space, a device employed by Puvis since his first works at Amiens. Puvis favoured this type of composition which recurs, for

instance, in *The Sacred Grove* (Plate XVI) for its ability to suggest a withdrawn, poetically privileged setting where his allegories could unfold without sacrificing all sense of reality. Victor Hugo's *Au Bord de la Mer* from his collection *Chants du Crépuscule* (1835) also offers an interesting, though perhaps coincidentally precise, adumbration of the metaphoric equation of landscape and figures in this painting:

> Cette montagne, au front de nuages couvert,
> Qui dans un de ses plis porte un beau vallon vert
> Comme un enfant des Leurs dans un pan de sa robe . . .

Banville also admired these svelte and charming nymphs, but had nothing to say of the painting's allegorical intention, perhaps because the theme of Death the reaper was so commonplace. It nevertheless seems legitimate to ask whether in submitting this work to the Salon together with *Hope*, Puvis may not have intended a sombre thematic counterpoint to the optimism expressed in that work. The two girls in the foreground, the smaller of whom is once again recognisable as Marie Cantacuzène, and who as a group paraphrase two figures in Chassériau's *Trojan Women* (Plate 14), seems contrived as a sober contrast with the thoughtless merriment of the others. The taller girl contemplates a dandelion clock. It may well be felt that here was a comment on the irresponsible France of the years immediately preceding the War. Such an interpretation would be wholly consistent with Puvis's thoughts at the time, and reveals the artist in a somewhat punitive moralistic light.

47. *Death and the Maidens* 1872. Sterling and Francine Clark Art Institute, Williamstown, Mass.

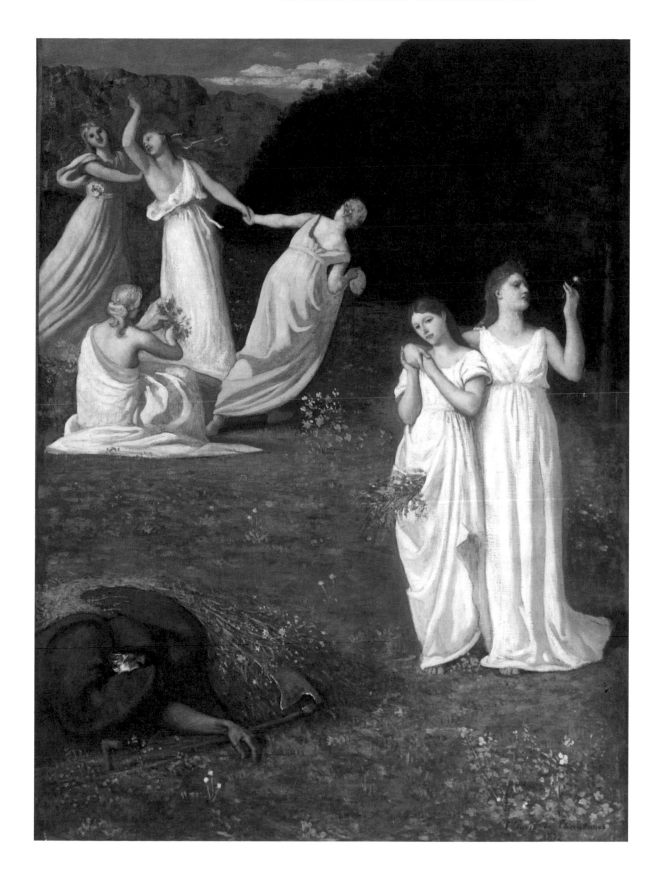

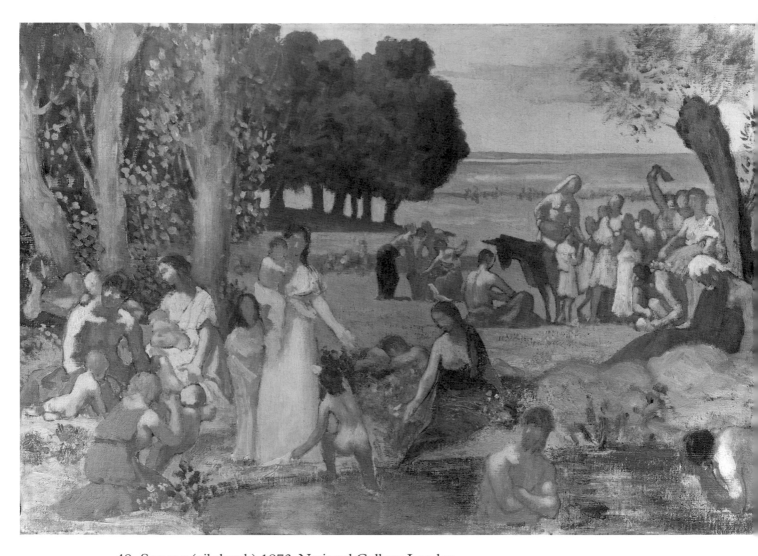

48. *Summer* (oil sketch) 1873. National Gallery, London.

THE POITIERS AND FIRST PANTHÉON MURALS

In 1873, life resumed its customary tenor for Puvis, who in that year exhibited one of his most beautiful works at the Salon, *Summer* (Plate VI), and found himself attacked, as usual, by Castagnary. Like *Sleep* this large decorative work was not executed in fulfilment of a specific commission, but unlike the earlier painting, *Summer* was immediately purchased by the State, for 8,000 francs, and sent to the museum at Chartres. Castagnary wrote that, 'society gets increasingly bored with rhetorical exercises like this', yet it was to a society trying to recover from its recent divisions that this allegory of a mutually supportive community rooted in the family was addressed.

This pastoral owes much of its restful poetry to the lucid classical manner in which it is composed. The foreground figures are arranged like a pedimental sculptural group offset to the left, and space is articulated through the diminishing groups to the right and in the centre as precisely as in a Poussin landscape. A comparison with the oil sketch (Plate 48) shows how thoughtfully this structure was evolved and also how many of the figures were adapted, in certain cases to be recalled in the much later *Summer* at the Hôtel de Ville, before the work assumed its definitive form. The seated mother and child is one of Puvis's most beautiful inventions, anticipating the massive dignity of some figures by Picasso. Three other figures are of special interest in indicating some of the painter's sources of inspiration. The critic Jules Clarétie made what was to become a frequent allusion to Virgilian poetry in discussions of Puvis, and went on to notice how certain figures stand out with gestures both seductive and sculptural. Prominent among these is certainly the standing figure who forms the apex of the pedimental group, whose style of drapery makes her irresistibly reminiscent of the *Venus de Milo*. Leconte de Lisle had devoted a famous poem to the 'impassive beauty' of this most famous figure from

the Louvre's collection of ancient sculpture, and long before, Puvis's friend Gautier had recommended her as both intrinsic paradigm and as the best object for study by modern artists. Gautier had died in 1872, and we may sense that Puvis was here offering him an indirect tribute – less direct than the homage offered in *Saint Radegonde* (Plate 51) a little later – especially in that Gautier had reverted to the subject of the *Venus* in *Tableaux de Siége* of 1871, the last book published in his lifetime. He had accepted the now discarded theory that the solution to the problem of the original gesture of the figure's lost arms should be understood as the victress in the Judgement of Paris, envisaging one arm extended to receive the prize. Puvis has his figure extend her arm to receive a flower picked by her companion, with the other supporting her drapery in an ingenious and maternal, if dispassionate, gesture. For Gautier had also come to stress, contrary to earlier beliefs, the impassibility of this beauty coexisting with an essentially human and womanly quality, and this is emphasised here by the maternal role given, and, throughout Puvis's painting, with the recurrent classicising mode.

There are two other figures of special interest for the light they cast on Puvis's development. For the woman holding a sheaf, at the front of the group in the middle-distance, he made a reduction of a similar figure in his *Ruth and Boaz* of 1854 (Plate 3), (another *Summer* indeed), which seems in turn to have been derived from Millet's picture of the same subject (known as *Harvesters Resting* (Plate 2)) of 1853. Here is an instance of the way Puvis, over the years, collected together the formal components of his designs, so that new inventions could coexist with older ones in a new synthesis. In the figure who stands next to his harvester, his raised arm profiled against the cornfields, there seems to be another echo of a gesture which occurs twice in Chassériau's *Trojan Women*. Such observations do nothing to detract from our sense that this is a masterpiece; they merely confirm that, like a better-known painting executed a decade later under the strong influence of Puvis – Seurat's *Une Baignade, Asnières* – this is a masterpiece of clarity, design, discipline, of classicising *invention*, rather than of passionate, romantic, *inspiration*.

An anecdote told by the Marquis de Chennevières, who as *Directeur des Beaux-Arts* had been responsible for commissioning the decorations of the Panthéon, confirms in a lively fashion the pragmatic nature of Puvis's

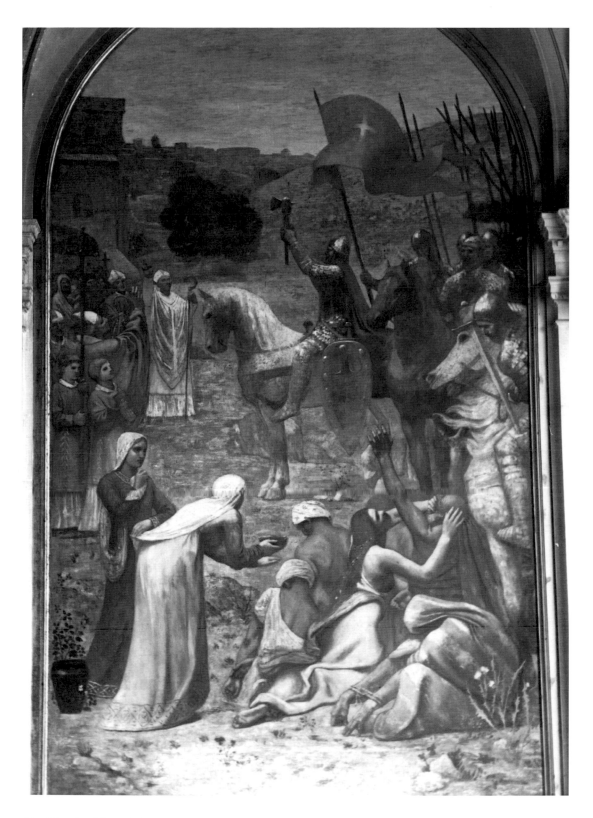

49. *Charles Martel, Conqueror of the Saracens* 1874. Hôtel de Ville, Poitiers.

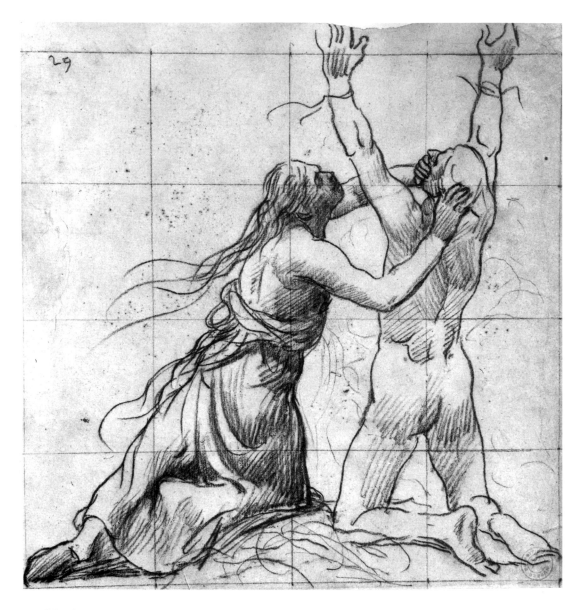

50. *Charles Martel* (drawing of kneeling figures) 1873–74. Musee Sainte-Croix, Poitiers.

thought. On hearing that one of his colleagues had announced that he, for his part, would prepare his work for the Panthéon in his normal manner without 'considering the wall', Puvis was said to have commented: 'if he doesn't give a toss for the wall, the wall will spew him up'. One of the several ways in which Puvis showed his sensitivity to this point was in the special structure of his major works. He minimised recession into deep space by his preference for groups arranged parallel to the picture plane,

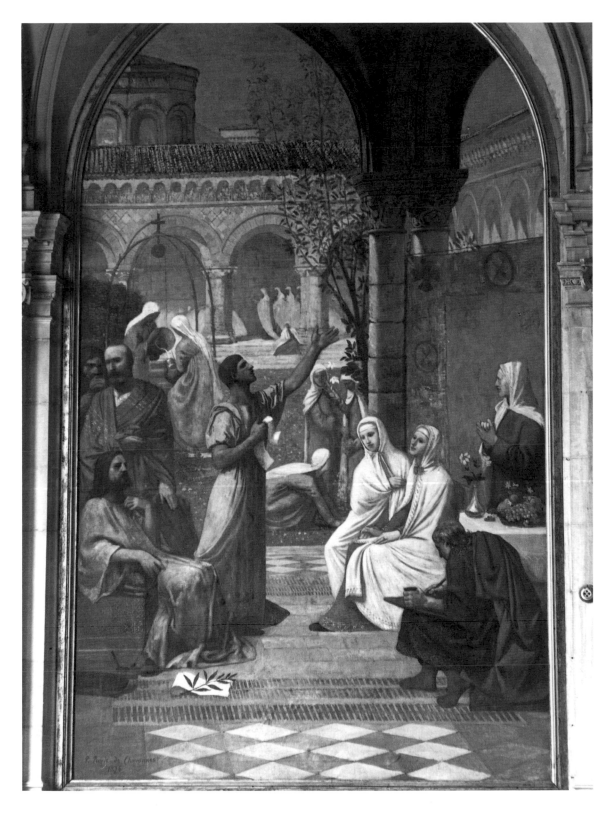

51. *Saint Radegonde at the Convent of Sainte-Croix* 1874. Hôtel de Ville, Poitiers.

and without denying all depth to his scenes, he confirmed their tendency to a frieze-like disposition by the carefully articulated intervals between landscape features. In his next works for the Salon, those of 1874 and 1875, *Charles Martel, Conqueror of the Saracens* and *Saint Radegonde at the Convent of Sainte-Croix* (Plates 49, 51), especially the latter, he came closest to the sort of window-like illusionism which he normally suppressed as far as possible. He clearly tried to relate his fictional space to the real space in which the work is set, even including a detail like the channelled soffits of the arches. Such a procedure was of course not possible with his normal landscape settings, where he sought a convincing atmosphere, rather than an illusionistic record, and as such revealed himself surprisingly close to the ambitions of an Impressionist like Monet.

The Marquis de Chennevières had commissioned Puvis, in July 1870, to paint these two decorative panels for the recently begun new town hall at Poitiers. The works were due for completion in 1871 or 1872, but the intervention of the war, and perhaps the fact that this was a state, not a city commission, led Puvis to delay. He does not seem to have begun to plan his works until 1873, and the two paintings were finally installed on the completion of the building in 1876.

The full title of *Charles Martel* (Plate 49) when shown as a cartoon (as was its companion *Saint Radegonde* a year later in 1875) was, *In the year 732 Charles Martel saves Christianity by his Victory over the Saracens near Poitiers*. The Frankish ruler is shown after his defeat of Abdar Rahman's army, the spearhead of the last major Arab invasion. As was his habit, Puvis avoided the depiction of violent action, and concentrated on the king's triumphant encounter with the Clergy, most of whose wealth he had confiscated to finance his campaign. There appears to be some indirect reminiscence of Delacroix in the group of captives in the foreground, which is enlivened by a moment of psychological rather than physical violence as a prisoner's imprecations are muffled by his companion in the face of a nearby soldier's threat. The drawing for this group (Plate 50) is a beautiful instance of Puvis's most concisely expressive technique as a draughtsman. Martel's relationship with the Church had been strained, and it is tempting to speculate that in choosing to show a moment of reconciliation, Puvis was suggesting an historical parallel with

the increasingly strained relations between Church and State under the Third Republic. The ladies offering sustenance to the captives are also perhaps symbolic of an anticipated reconciliation between Left and Right after the Commune.

Puvis chose a total contrast for the theme of the companion piece, the full title of which is, *Radegonde, having retreated to the Convent of Sainte Croix, gives asylum to poets and protects literature from the barbarism of the age*. Radegonde, who died in 583, was a Frankish queen who became a nun and offered hospitality to the poet Venantius Fortunatus, who later became bishop of Poitiers. He is shown reciting his verses to the Saint, who bears the features of Marie Cantacuzène. There are at least two other portraits in the work. The seated poet, his discarded manuscript covered with a branch of laurel, has features modelled after Bracquemond's portrait of Gautier. This reference to Gautier's 'immortality' won the work the mocking title 'Apotheosis of Gautier' from the cynics. The figure standing behind Gautier is a self-portrait of the artist, and thus indicates Puvis's personal homage to his most consistent critical supporter and friend.

He was sufficiently pleased with the figure of Venantius to use it at least twice again during the next few years, in *The Fisherman's Family* and in the Panthéon frieze. Emile Zola noted that Puvis here showed a 'truly original talent, and one far from any academic influence', though as propagandist for Naturalism he felt obliged to add that the painter 'is merely a precursor. It is indispensable that great painting should find its subjects in contemporary life.' It was not enough for this critic that contemporary references, political or cultural, should be presented in historical disguise.

Puvis's principle of economy, in the use of his ideas, is well demonstrated by the *The Fisherman's Family* (Plate 52) where two figures from *Summer* were recast. The first version (now destroyed) was shown at the Salon of 1875. Both this and *Summer* are fascinating instances of Puvis's mature ability to make form follow function without sacrificing the sense of a perfectly natural activity. The sleeping old man, too, is a variant, apparently based on a model who formed the most prominent figure in *Sleep* (Plate 35).

For very understandable reasons, but without, so far as is known, the

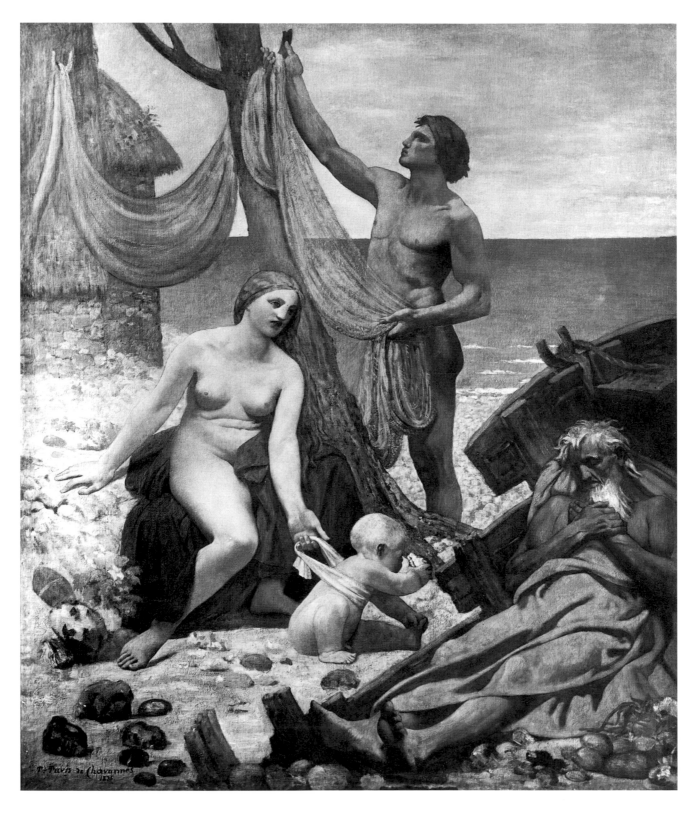

52. *The Fisherman's Family* 1875. (Formerly Staatliche Kunstsammlungen, Dresden, destroyed in 1945).

92

sanction of the painter himself, this composition has sometimes been considered as an allegory of the Three Ages of Man. Be that as it may, Puvis here worked with a theme which was a common focus for humanitarian sympathy in both the art and the literature of the nineteenth century, and one which he used himself on a number of occasions, particularly with *The Poor Fisherman* (Plate IX) in 1881. Here he devised his most compact treatment of his ruling preoccupation with the family unit, in which whilst poverty is certainly to be understood, so too is moral integrity, and one which expresses little of the later painting's pathos. In that later painting everything, above all the fisherman's physique, seems etiolated and melancholy, here Puvis has offset his simple landscape by the rounded and well-muscled forms of this family, who for all the abbreviation of the modeling with which their bodies are moulded express a confident vitality. In plastic terms the work is as strong as some paintings by Picasso, who was later to show the influence of some of Puvis's work at the Panthéon.

In many respects Puvis's work was conventional. His pallid – 'anaemic' in the view of advanced tastes – colour harmonies were conceived with no radical intent. His dislike of what he called 'misplaced colouristic effects' and his belief in the decorative appropriateness of certain scales accord with the views of the academician Auguste Couder who wrote in 1867 that 'monumental painting should banish all brilliant coquetry from its palette; sobriety, unified colour, a simple and austere tonality suffice'. It was as important that the work should harmonise with the lighting and adjacent stonework of its destined setting as that it should constitute a harmony in itself. According to Puvis's assistant Baudoüin, the cartoon might itself be tested *in situ*, the design might be modified, and although the cartoon was itself uncoloured, a final judgement could now be made on the possible effect of certain predominating tones applied over large areas.

The works for the Panthéon, the most monumental of all French Neo-Classical buildings, with a light and spacious, but also frigid and austere interior, offered a unique challenge to Puvis and the numerous other painters who contributed to its decoration. In 1873 Philippe de Chennevières had planned to have Puvis decorate the grand staircase in

the Louvre. This project never materialised (the staircase remains undecorated to this day), but in the following year he drew up a programme for the decoration of the church of St Genevieve, which had been built between 1757 and 1790 by the architect Soufflot. Visitors will find there a representative collection of the French official decorative art of the later nineteenth century, and Puvis's pre-eminence in this company is immediately apparent. His two large cycles of works are the only ones which effectively harmonise with their architectural setting, and it is unlikely that his superiority in this respect would have been challenged even if Millet had lived to carry out the commission offered to him. Some painters recognised the unsuitability of their styles to this sort of task. Gustave Moreau refused the offered commission, and Meissonier procrastinated for so long that he had only produced a small sketch by the time of his death in 1891. Most were content simply to enlarge their usual highly finished manner.

This unique physical aspect apart, the church of St Genevieve (as it was then known) also presented a certain historical and political challenge to the painters engaged to work there. Puvis wondered at one stage whether he was taking an undue risk in committing himself to so vulnerable a project. Completed in the year following the outbreak of the Revolution, the building's history was itself a reflection of the changing political climate of the century. In 1791 it was designated the Panthéon for the burial of the nation's great men, but was reconsecrated at the Restoration. It was the Panthéon once more under the July Monarchy and the Second Republic, but was returned to the church by Napoleon III in 1851. Its present designation was finally confirmed at the funeral of Victor Hugo in 1885, but was controversial throughout the earlier years of the Third Republic. Soon after receiving the commission Puvis wrote, 'the radical newspapers would like Saint Genevieve replaced by Robespierre, while those of the Clerical parties are scandalised by the choice of subjects which they find irrelevant to the site, and heretical'. The overall scheme was in fact an attempt by Chennèvieres to compromise. He wrote: 'The decoration of the Panthéon (thus named) should form a vast poem of painting and sculpture dedicated to the glory of Saint Genevieve who will remain the most ideal representative of our race's early history.' Patrio-

tism was confirmed by the inclusion in the transepts of works devoted to the life of Joan of Arc. National pride was further stressed by Chennevières's expressed ambition to unite in this task the greatest living artists of the French school, and thus to complement the Paris Opera. French art, he believed, would show Europe that it was capable not only of wit, grace and elegance, but it would also prove able to ascend the 'most severe and noble summits of religious and patriotic art'.

Puvis found in this programme the ideal vehicle for the expression of his moral convictions and artistic gifts, and it was appropriate that the unveiling in May 1877 of his first cycle, the first work in the building to be completed, should have brought him his first real public success, a wider reputation, and promotion to the status of Officer of the Legion of Honour.

Predictably, Castagnary objected on political grounds, but Zola addressed himself to the matter in hand and praised Puvis as 'the only one of our painters who can make really grandiose works . . . this is decorative painting in the broadest sense, which adds to, rather than detracts from, the building's own grandeur. It gives a peaceful character to a noble idea, and expresses that idea with clarity, peace and originality.' Puvis's themes were the first in the narrative sequence devised by Chennevières to recount the life of the Saint. He was instructed to represent, in the first intercolumnation on the right in the Nave, 'The Education of Saint Genevieve', and in the following three 'The Pastoral Life of the Saint'. He treated this programme with his usual freedom, and explained to Chennevières the subject of the first work: 'I have made the little Saint appear to a Woodcutter and his wife . . . obliged by my composition to show the main figure from behind, I have tried to suggest the expression of wonder and awe on his face by the overall composition of the group . . . I have also thought it necessary in the interests of appropriate feeling to give the child a form and garments reminiscent rather of an angel than of a real being . . . the Saint's devotion before her home-made cross are further focussed by having a ploughman in the background, watching her half-hidden behind a tree' (Plate 53). The explication given in the Salon catalogue, and inscribed on the painted border of the work is as follows: '*From her tenderest age Saint Genevieve showed the signs of an ardent piety.*

Constantly at her prayers, she was the object of the surprise and admiration of those who saw her.'

Puvis similarly recounted to Chennevières his intentions in painting the tripartite *Childhood of Saint Genevieve* (Plates 54, 55, VII), which, following the overall decorative schemes for the building, is conceived as a single composition divided by two pilasters: 'I have chosen the moment when her historical destiny overtakes the heroine, whose calling is divined by Saint Germain of Auxerre; this is not an old man and a child; these are two great souls in each other's presence. Their intense exchange of looks is the moral climax of the composition.' Thus far, with a ritually centralised main theme and its symmetrical flanking episodes, Puvis deployed the ordinary skills of classical history painting; his further comments show how he sought to introduce a more poetic symbolism into the work: 'I wanted, since I was representing the heroine's youth, to make everything around her young as well . . . it is spring . . . it is morning; finally the whole aspect is tender and sweet, like the child's own soul which must be revealed by, and permeate, the whole composition'. Similar methods had been adopted in *Hope* (Plate V). Finally Puvis also noted that he had placed his landscape between the ancient silhouette of Mont Valérien and the windings of the Seine.

Every narrative detail is carefully calculated in this most carefully planned of all Puvis's major compositions. Every age and condition of humanity is represented. One typical instance is that of the three figures in the middle-distance in the right-hand section, who clearly represent three contrasting and successive psychological states: piety, uncertainty and scepticism. The full title of this poetic morality reads: '*In the year 429, Saint Germain of Auxerre and Saint Loup, on their way to England to fight the Pelagian Heresy, arrive near Nanterre. In the crowd which comes to greet them Saint Germain recognises a child marked by the seal of Divinity. He speaks with her and predicts to her parents the high destiny to which she is called. This child was Saint Genevieve, Patroness of Paris.*'

Puvis is said to have included in this work heads among the populace based on those of the politicians Joseph Blanc, Gambetta and Clemenceau, all men of the Left. He certainly included some portraits in the main section of the frieze above (Plate 56) (the version of this composition here reproduced is an accurate reduction made in 1879). The various early

53. *Saint Genevieve as a child at Prayer* 1876. Panthéon, Paris.

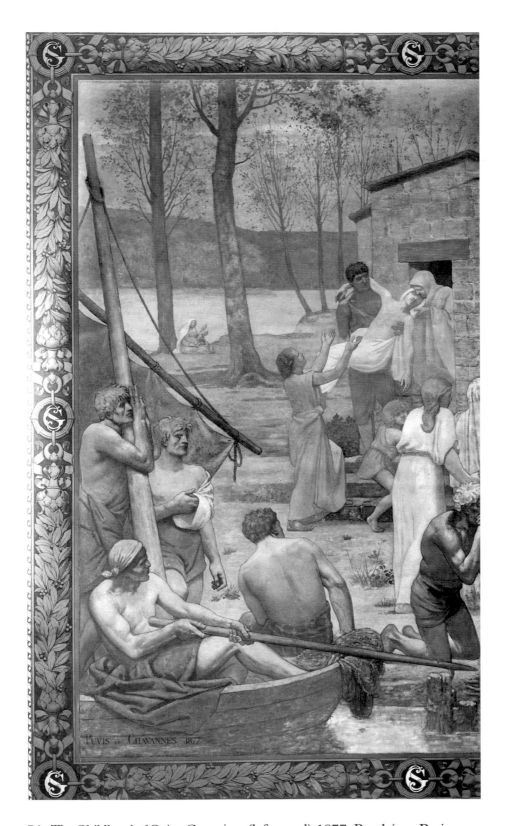

54. *The Childhood of Saint Genevieve* (left panel) 1877. Panthéon, Paris.

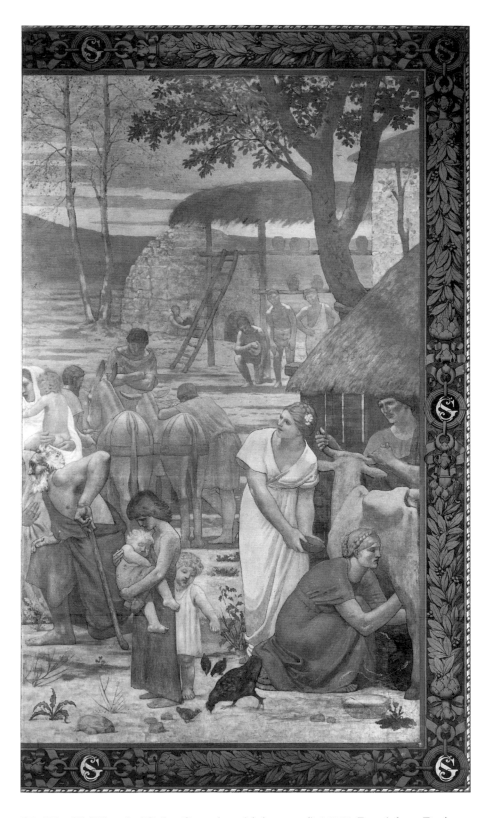

55. *The Childhood of Saint Genevieve* (right panel) 1877. Panthéon, Paris.

56. *Procession of Saints for the Frieze above 'The Childhood of Saint Genevieve'* (reduced version) 1879. Philadelphia Museum of Art.

French saints represented had been specified in Chennevières's programme, and among these the figure on the extreme right, Saint Paul of Narbonne, is a portrait of Chennevières, while his neighbour Saint Trophimus of Arles is a portrait of the painter himself. *The Three Theological Virtues* (Plate 57) with Saint Genevieve's cradle at their feet, is situated over the first, independent, composition. In all these works Puvis succeeded in reconciling a certain liturgical solemnity with his usual tender naturalism, and the cycle, though little adapted to more recent taste, remains one of the high points in the French painting of the nineteenth century.

57. *The Three Theological Virtues* 1874. Panthéon, Paris.

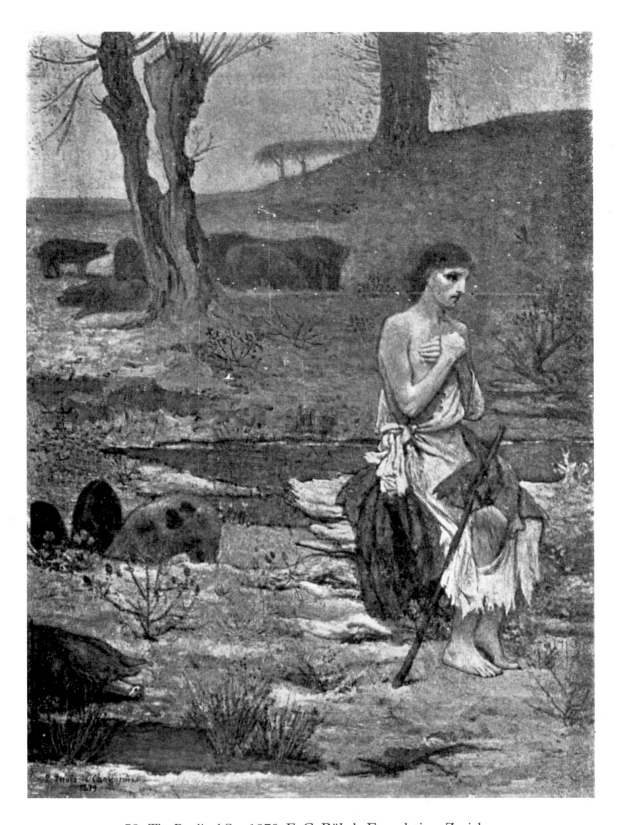

58. *The Prodigal Son* 1879. E. G. Bührle Foundation, Zurich.

THE AESTHETICS OF THE EASEL-PICTURES

In a letter of the late 1870s Puvis wrote of his alternative to decorative painting: the creation of easel-pictures where he would seek to evoke what he called *'le sens de l'expression'*, an expressive art distinct from the allegorical or historical approach of the murals. *The Prodigal Son* of 1879 (Plate 58) is such a work, which is reminiscent of a letter he had written in 1861: 'I have an infirmity which leads me to prefer the more melancholy aspects of nature, low skies, lonely, discretely coloured plains . . . the true type of what I like is in fact pretty well known – the Lido at Venice.' In the same letter Puvis went on to express a preference for poor weather, for grey skies under which each small patch of local colour could assume its true value. This dislike of sunshine is reaffirmed continually. In a letter of 1871 to Berthe Morisot he anathematised the sun with ponderous humour as 'this essentially ill-bred heavenly body . . . a necessary evil', and in 1889 he still found it to be 'the painter's worst enemy'. This aspect of Puvis's sensibility was certainly innate, but in speaking of *'le sens de l'expression'* he revealed himself to be somewhat disingenuous in his claim, often made in self-defence against Symbolist intellectuals at the end of the century, to intellectual innocence. In the *Cours d'Esthétique* by Th. Jouffroy (2nd ed. 1863) we find on p.347: 'Expression is within the object Aesthetic power is the manifestation in the object of a certain state of mind or expression . . .'. Thus what was to be for many Symbolists the central issue of the *'état d'âme'* could be identified with art itself. The plausibility with which Puvis could be identified with Symbolism, is negated by consideration of how far he passed beyond the aesthetic of *L'Art pour L'Art*. As Jouffroy wrote: 'more general and broader than the concept of beauty, is the art of expression which captures it'. With which we may compare Puvis as quoted by Guigou: 'symbolism if you like, but with nothing arbitrary about it'. Jouffroy (pp. 285–286), said: 'if a work

of art is to move us at all it must depict the invisible [i.e. the emotions] by clear and intelligible forms There is truth in expression when signs which are either natural or real, and not merely artificial or invented, are used to explain the invisible.'

The Prodigal Son was indeed 'natural'. Puvis told Vachon that the painting had originated in some studies he had made, while on a visit to the country, of a fine brood of fat pigs. No doubt he hoped thus to counter with a show of ruthless pragmatism the growing tendency of the late nineteenth century to attribute philosophical, indeed Symbolist, intentions to his art. This is one of the most important easel-pictures painted by the artist. As with *The Poor Fisherman* (Plate IX) for which a preliminary sketch is dated the same year, Puvis was seeking his *'sens de l'expression'*, as an emotional force transcending any particular narrative implications. The point seems to have been well taken by Toulouse-Lautrec when in his witty parody of *The Sacred Grove* (Plate 68) he substituted this figure for Melpomene, the Muse of Tragedy, under her willow.

In this work the simple and memorable design, the barren and ruined landscape, and the colouring, a muted harmony dominated by the pale greenish-ochre of the soil and the peat-brown pool, enriched by the dull maroon of the Prodigal's once rich embroidered cloak which echoes a pinkish-violet sky, all contribute to a powerfully expressive synthesis. But the critics were still divided. Paul de Saint-Victor noticed how a deliberate simplification of technique contributed to a work which seemed addressed to the soul much more than to the eyes. However kindly meant, these words cannot have pleased the artist, for they suggested the elevation of the 'idea' over the thing observed, which was to become, in his view, one of the more disagreeable aspects of Symbolism. Yet Saint-Victor redeemed himself with his praise for the painting's profound sincerity and penetrating sentiment, whereas Huysmans, still commited to Naturalism, found the artist up to his neck in a false genre, producing nothing but pretentious false-naivety and affected simplicity. But the tide was turning, for even Huysmans mentioned a certain grandeur and simplicity, and made a polite reference to the works at the Panthéon.

Another work exhibited in 1879 was perhaps the most beautiful of all Puvis's easel-pictures, and it is for that very reason interesting to find that in the catalogue to that Salon the work was specified as a 'decorative panel'. The artist indeed designed for it a flat, painted frame (now lost)

with which to stress this decorative function. This did not prevent some critics from reading symbolic meanings into the work. Théodore de Banville, a poet known to Puvis since the days of his friendship with Gautier, thought he recognised here an echo of Baudelaire's *Femmes Damnées*. The Symbolist poet and theoretician Gustave Kahn later wrote in 1888 of an allegory, as if that of the Sirens, and even, as if in anticipation of Edvard Munch's famous painting of three phases in the life of Woman. *Young Girls by the Sea* (Plate VIII) possesses human, as well as purely visual expressive qualities. But however fanciful such interpretations, they are the product of an age when, partly under the stimulus of Puvis's own works, the concepts of 'decorative' and 'symbolic' became inseparable. Puvis always resisted the spread of elaborate 'literary' glosses over his work, and this painting is certainly best understood in the light of a sensibility formed under the influence of Chassériau's *The Trojan Women* (Plate 14).

In abandoning all narrative pretext for this picture, Puvis effectively distilled the languid melancholy of Chassériau's figures and made melancholy itself the subject of his work. To that extent there is affinity, but not identity, with the simplest and most universal of Symbolist ambitions – to find plastic form for an '*état d'âme*' – an emotional state. The smaller, and certainly later, version of this work (Plate 59) has an interesting *pentimento* which shows how sensitive Puvis was to the effect of scale on the value of a design. The dune to the left had originally ascended to the full height of the canvas as it does in the larger work, but was overpainted no doubt because it overwhelmed the figures in this smaller format. The simple geometric structure often used by Puvis (which Seurat was to take up and elaborate), and his sense of the need not to let these armatures become too dominant, are both well illustrated.

The title of *The Poor Fisherman* was borrowed by Gauguin for one of his own Tahitian works. Puvis's work (Plate IX) rapidly became, and has remained, his most famous easel-painting. In his review of the Salon of 1881 Emile Gardon already recognised in Puvis, on the strength of this picture, 'the most distinctive and resolute personality of our age, whose work will retain an exceptional position in the history of nineteenth century art'. It was copied by Seurat and Maillol, and by the time of its entry into the Musée du Luxembourg in 1887 it had acquired a status like that of a *tableau manifeste*, despite the artist's own lack of interest in such

105

gestures. It was understood in this way by Maurice Denis when he wrote: 'and what was he, this man eternally sad . . . A universal triumph of aesthetic imagination over stupid imitation. The triumph of the feeling for beauty over the naturalist falsehood.' The work even provoked Signac to apply his pseudo-scientific Neo-Impressionist theories much later in his diaries. The feeling of sadness, he claimed, was derived from the leftward, 'inhibitory' inclination of the little boat's mast. There exist preparatory sketches by Puvis which reveal how foreign such notions were to the artist himself.

In a less sophisticated sense, however, the painting does attain a particular psychological force through its memorability, the result of its simplicity, here carried even further than it had been in *The Prodigal Son*. This too was noted by at least two contemporary critics. J. Buisson claimed that even if the painting was hidden away it would leave behind an ineffaceable memory, and Huysmans, though still unconverted, ended his dismissive review with these witty, but also revelatory words: 'despite the feeling of mutiny I experience when I'm in front of this picture, I can't help feeling rather attracted by it when I am far away'. Puvis had reportedly been inspired by a scene on the estuary of the Seine and always relied on memory in composing his landscapes. Here he certainly contributed to the new stress placed on this faculty in painting by some 'synthetist' artists, and particularly by Gauguin who twice paraphrased this theme in Tahitian terms.

After listening to an elaborate account of his achievement in this painting given by Camille Mauclair, Puvis went so far as to admit to the young writer that there is a power in the assembly of lines and colours, ideas which the painter himself, busy at his work, does not always perceive. Later he gave Marius Vachon a simple account of the painting which is typical of his constant concern with nothing more elaborate than universally understood human feelings: 'in the background this is not a woman, but an adolescent young girl. The mother is dead (*sic jubeo*) and she is there to watch over her little brother. She is gathering flowers with little monkey hands, feverishly, mechanically. A child who did otherwise on such a curious bed of flowers would not be natural. I detest novels illustrated in oils; my only excuse is that this vision of misery is my own creation . . . so much by way of reply to my critics.'

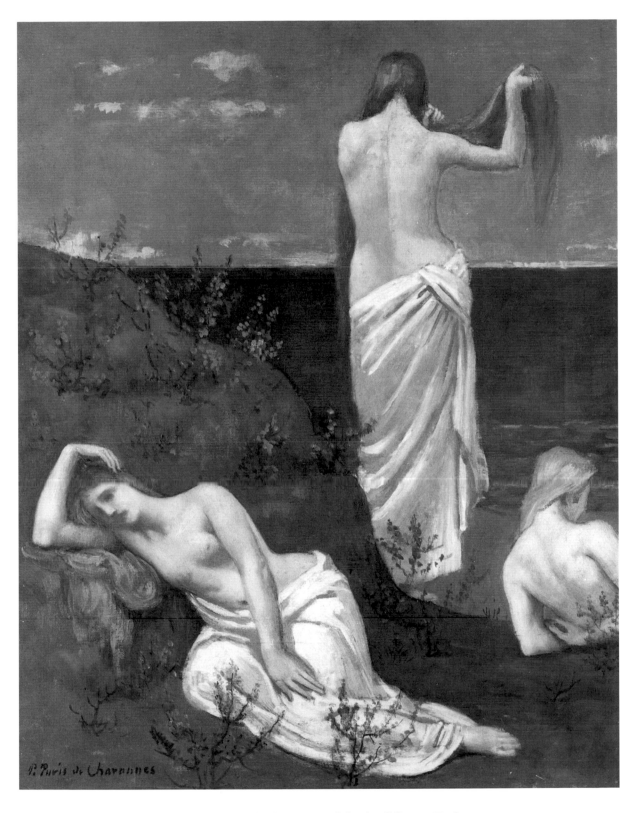

59. *Young Girls by the Sea* (reduced version) c. 1879. Musée d'Orsay, Paris.

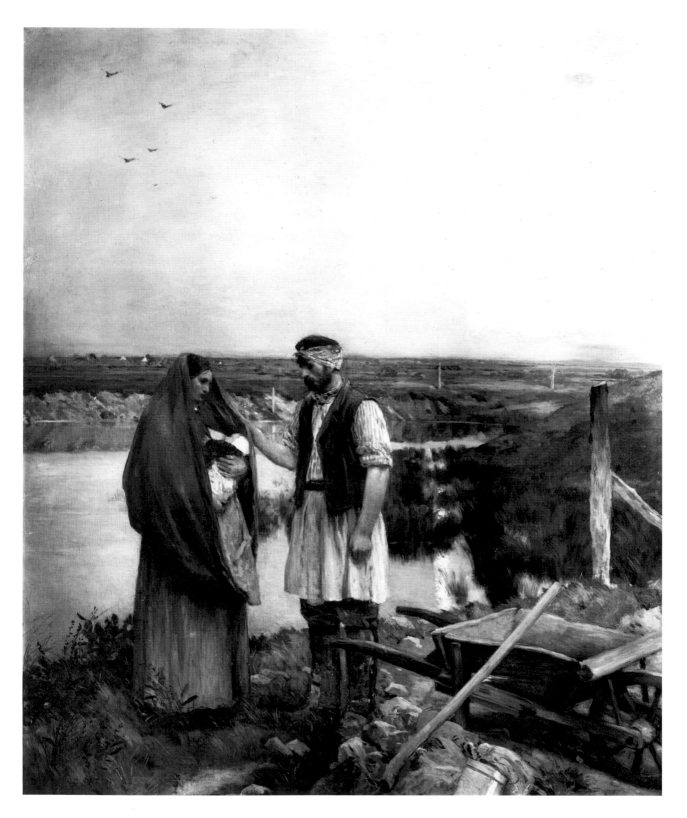

60. CAZIN: *The Day's work done* 1888. Musée d'Orsay, Paris.

THE SUCCESSES OF THE 1880s

Pro Patria Ludus (Games for the Fatherland), shown at the 1882 Salon, marked Puvis's return to decorative painting and stands high among his masterpieces (Plates 61a and b, XI). This was the last of his contributions to the decoration of the museum at Amiens, and he was pleased to confess that this landscape was derived from a brief glimpse of the flat, well-watered plains of Picardy seen from the window of a train. In this way Puvis could devise an appropriately characteristic landscape which could be carefully structured and integrated with the figure groups. His own practise is however unrelated to Lecoq de Boisbaudran's influential advocacy of the use of visual memory as training in accurate perception, which is better represented by *juste-milieu* naturalists like Legros and J. C. Cazin (Plate 60). The two most influential contemporary French art theorists, Charles Blanc and Hippolyte Taine, while stressing respectively scientific observation and scientific methods of analysis, both insisted that artists should interpret the thing seen according to a more characteristic and perfected vision. Although Puvis took no interest in theory, remarks touching on these broader issues accord with his own remarks when he spoke of his works as 'a transposition of natural laws, but remaining parallel to nature', and of nature as a 'harmonious ensemble' from which the artist must nevertheless select the most salient aspects of that harmony itself. In remarking to Guigou that 'art finishes what nature merely sketches' he was simply echoing an ancient but constantly reformulated principle with which only the most dogmatic of realists could have disagreed. Here again he showed himself to be a conservative thinker, whose individuality lay in his way of recasting traditional procedures, and who made no attempt to revise artistic methods, still less to redefine art itself. Here a comparison with Matisse, who found it necessary to make some comment on this giant of the preceding generation is interesting. Although Matisse emphatically distinguished his own intuitive method

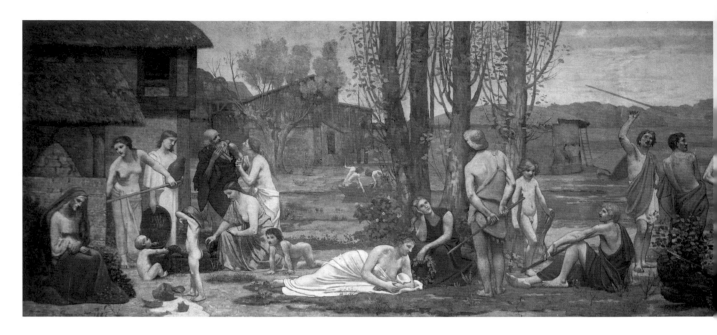

61a. *Pro Patria Ludus* (left section) 1882. Musée de Picardie, Amiens.

from Puvis's careful planning and forethought, both artists shared the belief that sensibility was best expressed through a reductive pictorial logic.

Pro Patria Ludus was commissioned by the State in 1880, for 40,000 francs, after Puvis had exhibited its predecessor, entitled *Young Picardians Practising the Javelin Throw* as a cartoon in the Salon that year. The painting itself occupies the full width of the wall on the upper level of the stairwell at Amiens, opposite *Ave Picardia Nutrix* (Plates 28, 29). Its execution only became possible when it was proposed to remodel this part of the building in the late 1870s. The wall this painting occupies had originally been pierced by windows, but top-lighting was now introduced, making it necessary to remove the original ceiling painting by Félix Barrias. Puvis thus acquired simultaneously a perfect site for his most frieze-like major composition and the total monopoly of the painted decoration of the Grand Staircase. Building work continued at the museum, and the work was not formally installed until 1886. A comparison between the Louvre sketch (Plate 62) and the painting itself falls into three distinct, but related parts, the leading theme of practice with the spear being flanked by domestic labours on the left and an emblematic group of two families to the right. This articulation was reinforced by the

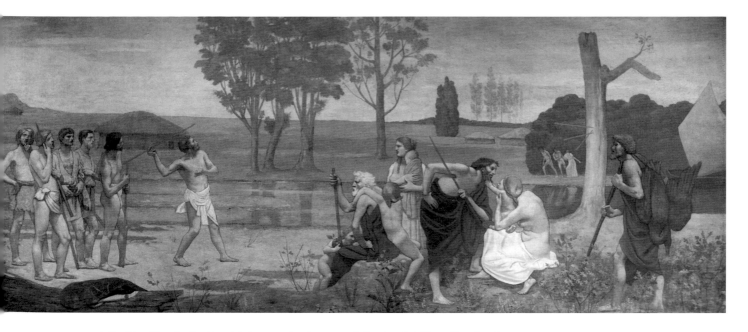

61b. *Pro Patria Ludus* (right section) 1882. Musée de Picardie, Amiens.

carefully sited trees. Certain figures like the old man on the right who watches, perhaps adjudicates, the exercise, and the spear-thrower in conversation with a woman under the trees to the left constitute a semi-narrative link between these groups. In thus clarifying and unifying his composition in a visual sense as well as by narrative means Puvis also made more explicit the leading idea underlying this allegory, which was the expression of the essential values of conservative Republican France: *Travail, Famille, Patrie*. It was by symptomatic coincidence Paul Derou-léde founded his openly *revanchiste* Ligue des Patriotes, one of whose

62. *Pro Patria Ludus* (sketch) c. 1879. Louvre, Paris.

aims was the encouragement of rifle clubs all over France. Puvis's allegory, though set in a timeless but morally paradigmatic youth of Gaulish society, was certainly meant to be understood as prescriptive to the late nineteenth century. Evident here, and also implicit in much of Puvis's work, is another recurrent preoccupation of French patriots: their concern over the slow growth of the population, which had already been overtaken by that of Germany in the 1840s. Puvis, who was himself childless, loved to populate his works with infants and children, a

63. *Pro Patria Ludus* (drawing of sitting child) 1882. Musée de Picardie, Amiens.

circumstance perhaps of private, as it was certainly of public significance in his work. The child, a beautiful study for whom is here reproduced (Plate 63) can be seen on the extreme left of this painting.

The work is marked thoroughout by Puvis's mature aesthetic of repose, as befits allegory. Even the most active figure betrays no great exertion, in the typically *gauche* but balanced gesture as he throws his spear. The family group at the right is one of Puvis's most brilliant inventions, in the structural interrelationship of the figures. The landscape also forms one of his most poetic muted harmonies, designed to accord with the diffused light from above. Puvis had indeed told Vachon that this landscape had been constituted from his memory of one seen from a carriage window on the way to Amiens, but he told Arsène Alexandre that the sky had been found elsewhere: 'one day on the way to Neuilly I saw the sky, and as it was just what I needed I looked at it very hard. When I got to the studio I painted it at once without hesitation.' Puvis's method, the synthesis of diverse realities, is visible in every aspect of this work.

The *Pleasant Land* (Plate XI), one of the most beautiful of Puvis's decorative paintings, was presented at the same Salon, in 1882. It is inscribed to Léon Bonnat, a highly successful academic painter whose portrait of Puvis was exhibited at this Salon (frontispiece). It was painted to decorate the staircase of Bonnat's house in Paris, and has since been moved to the museum built to house Bonnat's fine collection in Bayonne, where it is *marouflée* in the equivalent position.

The composition, with its beautiful sense of interval, includes a typical, half-pedimental group of figures to the left. This architectonic, classicising manner was immediately taken up by Seurat in his first large painting, *Une Baignade, Asnières*. It is again characteristic that whereas Seurat would adapt this type of composition to a conventional perspective structure, Puvis's figures are arranged as a frieze against their beautiful background, a harmony of blue and pale gold.

Though this is an idyll, there is nothing hedonistic about this vision of a 'fragrant' or 'pleasant' land, nothing of the mythical vision of Ingres's *The Golden Age* or of the sensuality of Matisse's *Joy of Life*, a work which may be considered an indirect reply to the *Pleasant Land*. Here we witness a pause, merely, in the necessary labour of fruit-gathering, an activity

demanding enough to confer on one of the figures standing to the right a Degas-like sense of repose from strenuous toil (Plate 38). It is clear why Degas should have confessed himself among Puvis's admirers. The fishermen's labour continues on the shore, and even the wrestling children seem to be preparing for a manhood like that of the spear-throwing Picards in *Pro Patria Ludus*. Despite its private destination the work thus has the same moral and patriotic undertones as those that are to be found in their purest form in *Pro Patria* and in most of Puvis's major decorations. Gauguin, like Seurat, was impressed by this painting; he adapted the motif of the wrestling boys more than once, and it is interesting to note that '*Pleasant Land*' becomes in the Tahitian language, the title of Gauguin's book '*Noa-Noa*'.

Puvis returned to easel-painting for the Salon of 1883, with *The Dream* (Plate XII). The benighted traveller's dream was explained in the Salon catalogue; in his sleep he sees Love, Glory and Wealth appearing to him. Love scatters flowers; Glory in a very *mondaine* contemporary costume, proffers a laurel wreath, and Wealth scatters largesse. The idea is a variation on the theme of Hercules at the Crossroads. All that saves the work from banality is its poetic harmony of nocturnal blues in the romantic spirit, here combined with a classical theme in another guise, the whole being curiously similar in its simplicity to some of Whistler's 'Nocturnes'. Perhaps it was this duality in the work that appealed to its first owner, Théodore Duret, an important critical supporter of the Impressionists, and also the author of one of the first monographs on Whistler.

In this same year Puvis painted, though he did not yet exhibit, his small *Orpheus* (Plate 64) in which he seems to have chosen to represent Orpheus's despair on his return to earth after the loss of Eurydice. Vachon saw this as the third in a 'trilogy of misery', the two other paintings being *The Prodigal Son* (Plate 58) and *The Poor Fisherman* (Plate IX). But it seems likely that in treating this theme he intended a neo-Romantic allusion, also with some personal significance, to the isolated and often miserable life of the artist. Such an implication is also to be understood in the treatment of the same subject by his friend Gustave Moreau. Puvis and Moreau had much in common, but it became usual to consider Puvis the 'poet among painters, where others were mere prosaists'. The phrase sheds light on the neo-Romantic element in Symbolism, which not only

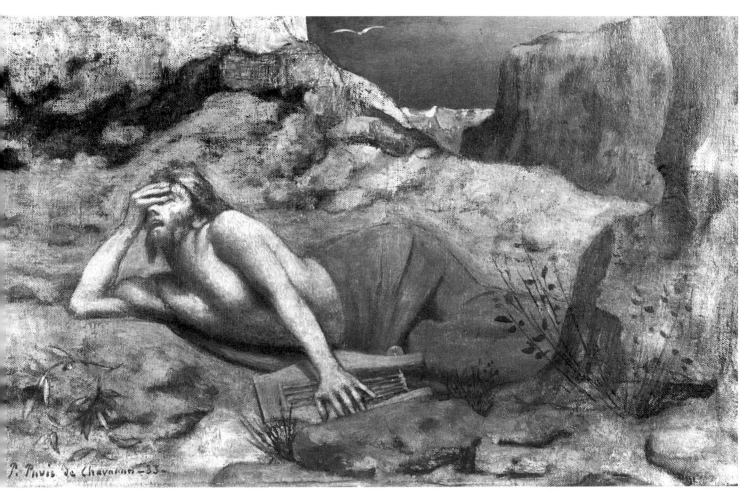

64. *Orpheus* 1883. Private Collection, Paris.

shared the poetic sensibility, one of the most notable features of Puvis's use of colour in particular, but was also allied to the way in which certain more obviously 'romantic' features survived into Puvis's maturity, despite the classical elements in his approach. The romanticism which marked the early *Meditation* (Plate 8) was refined, but not essentially altered in *The Poor Fisherman* and many subsequent works. Puvis took every opportunity to dissociate himself from Symbolism, but his concern with the constant features of the human condition betrayed him, and even his Parnassian sense of formal detachment could not completely isolate him from the changed times at the end of the century. *Orpheus* seems to betray in another sense the survival of earlier influences, for here was a recollection of Millet's *Hagar and Ishmael* (Plate 27).

115

Also in the same year, Puvis showed another easel-painting at the Salon. This was his *Woman at her Toilette* (Plate XIII), a subject of a kind which he rarely attempted, and in so doing he emphasised yet further the difference between his art and that of most of his contemporaries. This painting, in its simplicity, sculptural monumentality, and the rhythmic arabesque of its design, seems to anticipate Picasso and Matisse. In the preparatory studies the main figure held a mirror; Puvis showed his skill as a colourist in replacing this with a bunch of pink flowers in the painting itself. They bring perfectly into focus one of his most subtle muted harmonies, in which the dull gold of the woman's hair against a matt mid-blue curtain are the main elements.

Yet another painting was exhibited at the 1883 Salon, the portrait of *Madame Marie Cantacuzène* (Plate XIV). The work was appreciated in Symbolist circles, especially by the eccentric Peladan: 'he is such a thinker that in portraiture he rises to the abstract . . . Mme C. is not a widow, she is "The Widow".' In fact the lady was not to become a widow until the following year, though she had lived apart from her husband since the 1850s, and Puvis disclaimed any intention to convey a sense of sorrow, wishing only to communicate 'this pensive mood in which I have often seen her'. Puvis painted relatively few portraits, and of these the majority were done quite early in his career. This later painting is the finest of his works in the genre. Marie had married a member of the same Catacuzino family, though he came from the Russian, she from the Rumanian branch of a family descended from the last Christian Emperors before the fall of Constantinople to the Turks. She and Puvis met, probably in Chassériau's studio, not long before the death of the master and she became his lifelong friend, posed for many of his paintings, and finally married him in 1897, only a year before their deaths. The work is painted in an ascetic, but also poetic, black on brown harmony. Chassériau had made two portrait drawings of the Princess shortly before his death in 1856, and Puvis's own preparatory drawings show that he had alternated between those two poses, one sitting and the other standing, before settling on this monumental and immediate, almost icon-like solution.

Léon Riotor, the author of a long and still valuable essay on Puvis, and in no sense a partisan of the Symbolists, asked 'has he wished to fix his dream or to reproduce reality?' – introducing a distinction between nature

and the artist's inner life which would surely have seemed too intellectual and abstract, if not a false dichotomy, to the painter himself. 'How little they know me', he wrote in 1888, 'these frightful connoisseurs, who, forgetting how profound and faithful has been the life of Nature, try hypocritically to identify me with a few exceptional and constrained incursions into the realm of philosophy – something of which I stand in horror'. *The Poor Fisherman* was certainly one of the works which had rendered him vulnerable to this detested treatment, but so in quite a different way did his next large commission, to decorate the top-lit stairwell at the Palais Saint-Pierre (Palais des Arts) in Lyons, the city of his birth. These compositions had themes emblematic, if not symbolic, of the arts, as suited the city's collection. The price of 40,000 francs, modest enough for such an ambitious task, was shared between the State and the Municipality. Puvis insisted as usual on the right to choose his own themes, which he outlined in a letter to the architect: 'I shall be specially concerned to keep in mind the requirements particular to the decoration of a building devoted to the Arts, while looking for something . . . characteristic of Lyons and the surrounding region. In two compositions placed opposite one another I will symbolise . . . the two fundamental aspects of art: form and feeling. The first will be a sort of vision of antiquity, of the great Greek epoch [*Vision of Antiquity* Plate XV] the second could take the Campo Santo, considered one of the cradles of modern art [*Christian Inspiration* Plate 65] . . . I will try to glorify the modern feelings in the features of great Lyonnais artists of the past . . . between the two . . . will be a kind of sacred grove, where the inspiration-bringing Muses will appear' (Plate XVI), and opposite this scene 'Strength and Grace . . . symbolised by the Rhône and the Saône' (Plate 66).

Puvis's project showed some similarity with the Hôtel Vignon decorations some seventeen years earlier, but was planned on a more ambitious scale than were those simple personifications. *Vision of Antiquity* was compositionally derived from Chassériau's *Trojan Women* (Plate 14), while the painting on the wall in *Christian Inspiration* is evidently based on one of the same master's religious decorations. The former had been praised by Gautier for its 'profound feeling of Greek art', and has the same 'deep blue attic sky' which Puvis tried to achieve in his own vision of antiquity. In the foreground is an idyllic scene where the

117

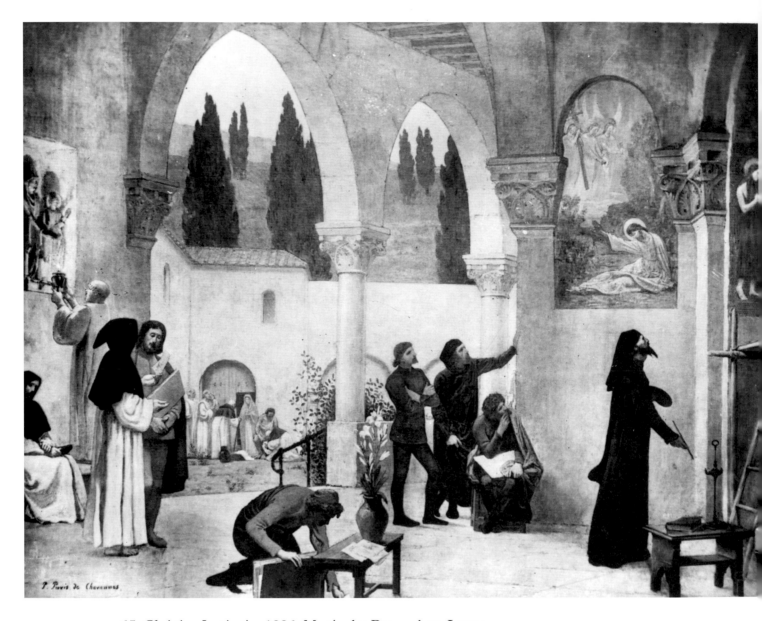

65. *Christian Inspiration* 1886. Musée des Beaux-Arts, Lyons.

central, reclining, figure in particular suggests the recollection of an antique model. On the prominence to the right a woman unveils her beauty before the eyes of an artist in a manner also celebrated in Gautier's *Le Poème de la Femme*:

> Glissant de l'épaule à la hanche
> La chemise aux plis nonchalants,
> Comme une tourterelle blanche
> Vint s'abâttre sur ses pieds blancs.

118

Pour Apelle ou pour Cléomène,
Elle semblait, marbre de chair,
En Venus Anadyomène
Poser nue au bord de la mer.

Marius Vachon already noticed the apparent allusion to the Parthenon frieze in the cavalcade along the shore which appears in the background. When in 1885 Puvis came to paint *Christian Inspiration*, he had abandoned his initial idea of setting the scene in the Campo Santo at Pisa. This small cloister with its capitals in the French Romanesque style was based, according to Léon Riotor, on one at Fourvières near Lyons. The theme of an expressive, as opposed to a formally self-sufficient art was intrinsically less well adapted to Puvis's talent as a decorator, however great the achievements of some of his easel-pictures. Here it is illustrated rather than embodied. A painter, watched by his colleagues, is at work on what the vase of lilies shows to be an Annunciation. He had already completed a *Christ in the Garden of Olives*, whose style owes more to Chassériau's religious works than it does to the Renaissance. According to Riotor, the three observers are portraits of the Lyonnais artists Hippolyte Flandrin, Victor Orsel and Paul Chenavard. The latter identification must be a matter of some doubt, for although Chenavard had projected but never executed some decorative paintings for the Palais Saint-Pierre he was not a Christian and Puvis had a very low opinion of him.

The two rivers which merge at Lyons, the Saône and Rhône respectively, are characterised as Grace and Strength, as willow and oak (Plates 66, 67), the one a nymph like those in *Ave Picardia Nutrix* and the other as a fisherman.

The most elaborate of these compositions is *The Sacred Grove Beloved of the Arts and of the Muses* (Plate XVI), which Puvis described in an explanatory note as constituting the key to the others. In the centre, beneath an Ionic portico, are the three plastic arts: Architecture seated on a carved capital, accompanied by Sculpture and Painting, who is offered flowers in an allusion to the tradition of flower-painting at Lyons. The Muses are, from the left, Melpomene, Muse of Tragedy, alone beneath her willow; Urania (Astronomy), contemplating a sickle moon reflected in the lake; Thalia and Terpsichore (Comedy and Dance) above whom float

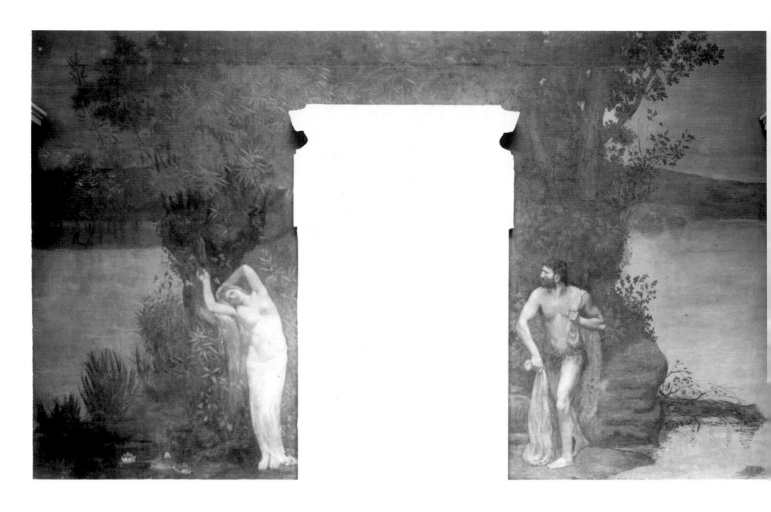

66. *The Rhône and the Saône* 1886. Musee des Beaux-Arts, Lyons.

67. *The Rhône and the Saône* (detail of the Saône) 1886. Musée des Beaux-Arts, Lyons.

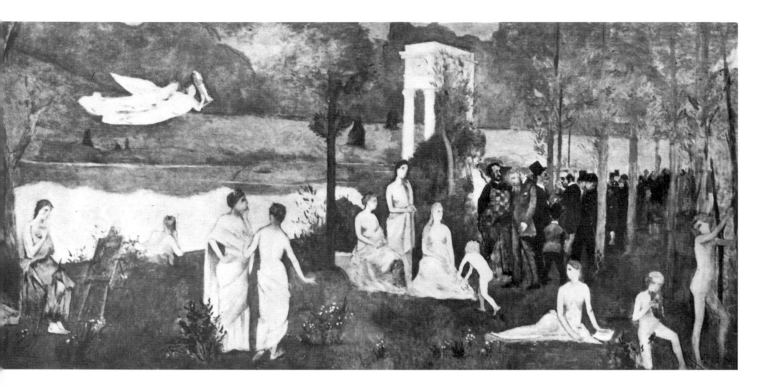

68. TOULOUSE-LAUTREC: *Parody of 'The Sacred Grove'* 1884. The Henry and Rose Pearlman Foundation, Inc., U.S.A.

Erato (Lyric Poetry) and Euterpe (Music). Beyond the personifications of the Arts are Polyhymnia (Eloquence) with her appropriate gesture and Clio (History) with her tablet. Finally Calliope, Muse of Epic Poetry, has as her attribute a page inscribed with the first words of the *Aeneid: Arma virumque cano*. Nearby, genii are preparing laurel wreaths. As for the landscape, it is bounded, Puvis wrote, by 'high azure mountains which prevent access to this favoured spot. From the flower-strewn ground rise the trees of these epic heights, laurel, pine and oak.' This is a high seriousness devoid of thematic originality, and one critic's grumble was typical of the Age: 'I am a citizen of France, not of the Vale of Tempe'. And in this sense Toulouse-Lautrec's parody (Plate 68) where he, with friends and gendarmes invade the sacred precinct, and where *The Prodigal Son*, seated before an easel, is wittily substituted for Melpomene, seems more than a mere *jeu d'esprit*, but a fair comment as well. Nevertheless the painting transcends its thematic limitations and remains one of Puvis's most beautiful inventions; his conventional allegory is secondary to this calm evocation of a classical, but not cold, spirit and beauty. The sym-

121

bolic landscape is also very harmonious, a colour structure based on the blue mountains, green meadow, and the golden water of the lake which reflects a sunset glow and is enlivened by a delicate range of pale draperies. According to Arséne Alexandre, this landscape was inspired by the comfortable Parc Monceau in Paris, through which Puvis's daily walk from Pigalle to Neuilly took him, and which is to this day landscaped with classical 'ruins' not unlike the fragment in the painting.

Owing to the architectural articulation of the stairwell at Lyons, Puvis was obliged to create in *The Sacred Grove* a composition which could turn a corner at each end, to abut the pilasters which frame the two lateral compositions. These corners coincide with the two caesuras in the composition, to the right of Melpomene and to the left of the two genii making laurel wreaths. Puvis's pragmatic concern as a decorator continued after the paintings had been installed. He proposed in 1887 to make some improvements in 'tone' so that they should accord more perfectly with their setting, and it is not surprising that after taking such care he was infuriated when in 1889 a velum was suspended over the stairwell which was so 'stupidly opaque', and as he put it 'so soporific', that it destroyed the tonal value of the paintings.

PUVIS AND SYMBOLISM

In the 1880s Puvis began to use pastel as a medium far more often than he had before. He exhibited a number of such works at the 1888 exhibition of the *Société des Pastellistes Français*, an exhibition reviewed by Félix Fénéon, whom Puvis had two reasons to distrust – for his Symbolist velleities and his then fashionable Anarchism. However, Fénéon found accurately enough, though in terms disagreeable to the artist, that 'the mutually harmonised rhythm of colour and line constitute an art of dreams, of silence, of slow movements, of tranquil beauty'. To the Symbolists, the dream was not a theme to be illustrated but a mode of experience, poetic and visionary, Strindbergian or Carlylean, which gave access, like art itself, to 'truths undreamed of' by Naturalism. Yet although Puvis would never have associated his art consciously with the Symbolist's dream, his poetic transcription of nature lent itself to interpretation in these terms. Although their notions were not as far-fetched as their transcendental terminology would have it seem, their elaborate definition of what Puvis chose to consider so simple a thing as Art led him to say, in self-demeaning defence, 'I am an ignoramus. I know nothing of philosophy, history, science. I am only concerned with my profession.'

If Puvis's mature manner can now readily be seen to show up the fallacy that lies in simplistic and polemical distinctions between 'idealism' and 'naturalism' this was not always so at the time, when aesthetic distinctions were obscured by the claims of rival schools, to none of which Puvis 'belonged'. Symbolism laid a particular stress on the rôle of the 'idea' in art, even acquiring the alternative designation of 'L'Art Idéiste'. An unsigned newspaper obituary notice of the painter, in *L'Eclair*, 26 October 1898, affords a good example of the sort of misleading interpretation of his work to which this preoccupation gave rise and which discredited Symbolism in the eyes of the artist himself. 'The characteris-

tic of his talent', wrote the journalist, 'is to affirm the supremacy of thought over matter, which is no more than pretext and symbol.' The same Symbolist stress on the 'idea' is evident in Gauguin's comments on Puvis, but by choosing to restrict the meaning of the term as applied to Puvis to allegorical content, Gauguin changed condemnation into praise. By overemphasising the part played by the 'idea' in Puvis's work, both writers devalued and so denatured it, laying it open to the charge, which Puvis sought to avoid, that this was a 'literary' art. Gauguin thought that he himself evaded such a fault because in his Mallarmean 'suggestive' art the 'idea' remained mysterious and untranscribable, and so did Puvis for different reasons. He felt that his art whatever its spiritual value, was above all a beautiful, harmonious transcription of concrete nature; 'I have hidden nothing *behind* the canvas', he said.

Such was the fear of the 'literary' in Symbolist circles, however, that those who wanted to praise Puvis's work often found it necessary to explain away the content altogether, leaving behind nothing but the vaguest poetic afflatus. In devising his Sorbonne mural (Plate 74), Puvis was obliged to account for every figure as Muse, personification of an academic discipline or as the Alma Mater herself, a fact which clearly worried the nineteen year-old Maurice Denis. For him, this painting's virtue lay in its general evocation of mood, which made its allegorical function quite extraneous to its artistic value. In his famous essay of 1890 *Définition du Néo-Traditionnisme* he wrote 'the depth of our emotion is due to the ability of these lines and colours to speak for themselves, as only the divinely beautiful can'. A few years later André Mellerio expressed a similar view: 'at bottom the idea *emerges* from Puvis's works . . . rather than rigorously determining them. His scenes are not a direct, willed exposition of concepts, but they suggest them through the breath of emotion that they exhale.' Behind the diversity of views and of means employed to praise or to blame Puvis's art there was a shifting sense of the word 'idea'. For some, like Gauguin, it was above all a transcendental value, an adumbration of great truths and mysteries, so Puvis could be accused of failing to aspire so high. For others Puvis's 'thought' was in itself worthy of praise, while for yet others, like Denis, his 'ideas' were negligible in themselves and the poetry of his work was the product of a pure aesthetic vision.

These battles, such were the political implications of style at the time, were fought in official as well as in avant-garde circles. The committee planning the themes and awarding the commissions for the decoration of the rebuilt Hôtel de Ville in Paris showed at one meeting in 1887 a characteristic division into two parties, promoting respectively 'realist' artists like Roll and Gervex, and 'idealists', among whom Puvis was listed. But there was present one Monsieur Lavastre who must have been a man after Puvis's own heart. He bluntly remarked that every idea can contain a concrete instance, and every phenomenon may be the manifestation of an idea. Lavastre's attempt to silence the ideologists by cutting the Gordian knot in this way certainly meant begging all the questions, but to Puvis, with his love of *'le bon sens'*, no more complex formula would have been likely to appear desirable or necessary. He had neither an historical nor an artistic need to set meaning over matter, or *vice-versa*. His own conscious position was, as usual, pragmatic, and is clear enough in a passage from his interview with Paul Guigou where an attempt to define his aims led him to make a final comment on Symbolism. Although Guigou is likely to have tidied it up for publication, this passage, which follows a reaffirmation of the essential virtues of order and clarity, remains exemplary *'bons sens'*:

'there exists a plastic transcription of all clear ideas. But ideas usually come to us in a jumbled and muddy condition. So the first thing to do is to clarify them, to keep them suspended limpidly in the inner vision.

A work is born from a sort of confused emotion, where it is held like an animal in the egg. I turn the thought at the root of this emotion over and over in my mind, until it emerges with all possible distinctness. Then I look for a scene which will express it with precision, *but which will also be, or at least could be, a real scene*. That's symbolism, if you like, but with nothing arbitrary about it.'

Even though an idea was necessarily present in his art, what Puvis was here describing was a commitment to the primacy of the idea as a working method, not the 'idea' as a mystical value. This can be seen in the development of his works from sketchy *première pensées*, through studies, to the cartoon and the finished work. Essentially the same method was employed by Raphael or by Leonardo.

Like the Symbolists, Puvis feared the literary because it devalued both the plastic and the spiritual quality of a painting. His art does

'suggest' in the poetic sense, even though it is not a 'Suggestive Art', and he deplored mystery. Symbolism was a conscious effort to redefine and to develop the by then traditional romantic view of art, at a time when it had been recently challenged and momentarily displaced by the Naturalists. Puvis was mature enough not to wish for any new intellectual stimulus, yet his classical clarity of expression did not definitively exclude the 'poetry' admired by the Symbolists. This was implied by the critic André Michel when he wrote that Puvis had 'given us, in the simplest and clearest terms, what our modern Symbolists advertise and profess – but do not give us'. Puvis's affinity with the Symbolists was obscured by the self-conscious intellectualism of the movement, which alienated the painter they admired.

Puvis received the commission for his next large-scale decorative works, three murals for the stairwell of the new Museum of Fine Arts at Rouen, in February 1888. The main subject was *Inter Artes et Naturam* (Between the Arts and Nature), accompanied by *Pottery* and *Ceramics* (Plates 69, 70, 71) which were seen at the Salons of 1890 and 1891. At the same time his assistant Paul Baudoüin was asked to decorate the stairwell of the nearby city library in Rouen. The State contributed over half the offered payment of 25,000 francs for Puvis's three paintings. Puvis's old adversary Castagnary, now *Directeur des Beaux-Arts*, wished that they should be executed in true fresco. Shortly before his death in 1888 Castagnary went so far as to offer Puvis and Baudoüin a grant to visit Italy to study fresco techniques, with a view to the revival of this medium in France. The offer was not finally withdrawn until 1893, for though Puvis never took it up he seems to have been reluctant to reject it outright.

The museum at Rouen brought together collections of Antiquities, Fine Arts, and Ceramics, the last of which was an important local art, whose manufacture Puvis treated in what was for him an unusually illustrative manner in one of the smaller paintings. This illustrative mode is partially retained in the larger composition, in which Puvis treated the three major functions of the museum through scenes showing ceramic flower-painting, the excavation of antiquities, and artists sketching from nature. Puvis's attempt to adopt a more modern approach was carried further: his landscape is unusually precise, a view of the city and the Seine as seen from the higher ground at Bonsecours to the east of the city, a

126

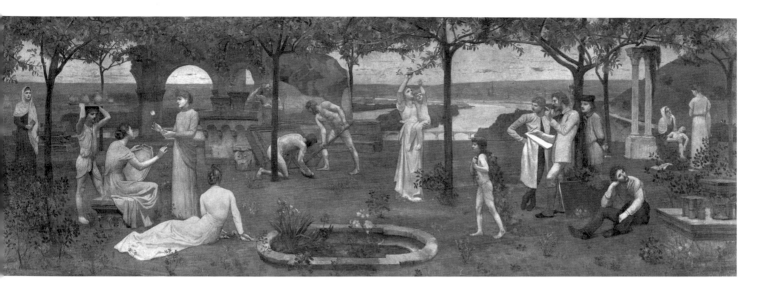

69. *Inter Artes et Naturam* 1890. Musée des Beaux-Arts, Rouen.

point noted by the authorities who afterwards constructed a small public park on or near the site of the painter's 'belvedere'.

It was a frequent complaint, in the more orthodox art theory of the nineteenth century, that contemporary costume was intrinsically unaesthetic, concealing the natural grace and the potential for rhythmic gesture of the human figure, and for this reason Puvis's illustrative compromise with the modern style of dress in these works caused alarm among some more traditional critics. The painter was well aware of the risk he was taking, but told Vachon that he thought that *Ceramics* proved that purity of gesture could be preserved. Van Gogh, who saw *Inter Artes et Naturam* at the Salon of 1890, expressed in a letter to his sister his idealistic approval of Puvis's new approach: 'One gets the feeling of being present at a rebirth, total but benevolent, of all the things one should have believed in, should have wished for . . . a strange and happy meeting of very distant antiquities and crude modernity'. Yet the feeling remains that Puvis here stepped outside his true *métier*, that despite the nobility of certain figures, among them one of his characteristic groups of a mother and child, they lack the comfortable, almost intimate sense of genre that the early works of Bonnard and Vuillard encapsulate.

But if these works represent a compromise on Puvis's part with the age in which he lived – with the 'refined' but not detached or classical

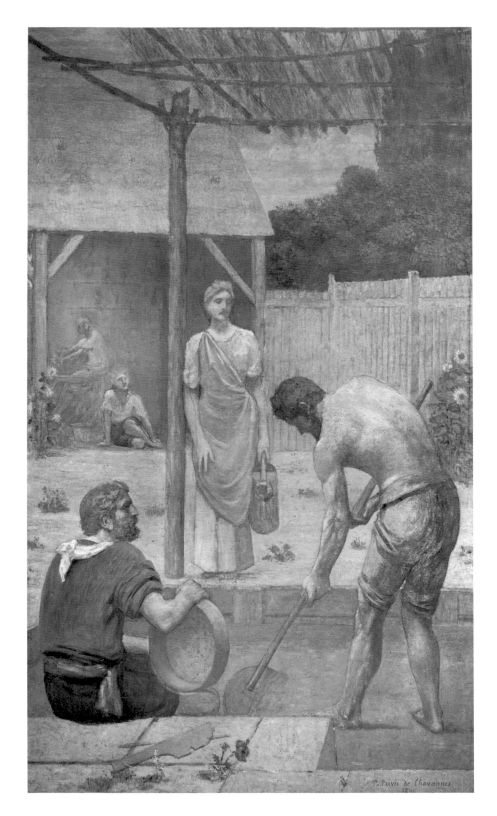

70. *Pottery* 1891. Musée des Beaux-Arts, Rouen.

71. *Ceramics* 1891. Musée des Beaux-Arts, Rouen.

spirit of the cultured middle-class – their colouristic effect is a masterly compromise of another sort. The cool and unified tones of the larger composition in particular are a perfect vehicle for the expression of this unemphatic allegory. With his habitual care for detail, Puvis specifically requested that the stairwell windows should themselves be glazed with 'frosted, but not tinted glass', for tinted glass would produce 'that appalling yellowish look' which would destroy the occluded tonality, a feeling for which was a predominant element in his sensibility.

The identification of Puvis with the Symbolist movement always tended to distort his art without misrepresenting it quite as radically as is sometimes claimed. But it certainly belies his conscious ambition and worse, implies an almost total disregard for the morality of his paintings. Despite the presence of certain Catholic Revivalist or more eclectic spiritualist tendencies, Symbolism seemed quite unconcerned with moral issues and tended to resort, as did Gauguin, to an irony which may well have implied the moral sense but which did so at the expense of conventional *idées reçus*. Even the Christian themes of Maurice Denis and Émile Bernard represent, at least at first, an attempt to achieve a primitive de-institutionalised religious sense, set carefully apart from the prevailing values of society as a whole. But there is nothing in Puvis's work, public or private, to suggest anything but a conventional attitude to religion and its place in society. Baudoüin mentions having called a priest to his master's death-bed 'knowing' as he said 'his mind'. He was committed to the attitudes of the traditional French patriot under the 'conservative republic', as it was known from a phrase of its first president Adolphe Thiers. But Symbolism acquired, generically, the reputation of a particularly extreme form of 'Art for Art's sake', and so it was possible for a writer who knew of Puvis's reputation as a Symbolist to attack him as a representative of an amoral modernism, as was the case with the article published in 1898 where a certain Muntz accompanied an appreciation of Tolstoy's moralising and in many ways Philistine *What is Art?* with a Tolstoyian dismissal of the 'decadent' advanced art of Baudelaire and Verlaine, Ibsen and Maeterlinck, Manet, Monet and Burne-Jones, Wagner, Liszt, Richard Strauss – and Puvis! The eccentricity of such a judgement is now self-evident, but it again confirms the misunderstanding courted by an artist who belonged to no school, who painted in a style that could seem aggressively modern

to some and naively primitive to others, and which in either case appeared to the more cursory conservative, to elevate form above content, just as the avant-garde found it to raise content or 'idea' above form.

That Puvis's art was deeply moral, though seldom didactic or moralising, is due to the fact that this morality lies less in explicit allegory than in the basic human language he consistently employed. In *Summer* (Plate VI), or the later treatment of this purely conventional theme at the Hôtel de Ville in Paris, the moral basis of Puvis's work is present in its purest state. Yet it is more implicit than overt, and, beyond the Parnassian ideal of the truth imminent in beauty, it is based on the sense of community, maternity, and leisure as the complements of work rather than as a self-sufficient way of life. Not even in the *Pleasant Land* (Plate XI) does Puvis adopt a hedonistic position. Like Matisse's, for all its idyllic aspect, this remains a land where work is necessary.

The moral force of the painter's work was of course widely recognised at the time. After speaking at *La Plume's* banquet in honour of Puvis, on 15 January 1895, the literary historian and Academician Ferdinand Brunetière was loudly abused by some of the avant-garde present. Their hostility can hardly have been provoked by his praise, then almost *de rigueur*, of the artist's revival of 'poetry' and 'ideas' after their 'supression' in the mid-century. Mallarmé's poem was read by the poet himself on this occasion:

Toute Aurore Même gourde
A crisper un poing obscur
Contre des clairons d'azur
Embouchés par cette sourde

À le pâtre avec la gourde
Jointe au bâton frappant dur
Le long de son pas futur
Tant que la source ample sourde

Par avance ainsi tu vis
O solitaire Puvis
De Chavannes jamais seul

De conduire le temps boire
À la nymphe sans linceul
Que lui découvre ta Gloire.

What was exciting was his additional comment that Puvis had 'given back to art its dignity and its social mission', with the implication that most of the avant-garde had singly failed to do any such thing. Brunetière was much nearer the truth than the more anarchic modernists in recognising in Puvis a moral, but not a moralising artist, but others thought to turn his art to more utilitarian ends. In 1896 a proselytising organisation called the *Union pour l'Action Morale* reproduced *The Childhood of Saint Genevieve* on posters all over Paris. *L'Echo de Paris* facetiously reported that these posters seemed to command the respect of the crowds on the Grands Boulevards, but that no conversions had been reported though they were at least immune from graffitti. Puvis cannot himself have harboured any illusion that his art would really prove capable of educating the *canaille*, nor was it designed to do so; the actively evangelical spirit is not often found together with the values of the *haute bourgeoisie* or with a tradionalist view of high culture. The values expressed by Matthew Arnold in his *Culture and Anarchy*, which can hardly have been known to Puvis, are of some relevance here. 'Culture goes beyond religion, as religion is generally conceived by us.' The book gives an accurate enough reflection of Puvis's position in this 'mid-Victorian' generation. As an artist he held the position described by Arnold as that of 'alien' to the 'Barbarian', 'Philistine' or 'Populace' classes, and led not by 'class' spirit, but by a general human spirit, and by the love of 'human perfection'. Arnold noted too what Puvis certainly exemplifies: that in almost all in whom this 'alien' spirit resides there is 'some quantity of class-instinct as well'. Rodin, Puvis's friend and portraitist, and one of the chief organisers of the 1895 banquet, might well have claimed that, 'it is enough to look at one of Puvis's masterpieces to feel oneself capable of noble actions'. But Rodin was from 1893 Puvis's co-president at the *Société Nationale des Beaux-Arts*, and planning what would be a posthumous monument to his friend. Rodin was himself speaking as the exponent of a high art which took its élite status for granted and was as opposed to the idea that culture can be radically democratised as were the more self-conscious and deliberately élite *petits cénâcles* of Symbolism.

The 'general human spirit' which is ever-present in Puvis's work was to be found again in his next decorative works, this time *Summer* and *Winter* (Plate 72) done for the Hôtel de Ville in Paris. They were exhibited

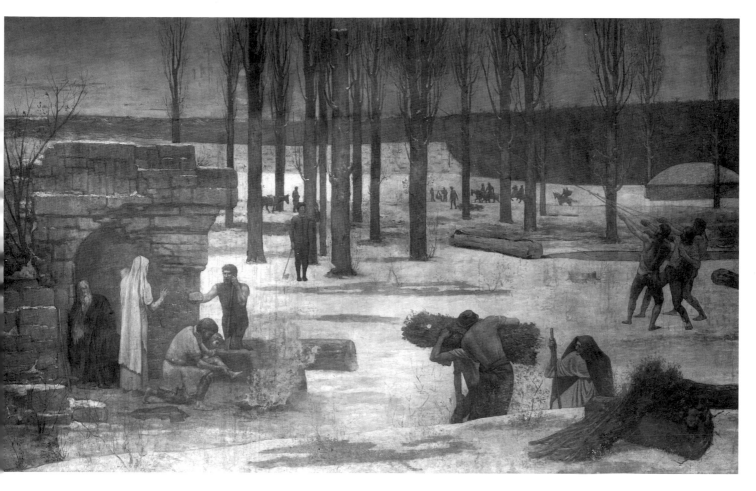

72. *Winter* 1892. Hôtel de Ville, Salon du Zodiaque, Paris.

at the Salons of the *Société Nationale* in 1891 and 1892 respectively. The famous sixteenth-century building had been burned down by the Communards in 1871, but was rebuilt to similar designs and in 1887 a commission met to consider the appointment of artists for its decoration and the themes they were to treat. Léon Bonnat, for whom Puvis had painted the *Pleasant Land*, believed, as Chennevières had when planning the decorations of the Panthéon, that the works commissioned should embody the essence of modern art and should together show future generations what was the French school at the end of the nineteenth century. The exclusion of the avant-garde was of course understood. Interestingly, before his death in 1883, Manet had offered to contribute, but had received no reply. Bonnat's ambitions were, from his conservative point of view, on the whole only too well fulfilled. The supporters of

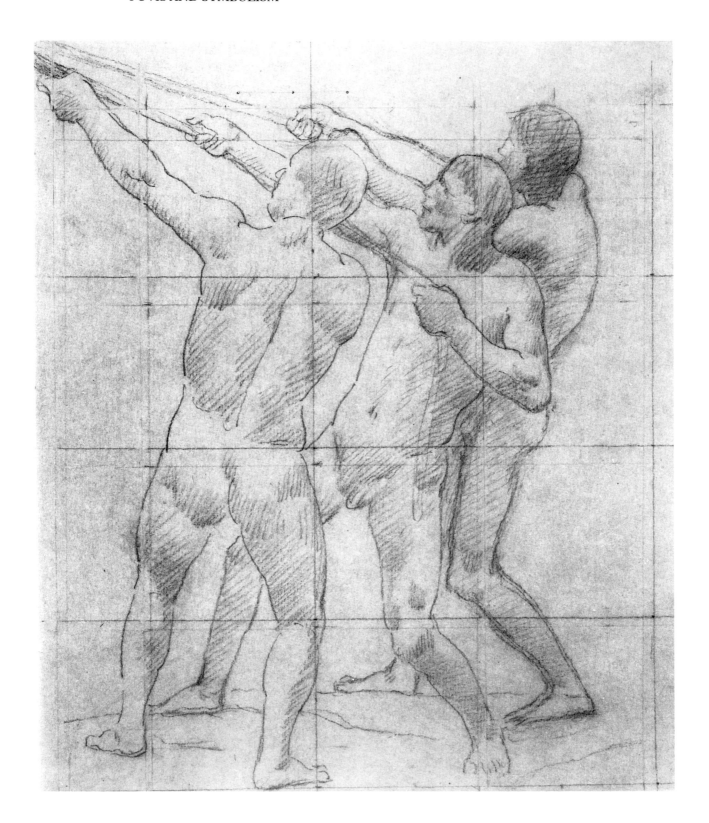

73. *Winter* (drawing of tree-fellers) 1892. Musée du Petit Palais, Paris.

Realism, among them Henri Rochefort, the former supporter of the Commune, looked to artists like Alfred Roll, Henri Gervex and Théodule Ribot; the supporters of Idealism looked to Bonnat, Jean-Jacques Henner, Bouguereau, Puvis and others. Puvis's work was certain to appear distinctive, at least, in such company.

Puvis was to decorate the *Salon laterale d'Introduction* or *Salon du Zodiaque*. This entrance lobby to the main reception rooms on the first floor owed its latter name to its equivalent in the original building which had housed a series of relief sculptures of the signs of the Zodiac by the great Renaissance sculptor Jean Goujon. Copies of these were to be set in the lower level of the walls and Puvis's themes were to be understood in relation to them. The copies were never set up and Puvis insisted on certain modifications to the initial scheme, which was for a frieze representing all four seasons: at his request the dado was lowered to permit him to create two larger compositions and four figures in the spandrels over the doorways, each amplifying one or other of the two larger scenes.

His subjects are conceived as a contrast between fecundity and self-sufficiency in Summer, where Puvis borrowed some ideas from his earlier painting on this theme (Plate VI), and the struggle to survive in Winter. In this painting a hunt is in progress in the background, but the charity offered by a woodcutter is the dominant motif. The curious device whereby the three tree-fellers haul on subsidiary cords attached to their main rope (Plate 73) was an invention of Puvis's to avoid what seemed to him the formal awkwardness of figures in single file. These are two of his simplest and most lucidly planned compositions.

THE FINAL DECADE

Democracy, positivist or materialist thought, and scientific progress were all things of which Puvis was suspicious. Some early schemes for decorating railway-stations or schools with modern imagery never bore fruit, and it is not surprising that when he did try to modernise his imagery, as in Physics at Boston (Plate 78), he only succeeded in demonstrating the incompatibility of such a theme with his broader manner and allegorical approach. These telegraph poles bearing good and bad news do not constitute a 'timeless' image and can only appear a

discordant note in the context of Puvis's simple yet universal language of humanity.

Yet in the preceding decorative work, *La Sorbonne*, he had been obliged to find allegorical means of representing the Sciences as well as the Arts. Puvis was commissioned in 1886 to paint this work (Plate 74) to decorate the hemicycle behind the rostrum in the newly constructed Grand Amphitheatre, the largest auditorium in the university. He was at first unwilling to accept the task, finding the project of allegorising the Arts and Sciences too similar to that which he had undertaken at Lyons, and the offered payment of 35,000 francs unappealing. But by December he had completed his design, and had agreed upon the elaborate pro-

74. *The Sciences and the Arts* 1889. Grand Amphitheatre, Sorbonne, Paris.

gramme of the work with the authorities. The cartoon was ready for exhibition at the Salon of 1887. The work itself was installed in time for the official inauguration of the new Sorbonne in August 1889, on which occasion Puvis was invested Commander of the Legion of Honour by President Sadi Carnot. Thus he entered his last, Olympian, decade.

The central section of the composition is another 'Sacred Grove' where the Alma Mater, the Sorbonne herself, is presented in the guise of a secular Virgin. The expression was used by Puvis himself, who showed her flanked by two genii and presiding over a gathering of Muses, among whom Eloquence occupies the most prominent place. In the foreground Youth and Age refresh themselves at the springs of Wisdom. (When in 1897 a mineral water bottler from Amiens requested to be allowed to use these three figures as the basis of the design on his bottle labels, he was refused by the Ministry.) The academic disciplines allegorised to the left are History (a formulation essentially the same as that which Puvis had employed at the Hôtel Vignon), and Philosophy, identified by four figures personifying Spiritualism and Materialism (with a flower), Pessimism (contemplating a skull) and Doubt. On the right are the Sciences: first the Natural Sciences represented by two lightly draped female figures standing for Geology and Marine Biology, with the appropriate attributes of crystal and coral, and accompanied by Mineralogy, a woman old as the world itself, but 'solidly built' as Puvis put it, and Botany, a figure based on Ingres's *Valpinçon Bather*. The next group, placed slightly further back, represents Physics, 'a sort of mysterious Isis', said Puvis, 'who unveils herself only to initiates, the ardent, the enthusiasts, the convinced'. This was a formulation showing unexpected affinities with the mystical aspiration to unite science and spiritualism which marked the Theosophical movement at that time. Lastly come the Mathematical Sciences, represented by three figures absorbed in a geometrical problem.

The most obvious prototype for a work of this kind was the enormous *Artists of Every Age* painted by Paul Delaroche in 1841 for the hemicycle at the *École des Beaux-Arts* (Plate 75). The overall tripartite arrangement, over which Delaroche's figures of Ictinos, Apelles and Phidias preside, as does Puvis's 'secular Madonna', is similar and what this comparison brings out most forcefully is the importance of the part played by

75. DELAROCHE: *The Artists of Every Age* (detail of central section) 1841. Hemicycle of the École des Beaux-Arts, Paris.

landscape in Puvis's decorative works. There was certainly a symbolic element in this landscape, as well as a pragmatic element in its overall design. This is another privileged environment like the hidden valley in which the Muses appear in *The Sacred Grove* at Lyons (Plate XVI), and the distant line of trees forms an arc which reflects the form of the hemicycle itself. But it was the poetry of pure form and of subtle colour, the extensive range of muted tones set against a dull golden sky, and hardly the academically allegorical content, that assured its popularity among the younger artists of the time. The Symbolists preferred either to

139

commission's vote of nineteen to only one for Puvis. It was only on Delaunay's death in 1891 that the commission was offered to Puvis. His general theme, inherited from Delaunay, was to be *The Glory of Paris*, to be interpreted in his own way, and he was to be paid 85,000 francs or 10,000 francs more than he had offered for the Salon du Zodiaque.

The area to be decorated consisted of the ceiling itself and fifteen subsidiary surfaces on the coving and the lunettes of the vault. In 1892 he described his subject for the central section in these terms: 'The city of Paris, crowned by Letters, Sciences and Arts accepts the homage of the immortal poet who extolled her virtue, Victor Hugo offers her his Lyre . . . behind him appear three winged figures who symbolise the essence of his work: Lyric Poetry, Legend or the Novel, and Drama. Beneath the portico, a group of youths waving palms forms the city's retinue. One is writing in the Golden Book, and another holds the banner on which is inscribed the city's glorious title, created by Victor Hugo: Paris, city of light, and the genius that is her glory.' This programme was precisely followed in the final work (cf. the finished work (Plate 76) and the sketch (Plate 77)).

The surrounding allegories of the Virtues of Paris represent, reading from left to right, in the four large covered sections around the sides and base of the main composition: Paris as home of the intellect; Patriotism (a colonial soldier in a pith helmet holding his regimental colours, departing for the lands toward which Paris directs him); Charity; and Enthusiasm for the Arts (with students gathered beneath the *Crouching Niobid*). The other two large panels depict Fame and Industry, and in the small triangular panels between the windows are personifications of medieval and modern Paris. The seven lunettes symbolise, from left to right: Elegance, with a peacock and a child holding a mirror; Urbanity, an old woman offering flowers to a young girl; Intrepidity, a rescue from the sea; Generosity, Paris dispensing largesse for distribution by two winged genii; Memory, candles perpetually relit before a tomb; Wit, a girl reading to another, beside whom lie a copy of Beaumarchais; and Imagination, a bird taking wing, pointed out by a reclining woman to a child.

This elaborate scheme was not on the whole well received. The moderate contemporary criticism of Georges La Fenestre may stand as

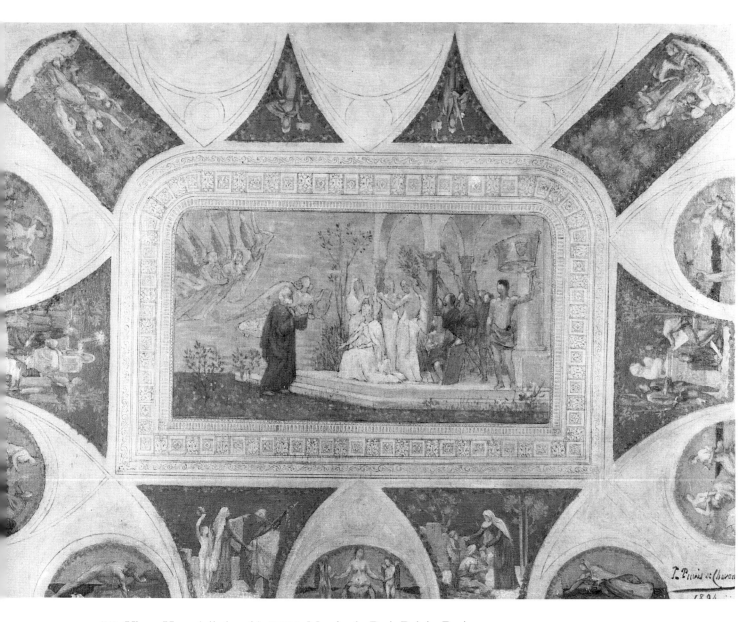

77. *Victor Hugo* (oil sketch) 1894. Musée du Petit Palais, Paris.

representative: 'We may well regret that Puvis has not found a clearer, more modern and more French way of characterising not only the extraordinary personality of Victor Hugo, but also the individuality of all these symbolic images which surround him'. Such a project was bound to reveal the relative poverty, the institutional rectitude, of Puvis's imagination in its purely allegorical guise. He was also constrained by the necessity for the first time in his life to paint a ceiling, a task over which he

had serious qualms, not least because it was customarily approached at the time, as indeed it was elsewhere in the Hôtel de Ville by Bonnat, in the Baroque illusionist manner. This approach was anathema to Puvis, and in rejecting it he went to the other extreme and produced the most 'primitive', in the Early Renaissance sense of the term, of all his large compositions, and one in which he could not exploit his usual poetic feeling for landscape. That the work is indeed executed in bright, enamel-like colours no doubt reflects the fact that Baudry had been the architect's original choice, since his light, decorative painting was felt especially suitable for this setting. For all its professional ingenuity this remains the least satisfying of Puvis's mature decorative works.

Puvis's relative failure with the Victor Hugo ceiling was no doubt due in part to his abdication from his own principles of independence and from the roots of his own sensibility. That he was himself conservative by both temperament and conviction cannot be doubted. His private income enabled him to pursue his career without, as a rule, compromising his beliefs, to accept public commissions for modest payment, and even to donate some of his works to the new museum at Amiens in order to ensure the unity of his decorative scheme there. His self-sufficiency also enabled him to turn down commissions more easily, as he did in 1879 when offered the task of decorating the staircase at the Bourse in Bordeaux. On that occasion he refused the commission on the grounds that he was not being permitted complete freedom in the choice of his theme. Ten years later he declined a State commission to paint an '*Apotheosis of the French Revolution*' – probably intended for the still undecorated apse of the Panthéon – on more political grounds. 'Initially this great movement was an apotheosis of practical Christianity, but too many events falsified this principle', he wrote to a friend. Its initial Christian impulse had become perverted by the 'politics of hate and envy'. Like Degas, Puvis was strongly anti-Dreyfusard during the notorious *affaire*, but he was not a politically sophisticated man, and this stance is best understood as a symptom of outraged and indeed rather naive patriotism. This patriotism, manifested in his work in a positive form, appeared negative and chauvinistic in his refusal to exhibit in Berlin in 1890, in his letter written in 1895 in support of Pasteur, who had refused to accept a German decoration, and through his facetious claim that in the spot wherein most

humans the heart resides there was often to be found in Germans nothing but a glass of beer. To be anti-Prussian was common enough at the time, and many Frenchmen, not necessarily of the Right, longed for revenge after the *débâcle* of 1870–71. Puvis's politics are more clearly evident in his earlier attitude to England, which, he told Berthe Morisot, had disgusted him on an early visit, and on another occasion he vented his spleen against those 'selfish, hypocritical, tiresome and treacherous English', provoked apparently by the ease with which former Communards, as opposed to members of the ex-Imperial family, had been able to find refuge there.

The nationalistic aspect of Puvis's nature makes it the more surprising that his next, and penultimate, decorations should have been made, uniquely, for another country. *The Inspiring Muses Acclaim Genius, Messenger of Enlightenment*, and its attendant works came about after Puvis was asked in 1891 to contribute to the decoration of the new public library in Boston, U.S.A. which was built to the designs of McKim, Meade and White. He was at first unwilling to accept the commission, being fully occupied with his work for the Hôtel de Ville, and in a letter of about this time quoted by Vachon he expressed the wish thereafter to 'enjoy a rest ... enlivened by work in a number of pictures in which I can indulge my imagination'. These works would no doubt have been easel-paintings, but they were not forthcoming for the Boston architects were very persistent, and were able to offer not only the liberty to choose his own themes, on which Puvis always insisted, and a payment of 250,000 francs, far more than he had received for any other work, but they also declared themselves prepared to wait for as long as he found necessary. In July 1893 he signed a contract to provide nine works to decorate the main stairwell. Puvis devised a scheme according to which the eight panels in the blank arcades on either side of the staircase on the upper level (three on the lateral walls and one on the re-entrant wall behind the main façade in each case) were to contain the general themes, suitable for such a building, of History, Philosophy, Poetry and Science; the five bays in the rear wall of the vaulted upper landing, pierced by a door into the main body of the building, were to be treated as a single composition, which was evidently derived from Raphael's Vatican *Parnassus*, and in which the nine Muses on a hill-top planted with oak and laurel greet the Spirit of

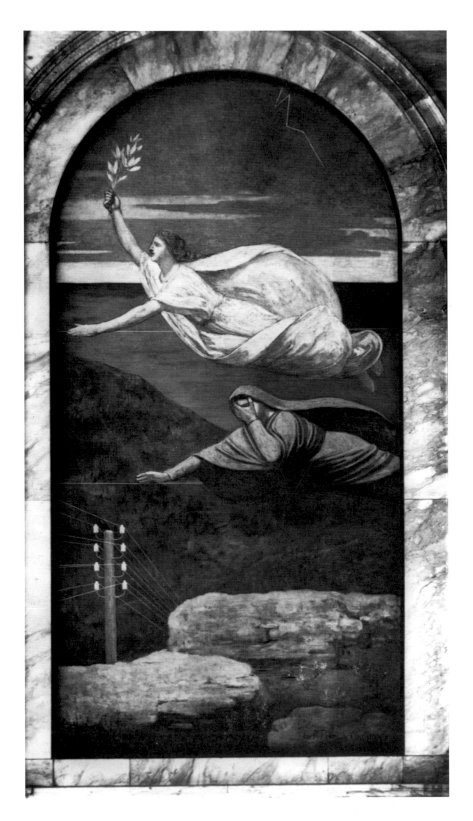

78. *Physics* 1896. Boston Public Library.

Illumination. Figures personifying Study and Meditation, more abstractly conceived than those he had painted for Amiens thirty years before, flank the doorway to each side.

The compositions on the walls to the left are primarily emotional, and those on the right more intellectual in their implications. Physics (Plate 78), on the left re-entrant wall, was described in a pamphlet explaining Puvis's programme as, 'The marvellous agent of electricity; speech traverses space with the speed of lightning, carrying good or bad news'. Next comes the Virgil of the *Georgics* (Plate 79) with his beehives; then Aeschylus and his vision of *Prometheus Bound* and the chorus of *Oceanides* (Plate 80), and Homer attended by a military personification of the *Iliad* and a nautical figure, with an oar, symbolising the *Odyssey*, both with branches of laurel (Plate 81). Chemistry (Plate 82), on the right re-entrant wall was explained as, 'the occurrence of a mysterious transformation under the wand of a spirit and among attentive genii'. An animal's skull, no doubt likewise symbolic of the transformations of matter, lies in the foreground, this panel is followed on the lateral wall by History, accompanied by another genius bearing the torch of illumination, and contemplating some buried ruins. Here Puvis considered the discipline in archaeological terms, as he had already done at the Hôtel Vignon and at the Sorbonne. Astronomy (Plate 83) represents the mythical origins of the science among the 'Chaldean shepherds [who] watch the stars and discover the laws of Number'. And finally, Philosophy (Plate 84) shows Plato in a stoa beneath the Parthenon, with a gesture evocative of his belief that, 'man is a plant born of Heaven, not of the Earth'. This Plato bears a remarkable resemblance to the Victor Hugo at the Hôtel de Ville.

Puvis had been given a model of this interior to help him formulate his design, and with his usual care requested a piece of the red Sienna marble with which it is clad to help him establish the tonality of his works. But he never saw them *in situ*, sending his assistant Victor Koos to oversee their installation. They were generally well-received, both in America and in France where they were exhibited at the Salons of 1895 and 1896, and where *Philosophy*, *Chemistry* and *Physics* could be seen at Durand-Ruel's in the autumn of the latter year. And with the exception of the unfortunately conceived Physics and the rather superficially imagined *Inspiring Muses* (Plate 85), where the predominance of etiolated, heavily draped

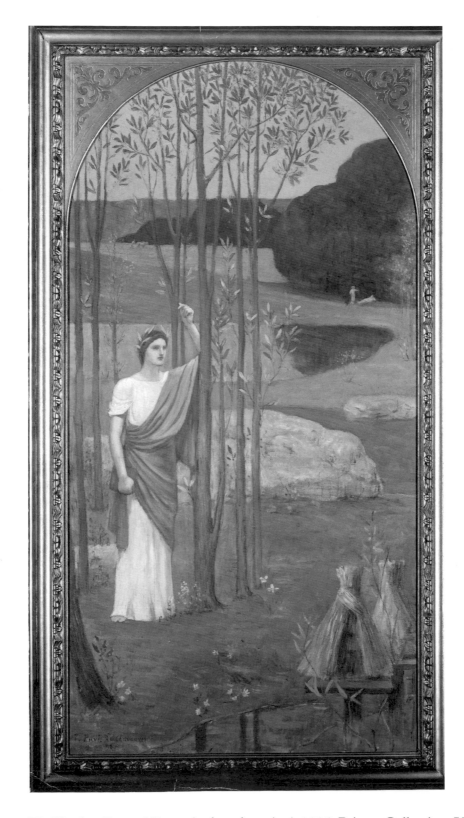

79. *Virgil or Pastoral Poetry* (reduced version) 1896. Private Collection, U.S.A.

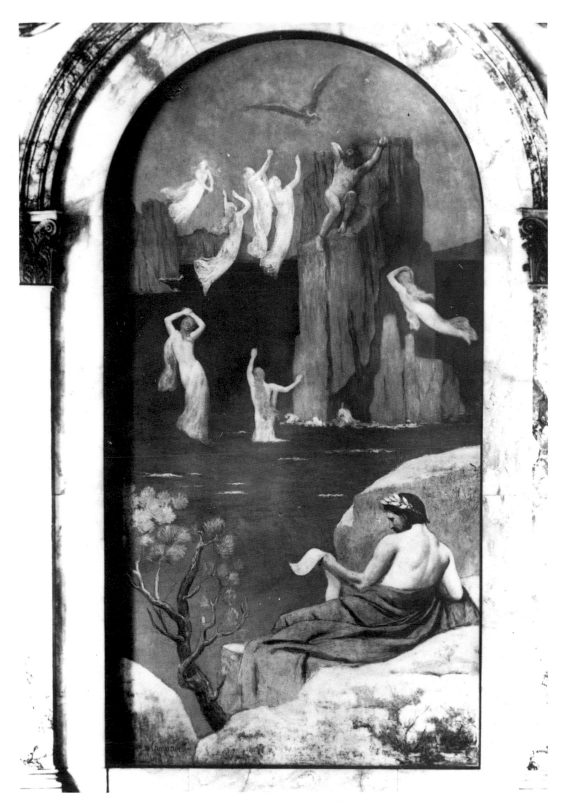

80. *Aeschylus or Dramatic Poetry* 1896. Boston Public Library.

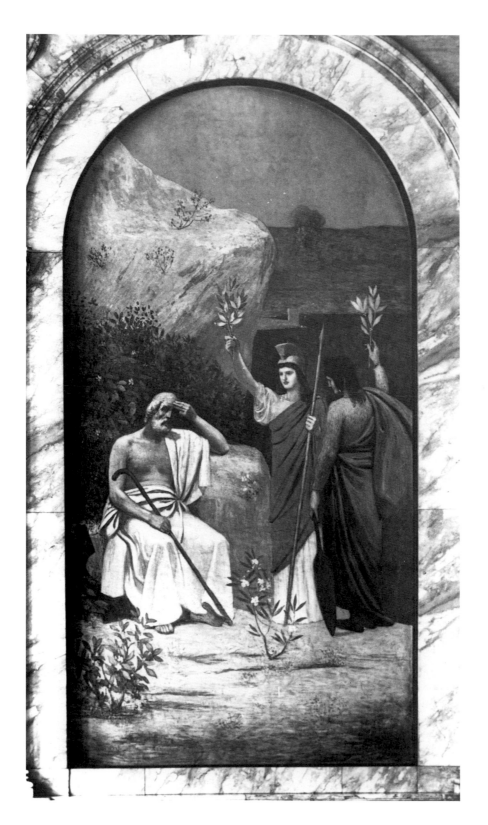

81. *Homer or Epic Poetry* 1896. Boston Public Library.

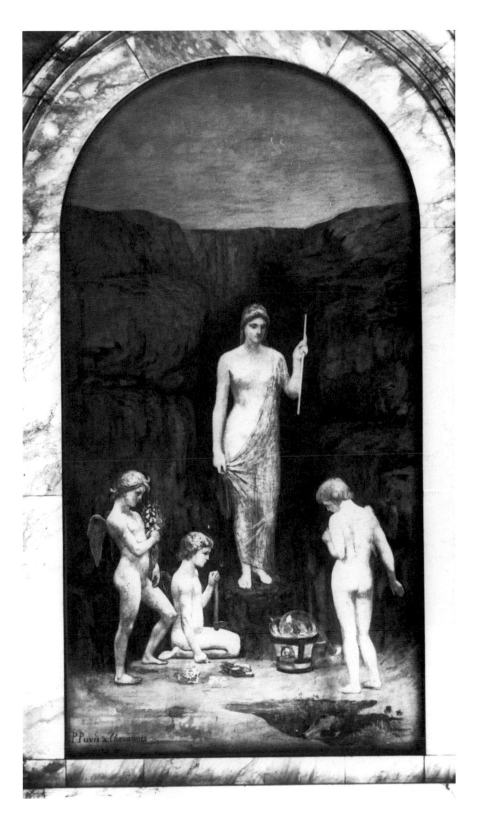

82. *Chemistry* 1896. Boston Public Library.

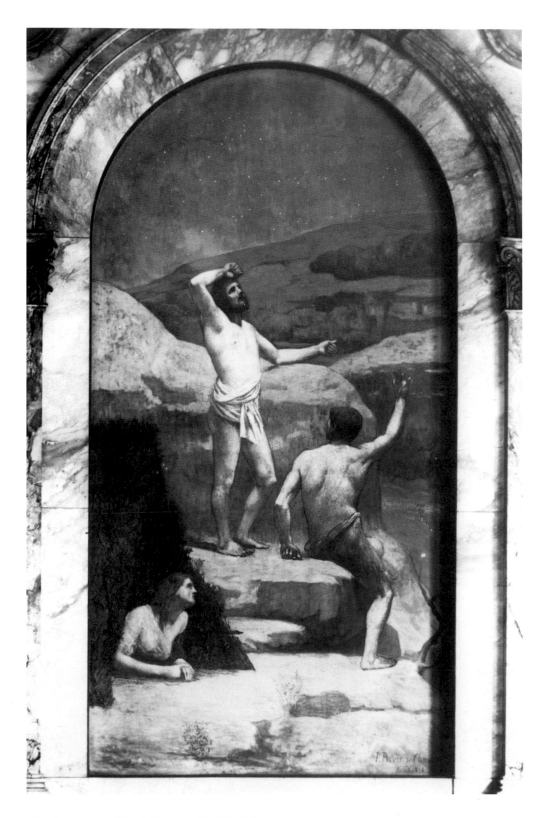

83. *Astronomy* 1896. Boston Public Library.

84. *Philosophy* 1896. Boston Public Library.

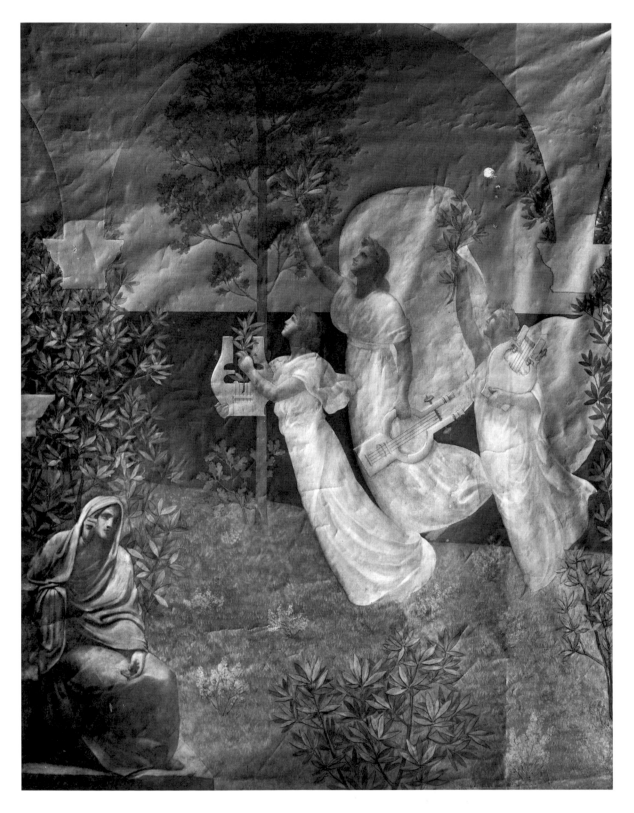

85. *The Inspiring Muses* (detail) (Cartoon) 1895. Opéra-Comique, Paris.

figures prevented Puvis from turning his figurative gifts to best advantage, the simplicity and natural dignity of these works is memorable and apposite.

Puvis's somewhat childlike resentment of the Germans takes another form in his caricatures, whose humour is rather less sophisticated, albeit more various, than the similar diversions of his near contemporary Burne-Jones. Puvis liked it to be known that most of these were done to pass the time on such occasions as the deliberations of Salon Juries, and was vain enough to permit the publication of some of these squibs, which spare neither the clergy nor the military, during his lifetime. It is tempting to see Puvis as an innocent preserving in his life, as in his art, a cautious distance between himself and his times, and was more easily seduced, as a result by attitudes so simple as to verge on the simplistic. Yet as has already been noted he was a man of wide culture, and there was in particular one contemporary writer in the second half of his career, the far from naive Ernest Renan, whom we know Puvis to have admired, and whose political and social outlook affords close similarities with his own. Renan's son Ary became Puvis's friend and assistant, though in this case their political views seem to have diverged. Renan's assertion that 'all civilisation is the work of aristocrats', meaning an intellectual and cultural élite, is not at all the same thing as Matthew Arnold's 'Barbarians'; and his scepticism over universal suffrage, seems quite consistent with Puvis's own views. More particularly, there is a letter of June 1871 in which Puvis appears precisely to echo the argument for the reform of the army and for universal conscription put forward by Renan in his famous *La Réforme intellectuelle et morale*, which was published in that year as a reflection on France's defeat and the remedies which might be sought to remove its causes. A characteristic passage from Renan's book even reads as an anticipation of *Saint Genevieve's Vigil* (Plate XVII), Puvis's last and most truly popular painting, whose theme, unlike that of its companion piece the *Provisioning* (Plates 86–88), had been wholly conceived by the artist himself 'A nation', Renan had written, is not a simple agglomeration of the individuals who compose it – it is a spirit, a consciousness, a being, and a living product of these things. This spirit may exist in a very small number of men . . . a head which watches and meditates while the rest of the nation does not think at all and barely feels.'

In the original programme of decorations for the Panthéon drawn up

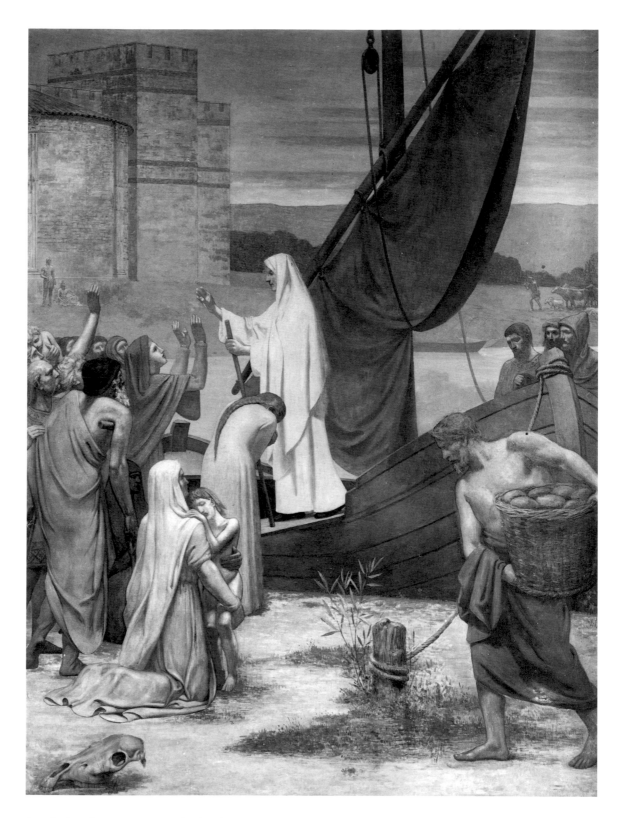

87. *Saint Genevieve Provisioning Paris* (centre section) 1897. Panthéon, Paris.

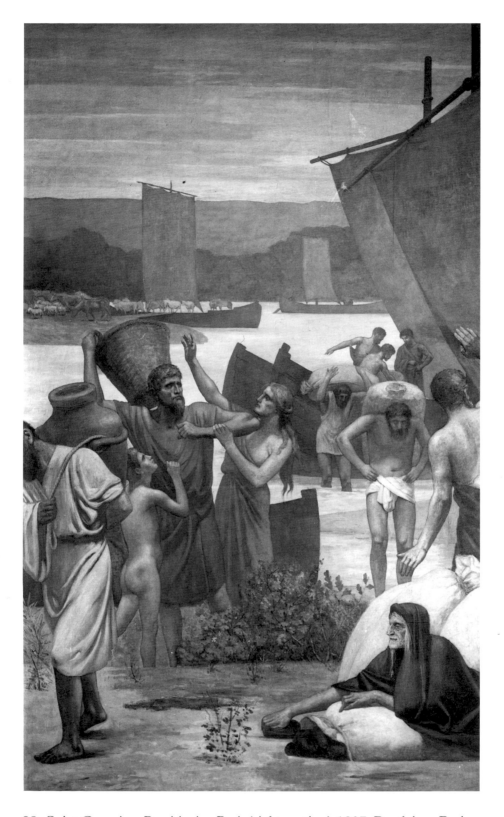

88. *Saint Genevieve Provisioning Paris* (right section) 1897, Panthéon, Paris.

of all his works and was much reproduced. It owed some of its success to the well-known fact that Princess Cantacuzène had modelled for the Saint, though she certainly did so for the *Provisioning* as well. Puvis had at last married her in 1897, and her death preceded his by a bare two months. Puvis was himself conscious that these were to be his last works. As early as 1893 he had written to Buisson that he intended to make them his 'testament'. It was natural that he should have asked for them to be installed at the west end of the Panthéon opposite his earlier cycle of works there, but this was of course impossible (part of this space was to be occupied by a work of his old customer and rival Bonnat). Puvis was unable to complete his work on the section of frieze to be placed above these works before his death, and this was finally carried out by his pupil Victor Koos as late as 1922, according to Puvis's designs, but in an inconsistent, suavely treated manner that lacks the simple vigour of Puvis's own works.

Marie Cantacuzène's role in the *Vigil*, as distant protectress of a sleeping people, may be felt to suggest a parallel with that of the artist himself in relation to his time. He was an upholder of principle, who avoided intimate contact with the world, perhaps finding it easier to love humanity than to admire human beings, and indeed whose disdain for the mob 'characteristic of the masters', was noted in a pen-portrait of Puvis in 1891. The combination of warmth, of maternal intimacy and empathetic figure style with distance in his work, seems consistent with the few observations of his personality made by those who knew him. They noted his 'air of a courteous high official with a rather distant manner' and his distinguished, serious appearance 'like a fashionable doctor'. The formal presence in Leon Bonnat's portrait (frontispiece) was that which he wished to present to the world, though, as Degas told Rouart on seeing this painting at the Salon, 'Chavannes . . . has the bad taste to show himself perfectly dressed and proud, with a fat dedication in the hand where he and a massive table with a glass of water are posing (*style Goncourt*)'. Puvis was annoyed, much to the sculptor's chagrin, by Rodin's first project for a portrait bust which showed him in heroic nudity, insisting that he be portrayed in his stiff collar and frock coat. Rodin later described the painter as he recalled him at the time: 'The head was held high, and his skull, firmly formed and well rounded, seemed

designed to wear a helmet. His curving chest looked well accustomed to carry armour. It was easy to imagine him fighting beside François I at Pavia, for the honour of his country.' In another of his characteristic veins however, Degas compared Puvis, according to Berthe Morisot in 1869, with the 'Condor in the Jardin des Plantes'.

This rather forbidding personality was also easily wounded; Marius Vachon was not the only writer to record how sensitive he could be, as late as 1883, to hostile criticism of his work. Paul Baudoüin remembered Puvis for his great kindness and for his joviality at his gargantuan dinners, for Puvis habitually went without a working midday meal. From Suzanne Valadon, who often modelled for Puvis in the 1880s we hear that he was wholly charming and as fastidious as a woman. His humour, to judge from his caricatures, and from descriptions of the painted sets he made for private theatricals at Gautier's house in Neuilly in the early 1860s, was rather ponderous. He turned down ensuing offers of work for the theatre.

If so few glimpses do little to modify Arsène Alexandre's conclusion, writing the year after Puvis's death, that the history of his life comes to little more than the history of his works; if indeed the relative scarcity of biographical information, as compared with what we know even of the reclusive Cézanne, for instance, seems consistent with the painter's own expression in a letter quoted by Vachon, of his 'enormous need for solitude and silence'; then it seems legitimate to reaffirm that Puvis, despite his wide acquaintanceship and official position, often found it a rather disagreeable duty to accommodate himself to the world in which he lived. His almost fanatical dedication to his work was noticed by most of those who knew him and was to his admirers poignantly confirmed by his struggle, bereaved and in ill-health, to complete the *Provisioning* before his death. In his work, Puvis could find what, through that same work, he could express – a necessary distance. Only at a distance, and with the degree of detachment it affords, could he create the classical sense of unified aesthetic and socially ideal order which made his art a beautiful and even exemplary expression of the spiritual aspirations of an 'alien' bourgeois in the 'bourgeois century'. He was far from immune to worldly ambition but, like Marcus Aurelius, whom he admired, he was at heart an innocent. His best works touch the broader vision without sacrificing contact with nature herself.

CHRONOLOGY

1824	14 December, born in Lyons
1846	First visit to Italy
1846–47	Studies in Henri Scheffer's atelier
1848	Second trip to Italy
	At end of the year spends about two weeks in Delacroix's studio
1849	Studies in Couture's atelier
1850–51	Accepted at the Salon for the first time
1854–55	First mural decorations executed for the dining room of his brother's house at Le Brouchy:
	The Miraculous Draught of Fishes (Spring), *Ruth and Boaz (Summer)*, *The Invention of Wine (Autumn)*, *The Return of the Prodigal Son (Winter)*
1861	First phase of the Musée des Beaux-Arts, Amiens: *Bellum* and *Concordia*
1863	Second phase of the Musée des Beaux-Arts, Amiens: *Work* and *Rest*
1865	*Ave Picardia Nutrix* (for Amiens)
1867	*The Dream*
	Made Chevalier of the Legion of Honour
1867–69	Decorative panels for Musée de Marseilles, *Massilia, Greek Colony* and *Marseilles, Gateway to the Orient*
1870	*Saint Mary Magdalen in the Desert (The Magdalen at Sainte-Baume)*, *The Execution of Saint John the Baptist*, *The Balloon*
1870–71	Joins the National Guard
1871	*The Carrier Pigeon*
1872	*Hope* (nude and clothed versions)
1873	*Summer* (Musée d'Orsay, Paris)
1873–75	Decoration of the Hôtel de Ville, Poitiers
	Charles Martel, Conqueror of the Saracens and *Saint Radegonde at the Convent of Sainte-Croix*

Jacques Foucart. Contributions by Marie-Christine Boucher and Douglas Druick and introductory essay by Aimée Brown Price.

Price, Aimée Brown, *Puvis de Chavannes: A Study of the Easel paintings and a Catalogue of the Painted Work.* Unpublished Doctoral Dissertation, Yale University, New Haven, Conn., 1972.

Price, Aimée Brown, *L'Allegorie reéle chez Puvis de Chavannes.* Gazette des Beaux-Arts, LXXXIX, January, 1977.

Riotor, Léon, *Puvis de Chavannes.* Paris, 1914.

Rood, Lily Lewis, *Puvis de Chavannes, a sketch.* Boston, 1895.

Roujon, Henry, *Puvis de Chavannes.* Paris, n.d. (c.1911–12).

Scheid, Gustave, *L'Oeuvre de Puvis de Chavannes à Amiens.* Paris, 1907.

Tapley, George Manning Jnr., *The Mural Paintings of Puvis de Chavannes.* Unpublished Doctoral Dissertation, University of Minnesota, 1979.

Thévenin, Léon, *Puvis de Chavannes.* Paris, 1899.

Thiébault-Sisson, François, *Puvis de Chavannes raconté par lui- même*, Le Temps, 16 January, 1895.

Tougendhold, Jacobà, *Puvis de Chavannes.* Saint Petersburg, n.d. (c.1915) (in Russian).

Vachon, Marius, *Puvis de Chavannes.* Paris, 1895.

Vachon, Marius, *Un maître de ce temps: Puvis de Chavannes.* Paris, n.d. (1900).

Werth, Léon, *Puvis de Chavannes.* Paris, 1926.

ADDENDUM

Mitchell, Claudine, *Time and the Idea of Patriarchy in the Pastorals of Puvis de Chavannes.* Art History, vol. 10, no.2, June 1987.

Pierre Puvis de Chavannes, Exhibition Catalogue by Aimée Brown Price with contributions by Jon Whiteley and Geneviève Lacambre. Van Gogh Museum, Amsterdam, 1994.

The most comprehensive Bibliographies are to be found in the 1977 Paris/Ottawa and 1994 Amsterdam catalogues.

166

LIST OF PLATES

Black and White Plates

Works are by Puvis de Chavannes unless otherwise stated. Measurements are given in inches and centimetres, height before width. Medium is oil on canvas unless otherwise indicated.

Frontispiece - BONNAT: *Portrait of Pierre Puvis de Chavannes*. 1882. Private Collection, France.

1. CHASSÉRIAU: *Princess Cantacuzène*. 1856, pencil. Private collection, London.

2. MILLET: *Harvesters Resting*. Salon of 1853, 24¾ × 47⅛ in. (62.8 × 119.9 cm.). Museum of Fine Arts, Boston.

3. *Ruth and Boaz* (Decoration for the dining room at *Le Brouchy*) 1854–55, 98⅜ × 87⅜ in. (250 × 222 cm.). Private collection, France.

4. *The Return of the Prodigal Son* (Decoration for the dining room at *Le Brouchy*) 1855, 99¼ × 126⅛ in. (252 × 322 cm.). Private collection, France.

5. *The Miraculous Draught of Fishes* (Decoration for the dining room at *Le Brouchy*) 1854–55, 98⅜ × 80¾ in. (250 × 205 cm.). Private collection, France.

6. *The Return from the Hunt* 1859, 135⅞ × 116 in. (345 × 295 cm.). Musée des Beaux-Arts, Marseilles.

7. *The Execution of Saint John the Baptist* 1856, 55 × 35⅜ in. (140 × 90 cm.), oil on wood. Museum Boymans-van Beuningen, Rotterdam.

8. *Meditation* 1857. Present whereabouts unknown. (Stolen from the artist during the siege of the Commune in 1871).

9. *Jean Cavalier playing the Luther Chorale for his dying mother* 1851, 54⅛ × 70⅞ in. (138 × 180 cm.). Musée des Beaux-Arts, Lyons.

10. *The Village Firemen* 1857, 69¼ × 89 in. (176 × 226 cm.). Hermitage Museum, Leningrad.

11. *Portrait of a Woman* 1852, 13¾ × 10½ in. (35 × 27 cm.), oil on wood. Musée des Beaux-Arts, Algiers.

12. *Self-Portrait* 1857, 26⅛ × 21½ in. (65.5 × 54.5 cm.). Musée du Petit Palais, Paris.

13. *The Martyrdom of Saint Sebastian* 1862, (Etching after the painting of 1857), 12 × 9¼ in. (31 × 23.4 cm.). Bibliothèque Nationale, Paris.

14. CHASSÉRIAU: *The Trojan Women* 1841, 66⅛ × 85 in.(168 × 216 cm.). (Destroyed in Budapest in 1945).

15. *Concordia* 1861, 141¾ × 214½ in. (360 × 545 cm.), oil and wax on canvas. Musée de Picardie, Amiens.

16. *Bellum* 1861, 141¾ × 214½ in. (360 × 545 cm.), oil and wax on canvas. Musée de Picardie, Amiens.

17. CHASSÉRIAU: *Peace* (Fragment of the Cour des Comptes decorations), 1844–48, 133⅞ × 142½ in. (340 × 362 cm.), oil on plaster transferred to canvas. Louvre, Paris.

18. CHASSÉRIAU: *War* (study), 1844–48, 17¼ × 24½ in. (44 × 61.9 cm.), pencil, black chalk, and white highlights on cream paper. Louvre, Paris.

19. CHASSÉRIAU: *War* (*The Blacksmiths*), 1844–48 (Fragment of the Cour des Comptes decorations), 32⅞ × 44⅞ in. (83.5 × 114 cm.), oil on plaster transferred to canvas. Louvre, Paris.

20. *Rest* 1863, 141¾ × 214½ in. (360 × 545 cm.), oil and wax on plaster. Musée de Picardie, Amiens.

21. *Work* 1863. 141¾ × 214½ in. (360 × 545 cm.), oil and wax on plaster. Musée de Picardie, Amiens.

22. The Amiens Cycle *in situ* (Left: *Pro Patria Ludus*, Centre: *Work*, Medallion: *Study*, Right: *Ave Picardia Nutrix*).

23. *Work* (study), 1863, 20¾ × 36 in. (53 × 91.3 cm.), charcoal. Musée de Picardie, Amiens.

24. *Rest* (study), 1863, 17 × 30¼ in. (43.3 × 76.8 cm.), red chalk and pencil on cream paper. Louvre, Paris.

25. *Autumn* 1864, 112¼ × 89 in. (285 × 226 cm.). Musée des Beaux-Arts, Lyons.

26. GLEYRE: *Minerva and the Graces* 1866, 88¾ × 54⅛ in. (225 × 138 cm.). Musée cantonale de Lausanne.

27. MILLET: *Hagar and Ishmael* 1849, 59 × 93 in. (146 × 236 cm.). Mesdag Museum, The Hague.

28. *Ave Picardia Nutrix* (left side: *Cider*) 1865, 177⅛ × 689 in. (450 × 1750 cm.), (whole, with border), oil and wax on canvas. Musée de Picardie, Amiens.

29. *Ave Picardia Nutrix* (right side: *The River*) 1865, 177⅛ × 689 in. (450 × 1750 cm.) (whole, with border), oil and wax on canvas. Musée de Picardie, Amiens.

30. *Ave Picardia Nutrix* (study for *The River*) 1865, 10⅜ × 5 in. (26.5 × 12.5 cm.), red and black chalk on tan paper. Musée de Picardie, Amiens.

31. *History* 1866 (for L'Hôtel Vignon), 106½ × 60¼ in.(271 × 153 cm.). Musée d'Orsay, Paris.

32. *Fantasy* 1868 (for L'Hôtel Vignon), 106½ × 60¼ in. (271 × 153 cm.). Ohara Museum of Art, Kurashiki, Japan.

33. *Concentration* 1866 (for L'Hôtel Vignon), 106½ × 41 in. (271 × 104 cm.). Musée d'Orsay, Paris.

34. *Vigilance* 1866 (for L'Hôtel Vignon), 106½ × 41 in. (271 × 104 cm.). Musée d'Orsay, Paris.

35. *Sleep* 1867, 150 × 236¼ in. (381 × 600 cm.). Musée des Beaux-Arts, Lille.

36. *Sleep* (study) 1867, black chalk and blue crayon. Pushkin Museum, Moscow.

37. *Sleep* (compositional study) 1867, 6½ × 8¾ in. (16.6 × 22.1 cm.), pen and wash. Musée des Beaux-Arts, Lille.

38 *Pleasant Land* (figure study) 1882, Private collection, England.

39. *At the Fountain* 1869, 71⅝ × 57 in. (182 × 145 cm.). Museum of Fine Arts, Boston.

40. *Marseilles, Gateway to the Orient* (drawing of an oriental) 1868–69, 14 × 7½ in. (35.6 × 19.4 cm.), conté crayon. Musée des Beaux-Arts, Marseilles.

41. *Marseilles, Gateway to the Orient* (drawing of a deck-hand) 1868–69, 10¼ × 6⅝ in. (26 × 17 cm.), conté crayon. Musée des Beaux-Arts, Marseilles.

42. *The Execution of Saint John the Baptist* 1869, 94½ × 124½ in. (240 × 316 cm.). National Gallery, London.

43. *The Balloon* 1870, 53½ × 33 in. (136.5 × 84 cm.). Musée d'Orsay, Paris.

44. *The Carrier Pigeon* 1871, 53½ × 33 in. (136.5 × 84 cm.). Musée d'Orsay, Paris.

45. NADAR: *The Departure of the 'Armand Barbès'* 1870, 40⅛ × 32¼ in. (102 × 82 cm.). Musée de l'Air, Paris.

46. *Hope* (small version) 1872, 27⅞ × 32¼ in. (70.7 × 82 cm.). Musée d'Orsay, Paris.

47. *Death and the Maidens* 1872, 57½ × 46⅛ in. (146.1 × 117.2 cm.). Sterling and Francine Clark Art Institute, Williamstown, Mass.

48. *Summer* (oil sketch) 1873, 17 × 24½ in. (43 × 62 cm.). National Gallery, London.

49. *Charles Martel, Conqueror of the Saracens* 1874, 196⅞ × 118⅛ in. (500 × 300 cm.). Hôtel de Ville, Poitiers.

50. *Charles Martel* (drawing of kneeling figures) 1873–74, 10⅞ × 10⅝ in. (27.5 × 27 cm.), pencil on tracing paper, squared for transfer. Musée Sainte-Croix, Poitiers.

51. *Saint Radegonde at the Convent of Sainte-Croix* 1874, 196⅞ × 118⅛ in. (500 × 300 cm.). Hôtel

de Ville, Poitiers.

52. *The Fisherman's Family* 1875, 102⅜ × 85⅞ in. (260 × 218 cm.). (Formerly Staatliche Kunst-sammlungen, Dresden, destroyed in 1945).

53. *Saint Genevieve as a child at Prayer* 1876, 181⅞ × 87 in. (462 × 221 cm.). Panthéon, Paris.

54. *The Childhood of Saint Genevieve* (left panel) 1877, 181 × 109⅜ in. (460 × 277.8 cm.). Panthéon, Paris.

55. *The Childhood of Saint Genevieve* (right panel) 1877, 181 × 109⅜ in. (460 × 277.8 cm.). Panthéon, Paris.

56. *Procession of Saints for the Frieze above 'The Childhood of Saint Genevieve'* (reduced version) 1879, 30¼ × 100 in. (76.8 × 254 cm.). Philadelphia Museum of Art.

57. *The Three Theological Virtues* 1874, 88½ × 87 in. (225 × 221 cm.). Panthéon, Paris.

58. *The Prodigal Son* 1879, 51⅛ × 37½ in. (130 × 95.5 cm.). E. G. Bührle Foundation, Zurich.

59. *Young Girls by the Sea* (reduced version) c.1879, 24 × 18½ in. (61 × 47 cm.). Musée d'Orsay, Paris.

60. CAZIN: *The Day's Work Done*, 78⅜ × 65⅜ in. (199 × 166 cm.). Musée d'Orsay, Paris.

61a. *Pro Patria Ludus* (left section) 1882, 177⅛ × 689 in. (450 × 1750 cm.). (whole, including border). Musée de Picardie, Amiens.

61b. *Pro Patria Ludus* (right section) 1882, 177⅛ × 689 in. (whole, including border). Musée de Picardie, Amiens.

62. *Pro Patria Ludus* (sketch) c. 1879, 24⅜ × 98⅞ in. (62 × 251 cm.), pencil, red chalk and oil on canvas. Louvre, Paris.

63. *Pro Patria Ludus* (drawing of sitting child) 1882, 5¾ × 5½ in. (14.5 × 13.9 cm.). Musée de Picardie, Amiens.

64. *Orpheus* 1883, 13¾ × 22 in. (35 × 56 cm.). Private Collection, Paris.

65. *Christian Inspiration* 1886, 181 × 227½ in. (460 × 578 cm.). Musée des Beaux-Arts, Lyons.

66. *The Rhône and the Saône* 1886, 181 × 409⅜ in. (460 × 1040 cm.). Musée des Beaux-Arts, Lyons.

67. *The Rhône and the Saône* (detail of the Saône) 1886. Musée des Beaux-Arts, Lyons.

68. TOULOUSE-LAUTREC: *Parody of 'The Sacred Grove'* 1884, 68 × 150 in. (172 × 380 cm.). The Henry and Rose Pearlman Foundation, Inc., U.S.A.

69. *Inter Artes et Naturam* 1890, 115⅛ × 326¾ in. (295 × 830 cm.). Musée des Beaux-Arts, Rouen.

70. *Pottery* 1891, 115⅛ × 65 in. (295 × 165 cm.). Musée des Beaux-Arts, Rouen.

71. *Ceramics* 1891, 115⅛ × 65 in. (295 × 165 cm.). Musée des Beaux-Arts, Rouen.

72. *Winter* 1892, 232¼ × 358¾ in. (590 × 910 cm.). Hôtel de Ville, Salon du Zodiaque, Paris.

73. *Winter* (drawing of tree-fellers) 1892, 12⅝ × 11 in. (32.1 × 27.8 cm.), black chalk on tracing paper, squared for transfer. Musée du Petit Palais, Paris.

74. *The Sciences and the Arts* 1889, 224⅜ × 1023⅝ in. (570 × 2600 cm.). Grand Amphitheatre, Sorbonne, Paris.

75. DELAROCHE: *The Artists of Every Age* (detail of central section)1841, 153½ × 1063 in. (390 × 2700 cm.), encaustic. Hemicycle of the École des Beaux-Arts, Paris.

76. *Victor Hugo Offering his Lyre to the City of Paris* 1894, Length approx. 315 in. (800 cm.). Staircase of Honour, Hôtel de Ville, Paris.

77. *Victor Hugo* (oil sketch) 1894, 26⅛ × 32⅞ in. (66.5 × 83.5 cm.), Musée du Petit Palais, Paris.

78. *Physics* 1896, 171¼ × 86⅝ in. (435 × 220 cm.). Boston Public Library.

79. *Virgil or Pastoral Poetry* (reduced version) 1896, 47¾ × 23¾ in. (121 × 61 cm.). Private collection, U.S.A.

80. *Aeschylus or Dramatic Poetry* 1896, 171¼ × 86⅝ in. (435 × 220 cm.). Boston Public Library.
81. *Homer or Epic Poetry* 1896, 171¼ × 86⅝ in. (435 × 220 cm.). Boston Public Library.
82. *Chemistry* 1896, 171¼ × 86⅝ in. (435 × 220 cm.). Boston Public Library.
83. *Astronomy* 1896, 171¼ × 86⅝ in. (435 × 220 cm.). Boston Public Library.
84. *Philosophy* 1896, 171¼ × 86⅝ in. (435 × 220 cm.). Boston Public Library.
85. *The Inspiring Muses* (detail) (cartoon) 1895. Opéra-Comique, Paris.
86. *Saint Genevieve Provisioning Paris* (left section) 1897, 181⅞ × 109⅜ in. (462 × 278 cm.). Panthéon, Paris.
87. *Saint Genevieve Provisioning Paris* (central section) 1897, 181⅞ × 133⅞ in. (462 × 340 cm.). Panthéon, Paris.
88. *Saint Genevieve Provisioning Paris* (right section) 1897, 181⅞ × 109⅜ in. (462 × 278 cm.). Panthéon, Paris.

Colour Plates

 I *Massilia, Greek Colony* 1869, 166½ × 222⅜ in. (423 × 565 cm.). Marseilles, Musée des Beaux-Arts (Palais Longchamp).
 II *Marseilles, Gateway to the Orient* 1869, 166½ × 222⅜ in. (423 × 565 cm.). Marseilles, Musée des Beaux-Arts (Palais Longchamp).
 III *The Execution of Saint John the Baptist* 1869, 48⅜ × 65 in. (123 × 165 cm.). The Barber Institute of Fine Arts, University of Birmingham.
 IV *Saint Mary Magdalen in the Desert* 1869, 61⅝ × 41½ in. (156.5 × 105.5 cm.). Städelsches Kunstinstitut, Frankfurt.
 V *Hope* (large version) 1872, 40⅜ × 50⅛ in. (102 × 127.5 cm.). The Walters Art Gallery, Baltimore.
 VI *Summer* 1873, 120 × 199½ in. (305 × 507 cm.). Musée d'Orsay, Paris.
 VII *The Childhood of Saint Genevieve* (central panel) 1877, 181 × 134⅜ in. (460 × 343.1 cm.). Panthéon, Paris.
VIII *Young Girls by the Sea* (large version) 1879, 80¾ × 60⅝ in. (205 × 154 cm.). Musée d'Orsay, Paris.
 IX *The Poor Fisherman* 1881, 61¼ × 75¾ in. (155.5 × 192.5 cm). Musée d'Orsay, Paris.
 X *Ludus Pro Patria* (replica of 'Pro Patria Ludus') 1888–89, 13⅛ × 52⅞ in. (33.4 × 134.6 cm.). Metropolitan Museum of Art, New York (Gift of Mrs Harry Payne Bingham, 1958; 58.15.1).
 XI *Pleasant Land* (reduced version) c.1882, 10⅛ × 18⅝ in. (25.8 × 47.3 cm.). Yale University Art Gallery, New Haven (The Mary Gertrude Abbey Fund).
 XII *The Dream* 1883, 32¼ × 40⅛ in. (82 × 102 cm.). Musée d'Orsay, Paris.
XIII *Woman at her Toilette* 1883, 29½ × 24⅞ in. (75 × 63 cm.). Musée d'Orsay, Paris.
XIV *Madame Marie Cantacuzène* 1883, 30¾ × 18⅛ in. (78 × 46 cm.). Musée des Beaux-Arts, Lyons.
 XV *Vision of Antiquity-Symbol of Form* c.1887–89, 41½ × 52½ in. (105.4 × 133.3 cm.). Carnegie Museum of Art, Pittsburgh.
XVI *The Sacred Grove beloved of the Arts and of the Muses* (reduced version) 1884–89?, 36½ × 82⅞ in. (92 × 210 cm.). The Art Institute of Chicago.
XVI *Saint Genevieve's Vigil* 1898, 181⅞ × 89 in. (462 × 226 cm.). Panthéon, Paris.

PHOTOGRAPHIC CREDITS

INDEX